DESIGNING SOUND
for ANIMATION

Robin Beauchamp

D0550693

AMSTERDAM • BOSTON • HEIDELBERG • LONDON
NEW YORK • OXFORD • PARIS • SAN DIEGO
SAN FRANCISCO • SINGAPORE • SYDNEY • TOKYO

Focal Press is an imprint of Elsevier

ELSEVIER

Focal Press

Acquisitions Editor: Amy Eden Jollymore
Assistant Editor: Cara B. Anderson
Production Manager: Simon Crump
Marketing Manager: Christine Degon
Interior Design: Jennifer Plumley

Focal Press is an imprint of Elsevier
30 Corporate Drive, Suite 400, Burlington, MA 01803, USA
Linacre House, Jordan Hill, Oxford OX2 8DP, UK

♾ Recognizing the importance of preserving what has been written, Elsevier prints its books on acid-free paper whenever possible.

Library of Congress Cataloging-in-Publication Data

British Library Cataloguing-in-Publication Data
A catalogue record for this book is available from the British Library.

ISBN-13: 978-0-240-80733-1 ISBN-10: 0-240-80733-2

For information on all Focal Press publications
visit our website at www.books.elsevier.com

06 07 08 09 10 10 9 8 7 6 5 4 3 2

Printed in the United States of America

Contents

About the Author

Robin Beauchamp is a professor of sound design at the Savannah College of Art and Design. There he teaches introduction to sound design, recording engineering, music for motion picture, advanced sound effects, Foley, and surround sound mixing. Mr. Beauchamp continues to work as a music editor and sound designer for independent animations. He is also a freelance composer and arranger, working on a variety of commercial projects. The author may be contacted by email at rbeaucha@scad.edu or by phone at 912-525-6463

Credits

THE ANIMATORS

To Aaron Conover, Chris Evans, Kyle Winkleman, Joshua Merck, Ginka Kostova, Daesup Chang, and Todd Hill, thank you for sharing your first animation projects with us. Your work continues to educate and entertain us. Thanks to Joe Pasquale for making sure that these animations got completed and for mentoring me in the animation process.

THE ILLUSTRATOR

Special thanks to Keith Conway (principle illustrator), Veronica De La Pena, and Anthony Kramer for turning my really bad drawings into beautiful illustrations.

MOTION GRAPHICS

Special thanks to Laura Rieland for her brilliant work on the motion graphics.

COVER

Thanks to Mike Goubeaux for a fantastic cover.

PHOTOGRAPHS

Special thanks to Bob Duncan for the digital photographs.

DVD

Thanks to Mike Goubeaux for his facilitating a DVD with so much instructional material. Also, thanks to Matt Espinoza for consulting on the DVD.

Acknowledgments

To Amy Jollymore, Anthony Kramer, Laura Rieland, and Dane Davis, thank you for your encouragement in writing this book.

To Tom Fischer and Pierre Archenbault, thank you for giving me the opportunity to teach and practice sound design.

To Lewis Herrin, Matt Akers, Chris McKnight, Patrick Commack, Brad Barham, Matt Browning, Ron Ferrell, Phil Morales, and Ralph Gnann, thank you for your patient mentoring with gear, software, and audio concepts.

To Bill Dannevik, many thanks for your countless hours of tutoring on audio postproduction.

Thanks to Sophia Caparisos, Bill Dannevik, Dane Davis, Angela and Paul Hackner, Chris McKnight, Rob Miller, Dave Moulton, Gary Rydstrom, Steven Subotnick, Erin Scott Carrie Sutton, Valerie Thielker, and Lauren Weinger, for proofing the manuscript. Thanks to Debra Wagnon, Ernie Lee, and Janice Shipp for legal assistance.

Special thanks to the administration of the Savannah College of Art and Design for their support for this book: Paula Wallace (president), Brian Murphy (executive vice president and chief operating officer), John Burger (executive vice president), Harley Lingerfelt (vice president of information technologies), Jeff Eley (vice president of academic affairs), Peter Weishar (dean of film and digital media), and Harvey Ray (director of film industry relations).

To Clyde Andrews, for all your help and support through this process.

To Gabe Herman and Stephen Villari for their work designing additional sfx for "Sam"

For technical assistance and permission to print screen shots: Thom Ehle, Dolby Laboratories; Brian Doser, Digidesign; Ken Bogdanowicz, Wave Mechanics; Joel and Ben Chababe, GRM USA; Marcie Jacobs, DeWolfe Music; and Rob Nokes, SoundDogs.

To Chuck Lauter, for insisting that we all learn to write.

Methodology is not a substitute for personal logic. —Ronald B. Thomas

Introduction

A. Overview

The digital age has empowered animators with the means to realize their creative visions without relying on the resources of the major studios. The relatively low cost of essential technologies has opened the door to an increasing number of animators. Academic programs have emerged to meet the growing interest and demands for formal instruction in this art form. Those responsible for curriculum face the daunting task of compressing essential animation courses into a traditional four-year program of study. Due to competing forces, courses addressing sound for image are often omitted from these programs. As a result, many developing animators do not get the opportunity to study the sound track and fail to develop a comprehensive aesthetic for storytelling that includes sound. They remain unaware of both the process and the tools used to develop a purposeful sound track. In addition, many animators struggle to find the resources (legal or otherwise) required to develop sound tracks consistent with their vision. This book explores aspects of a sound track in language that is accessible and relevant to the animator yet comprehensive enough for the developing sound designer. In addition, it encourages animators to develop a production path that facilitates and maximizes sound at *all phases*. The book explores the aesthetic, technologi-

cal, and collaborative issues with the purpose of creating a legal sound track that can be submitted to employers, distributors, and festivals.

B. The Elements of a Sound Track

*Every child is an artist. The problem is how to remain
an artist once he grows up.* —Pablo Picasso

Eavesdrop on a child playing with toys, the kind that are powered more by imagination than batteries. Notice the detail with which children sonify their play. They produce vocal sound effects that vividly portray the object(s) in hand. A diverse cast, uniquely voiced, interacts seamlessly to produce dialog that provides us with essential narrative elements. From time to time an occasional melody is performed to underscore the action. Listen closely and you will hear volume and pitch changes that reflect their innate understanding of physics and acoustics. Children develop sound tracks intuitively. As we mature, the ability to approach story telling with the same playful and creative ear remains essential. The three essential elements comprising the sound track are dialog, sound effects (SFX), and music. The dialog and sound effects elements of the sound track are created by a staff of *sound recordists* and *editors* directed by a *supervising sound editor*. The *composer* and the *music editor* develop the score separately. *Rerecording mixers* complete the sound track by blending all three elements at the final mix and formatting the sound track for release. *Sound design* is a term that is sometimes used generically to refer to persons responsible for creating the sound track. Ben Burtt ("Star Wars") and Walter Murch ("Apocalypse Now") began using Sound Design to denote the person responsible for directing sound elements for film and animation. The term *sound designer* (for lack of a better term) will be used on occasion to denote a vari-

ety of roles held by persons involved in the process of designing sound of all types for the sound track. Perhaps the most important interpretation of the term *sound design* is viewing it as a process in which sound (of all types) is allowed to influence the animation creatively at all phases of production.

C. Scope of Book

The majority of writings on sound for image focus primarily on live action, providing only brief mention of the contributions and general practices associated with animation. There are significant aesthetic and production differences between live action and animation. For example, animation is not tied to *production audio* (sound acquired on a live set), so dialog and ambience must be created and edited differently. In addition, the *animatic* (moving storyboard) created in pre-production, provides a working model by which initial sound elements can be developed. This book acknowledges the many contributions that live action has made to the development of animation, and includes examples and techniques drawn from live action films, however, the main focus of this text is designing sound specifically for animation.

Over the past decade, many post-production audio facilities have transitioned from analog to digital. The software that made this transition possible has provided a virtual interface modeled after the physical counterparts associated with analog studios. There are, however, important differences in the way each system handles audio production. This book will limit the discussion primarily to digital audio workstations and associated production practices.

Sound design is a significant element in the collaborative process of animation. As with any collaborative effort, those persons involved must develop a working understanding of the aesthetics,

tools, and procedures associated with each aspect of the production; consequently, this book must serve two masters: the animator and those individuals responsible for the sound track. At times, the animator might feel overwhelmed with the technical aspects of this book while the sound designer may feel a need for greater depth. A conscious decision was made to consider the needs of the animator first. The bibliography contains many of the significant writings on sound design to date; these books explore, in great depth, content that is valuable to both the sound designer and the animator.

D. Using This Book

This book is designed as a text or self-directed study on sound for narrative short-form animation. Section I (Chapters 1 and 2) covers the foundations and theories of sound as they apply to the audio/visual experience. The concepts addressed in these chapters provide an essential foundation in physics, acoustics, human perception, and aesthetics. The vocabulary presented in these chapters will become more relevant as the reader works through the book. The math has been simplified, the techno babble has been removed, and the acronyms have been spelled out. These chapters seek to close the gap between conceptualization and application. Section II (Chapters 3, 4, and 5) defines the three main audio stems used in animation: dialog, sound effects, and music. Each chapter explores the unique contribution of that stem to the art of storytelling. These chapters define the individual elements that make up each stem while also providing suggestions on how to acquire them. Section III (Chapter 6) covers the legal aspects of

developing a sound track for animation. It is important to understand the basic principles of arts law to ensure that the sound track can be exhibited and distributed legally. Section IV (Chapters 7 and 8) covers the tools and techniques associated with sound design. In Chapter 7, an attempt was made to take as global an approach to software and hardware as possible. Specific products come and go, which is why we rely on trade magazines to review these emerging products. The most important aspect of this chapter is that it identifies the types of tools available for production. The goal of these technologies is to facilitate the making of art, becoming as transparent to the process as possible. Chapter 8 explores the use of these tools to design the elements discussed in Section II. Section V (Chapters 9, 10, and 11) explores the production path from pre-production through post-production. These chapters explore the critical sequence in which audio and visual elements are created and combined. The goal of these chapters is to facilitate interaction between content developers. These chapters are not intended to provide a definitive production model for sound design in animation. Both the animator and the sound designer have been given access and freedom to create; with that comes the personal responsibility to develop a unique production process. Sections VI (Chapters 12 and 13) provides case studies that document the decisions made when producing the sound design for the animations found on the accompanying DVD. These chapters are intended to guide the listeners as they experience each of these animations. The sound track can be heard as a full mix, SFX only, or music only. The design decisions made on each of these animations reflect the approach of one designer under the direction of student animators. QuickTime™ movies are included (without sound) on the DVD for those who wish to produce an entirely new sound track.

Foundations and Theory

Sound is fifty percent of the motion picture experience. —George Lucas

Every artist must strive to understand the nature of the raw materials he or she uses to express creative ideas. This is equally true when developing a soundtrack. Chapter One explores the physical and acoustical properties of audio in the context of human perception. It also describes many technical aspects of digital audio. Chapter Two explores many of the unique roles sound plays in the art of storytelling with moving image. The importance of these concepts to your work will become increasingly relevant as you work into later chapters.

Foundations of Audio for Image 1

A. The Physics of Sound

1. Overview

There are three basic requirements for sound to exist in the physical world. First, there must be a *sound source*, such as a gunshot, which generates acoustic energy. The acoustic energy must then be transmitted through a *medium* such as air, water, or drywall. Finally, a *receiver*, such as a microphone or a listener's ears, must pick up the acoustic energy. Once acoustic energy enters the ears, it is converted to nerve impulses and directed to the brain. The brain then processes these impulses to produce a subjective interpretation called *sound*. The animator creates the first two conditions, the sound designer represents these conditions with sound, and the audience completes the process. Another way in which we experience sound does not follow this model—a process known as *audiation*, which is a mental rather than a physiological process. As you are silently reading this book, the words are sounding in your brain as if they were being produced in the physical world; however, these sounds are not a direct product of your hearing mechanism. Just as animators visualize their creations, composers and sound designers conceptualize their creations through the process of audiation. Voice over (in the first person) allows us to hear the thoughts of a character, an example of scripted audiation (Figure 1.1).

FIGURE. 1.1.
Audiation.

2. The Anatomy of a Sine Wave

A sine wave is the most basic element of sound (Figure 1.2).

The horizontal line shown represents the *null point*, the point at which no energy exists. The space above the line represents high pressure (*compression*). The higher the wave ascends, the greater the sound pressure. The highest point in the excursion above the line is the peak. The space below the line represents low pressure (*rarefaction*). As the wave descends, a vacuum is created. The lowest point in the downward excursion is the *trough*. A single, 360° excursion of a wave (*over time*) is a *cycle*. *Phase* (Figure 1.3) is expressed in degrees and describes specific points in the excursion of a cycle.

When two identical waves are combined in phase, they are summed to produce a signal with greater energy. When an identical wave is combined out of phase, the two waves progressively cancel each other to produce a wave with less energy. This phenomenon is referred to as *phase cancellation* (Figure 1.4).

In *digital audio workstations* (DAWs), we have the ability to zoom in on each cycle. When trimming a signal (Figure 1.5), it is advisable to trim at 0°, 180°, or 360° (points of zero energy) to avoid audible pops.

When creating loops, the end of the first region must continue toward the beginning of the subsequent region. Both must be trimmed at the zero crossing point. Loops are useful for extending music, ambient tracks, the sustained component of layered effects, and DVD menus.

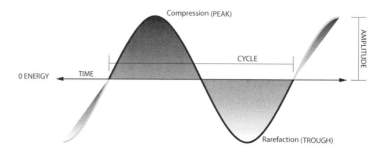

FIGURE 1.2. The sine wave.

3. Frequency

Frequency, determined by counting the number of *cycles* per second, is expressed in units called *hertz* (Hz); one cycle per second is equivalent to 1 hertz. *Pitch* is our subjective interpretation of frequency. In musical terms, the frequency range of human hearing is 10 octaves, eight of which are present in a grand piano. The *fre-*

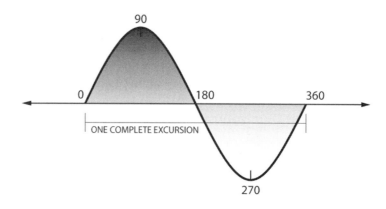

FIGURE 1.3. The degrees of phase.

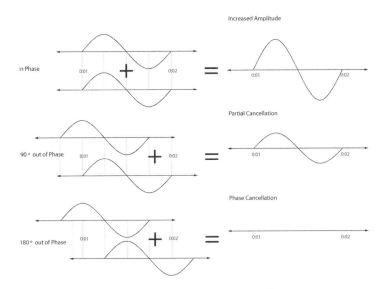

FIGURE 1.4. Summing and cancellation.

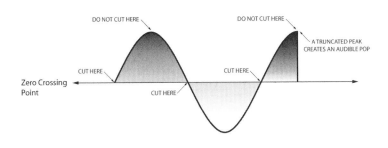

FIGURE 1.5. Cutting at the zero crossing point.

quency threshold (hearing range) for humans begins around 20 Hz and extends upward to 20,000 Hz (20 kHz). *Frequency response* refers to the range of fundamental frequencies that an object can produce. Many of the end-user playback systems have a narrower frequency response than our ears (Figure 1.6).

Frequency has many narrative applications to sound design. For example, we associate higher frequency with smaller sound sources, youth, and increased speed. Low frequencies travel up our bodies through our feet, a physiological response that influences our perception of vertical movement. Thus, we can enhance visuals that imply downward movement by simultaneously increasing low-frequency material. Audiences also use low frequency to perceive depth and high frequency to localize horizontal positioning; therefore, images represented by low frequencies are most convincing when moving from back to front, and images represented by high frequency are most convincing when panned from left to right. In many cases, sound effects are pitched up or down to create contrast or to work harmoniously with the underscore.

4. AMPLITUDE

When sound waves are recorded, the resultant wave is referred to as a *signal*. The term amplitude is used to describe the amount of energy (voltage) present in the signal. When a signal is converted back to acoustical energy (playback monitors), greater *amplitude* results in increased pressure exerted against the listener's hearing apparatus. The technical term used to describe this acoustic pressure is *dB SPL*, where dB stands for *decibel* and SPL stands for *sound pressure level*. Our subjective interpretation of the increase in SPL is *volume*, or *perceived loudness*. The continuum starting from the softest perceptible sound (0 dB SPL) and extending to the loudest perceptible sound is known as the *dynamic range*. Audiences perceive volume in terms of relative change rather than specific dB levels. An increase of 6 to 10 dB is perceived by most

Designing Sound for Animation

FIGURE 1.6.
Frequency in
context.

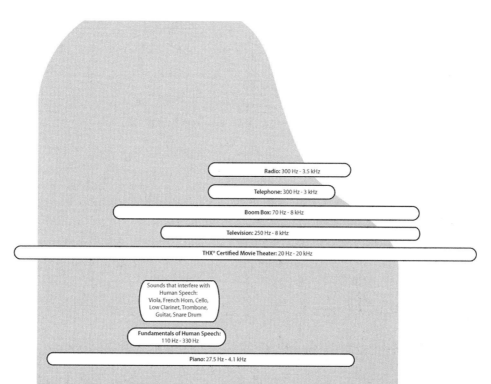

Radio: 300 Hz - 3.5 kHz

Telephone: 300 Hz - 3 kHz

Boom Box: 70 Hz - 8 kHz

Television: 250 Hz - 8 kHz

THX® Certified Movie Theater: 20 Hz - 20 kHz

Sounds that interfere with
Human Speech:
Viola, French Horn, Cello,
Low Clarinet, Trombone,
Guitar, Snare Drum

Fundamentals of Human Speech:
110 Hz - 330 Hz

Piano: 27.5 Hz - 4.1 kHz

32 Hz	62.5 Hz	125 Hz	250 Hz	500 Hz	1 KHz	2 KHz	4 KHz	8 KHz	16KHz
Bottom End	Lower End	Upper Bass	Mudrange	Lower Mid range	Mid range	Upper Mid	Presence	Highs	Extreme Highs

audiences as a doubling in volume. Dialog, if present, is the single most important sound element used by audiences to judge the volume levels for playback. Sound designers use amplitude to achieve a variety of effects. Variations in amplitude applied to music, dialog, or sound effects influence the intensity, emphasis, perceived size, and proximity of the source or sound object. The perception of volume is also frequency dependant. Human hearing is most sensitive in the mid-range frequencies. More amplitude is required for low and high frequencies to match the apparent loudness of the mid-range frequencies. This perceptual curve is known as the *equal loudness* curve. Mixing at lower levels could result in over-compensating in the lows and highs, and the mix will not translate very well in theaters.

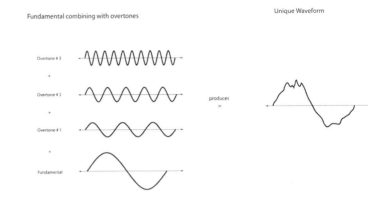

FIGURE 1.7. Timbre.

5. TIMBRE

We have the ability to accurately identify a multitude of objects and characters by the sounds they make. Friends and family instantly recognize our voices and will notice even the slightest variations. This aural signature (or fingerprint) is known as *timbre* (Figure 1.7).

Each unique waveform is the product of a fundamental wave, its respective overtones, physical characteristics of the sound object, and the volume envelope. The *fundamental* is the lowest frequency and the greatest amplitude. All waves above the fundamental are referred to as *overtones*. Multiple overtones of various amplitudes combine with the fundamental to produce a *waveform* that is as unique as a fingerprint. Variation in timbre is a critical factor when developing readily identifiable characters and sound objects for an animation.

6. THE VOLUME ENVELOPE

Volume envelopes contribute to our ability to identify specific sounds. The four stages of a volume envelope are attack, decay, sustain, and release, or *ADSR* (Figure.1.9). Sound begins from a resting (null) position and gets progressively louder over time until it reaches its maximum level, or *peak*. When the volume of a sound rises rapidly, a more percussive type of sound is produced. Sound editors refer to the *attack* as a *transient*. When the peak of an attack is achieved, the sound begins to fall off in intensity. This subsequent drop off is referred to as *decay*. The *sustain* component which follows is relatively constant in volume, providing an opportunity for looping. The final stage of the envelope is the *release*, in which levels gradually fall off to the point below the threshold of hearing. Some releases are immediate, such as a door closing, and some are more gradual, like the sound of a jet engine winding down. Sound designers are routinely required to create new sounds by layering a

multitude of sounds. The sound envelope provides a visual model for conceptualizing and manipulating multiple sounds to produce a layered or *built-up effect* (Figure 1.8).

7. WAVELENGTH

Wavelength is the horizontal measurement of the complete cycle of a wave. Wavelengths are inversely proportionate to frequency (Figure 1.9).

The average ear span of an adult is approximately 7 inches. Waves of varied length interact uniquely with this fixed ear span. Low-frequency waves are so large that they wrap around our ears and reduce our ability to determine the direction (*localization*) of the sound source. The closer the length of a wave is to our ear span (approx 2 kHz), the easier it is for us to localize. One popular application of this concept is the use of low-frequency sound effects to increase the audience's fear response. This technique plays on the human "fight or flight" response. When audiences are presented with visual and sonic stimuli determined to be dangerous, the body instinctively prepares to fight or escape. If the audience cannot determine the origin or direction of the sound, their sense of fear and vulnerability is heightened.

8. SPEED OF SOUND

Sound travels at roughly 1130 feet per second through air at a temperature of 70°F; the more dense the medium (steel *versus* air), the faster the sound travels. The speed of sound is equal at all frequencies. In reality, light travels significantly faster than sound. In the real world, we see an action or object before we hear it; however, the accepted practice in sound editing is to sync the audio within a few frames of the on-screen source (hard sync).

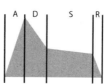

FIGURE 1.8. Volume envelope and built-up effects

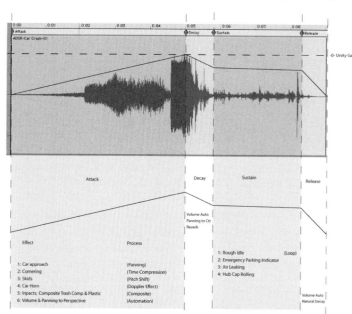

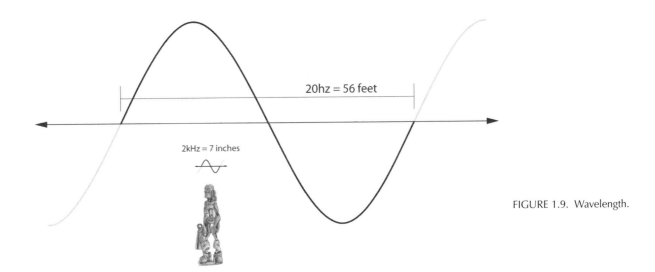

20hz = 56 feet

2kHz = 7 inches

FIGURE 1.9. Wavelength.

B. Perception of Sound

1. HEARING *VERSUS* LISTENING

When acoustic energy arrives at our ears, it excites the hearing apparatus and causes a physiological sensation, interpreted by the brain as sound. This physiological process is *hearing*. If we are not attending to the sound, the information contained is not processed and no meaning is derived. Being inattentive to sound is analogous to reading while listening to the radio, only to realize at the end of each page that you cannot recall a single word or concept presented. *Critical listening* involves a conscious effort to process the presenting sounds. Most people attend to only a small fraction of the sounds presented to them in their physical world. An effective sound track will motivate the audience to attend to those sounds selected for them to support the narrative goals of the animation.

2. DEFINING A SPACE

As acoustic energy travels from its source, it produces three types of sound: direct sound, early reflections, and late reflections (reverb and echo). Together, these three components help define the space in which sound objects exist and interact. The terms dry and wet are subjective terms describing direct and reflected sound. Dry sounds are often associated with close-up shots; as the camera zooms out, early and late reflections gain more prominence. *Reverb* and *echo*

are terms that are often used interchangeably (but not correctly) to describe early and late reflections, respectively (Figure 1.10).

Reverb is a lengthening of the sound where echoes are heard as discrete events. The presence of reverb and echo promotes the concept that a space is large, open, and constructed from reflective surfaces. Frequency also helps us define a space. In the physical world, high frequencies are absorbed more rapidly as sound travels over distances or through barriers; hence, the larger the space, the greater the potential for high-frequency loss.

3. STEREO IMAGING

I am sitting in a room different from the one you are in now. —Alvin Lucier

Sound projecting from theater loudspeakers defines the virtual space constructed for the narrative. Most independent animations will be screened in venues with primarily stereo playback systems. The space between the left and right speakers is the *stereo field*. Sound can be placed (*panned*) in the stereo field to accurately match on-screen visuals using volume differences between loudspeakers. By adjusting levels over time, we can create the illusion that the sound is moving with the image (*dynamic panning*). The audience's ability to perceive discrete placement and dynamic movement is referred to as *localization*. The stereo pan pot was developed in 1938 for Walt Disney's "Fantasia" to facilitate panning (Figure 1.11).

Since that time, many basic panning conventions have developed which are still in use today. Dialog is typically panned toward the center position, where the audience can most easily hear it. Music and ambience typically share the left and right sides of the stereo image. Sound effects are *panned to perspective* (matching the image), often moving dynamically with the image.

4. RHYTHM AND TEMPO

Rhythm is the identifiable pattern of sound and silence. The speed of these patterns is referred to as the *tempo*. Tempo can remain constant, accelerate, or decelerate over time. Rhythm and tempo influence the audience's perception of the visual timing of on-screen images. Examples of sounds with rhythm and tempo include dialog, footsteps, music, clocks, and heartbeats.

5. NOISE

Two definitions of noise relate to sound design; one comes from aesthetics and the other from physics. The aesthetic definition of noise includes all unwanted sound. Noise is often deliberately added to hard effects to heighten realism. For example, vinyl pops and radio static are often added to music tracks to make them sound used or analog. Noise can be viewed from the perspective

Direct REV Veerrrbbb Echo Echo Echo

No Repetitions, Dry, No high frequency loss

Overlap is so close that the effect is a lengthening of the sound with a gradual decay.

Time delay is significant enough that the brain perceives discrete repeated events.

FIGURE 1.10. Defining space.

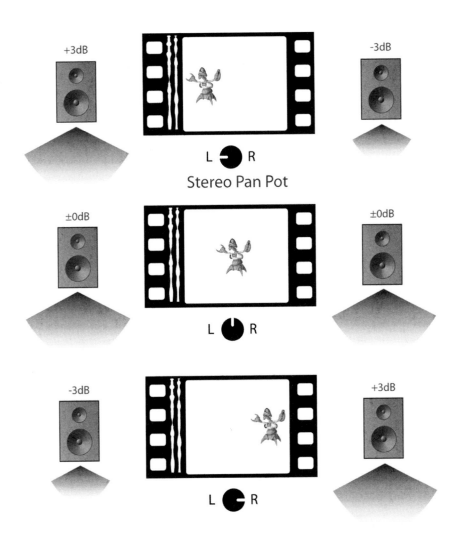

+3dB -3dB

Stereo Pan Pot

±0dB ±0dB

-3dB +3dB

FIGURE 1.11. Volume panning.

of physics as well as aesthetics. In physics, when no fundamental frequency is clearly heard due to the equal presence of all frequencies at similar volume levels, the sound is referred to as noise. White and pink noise are two examples that fit this definition. *White noise* contains all frequencies at equal amplitude. *Pink noise* is equalized so each octave is perceived as having equal energy. White noise is often used to imply that a station is off the air or experiencing interference. Noise that has a *fixed frequency* (pitch is unchanging) and a *narrow band* (limited frequency range) is easier to identify and remove with noise-reduction software. Noise always exists to some degree. In sound design, the goal is to control the level of noise in such a way that it either works with the desired sounds (signals) or does not compete with it. The relationship between noise and sound is expressed in terms of the *signal to noise ratio* (s/n).

6. SILENCE

The jazz trumpeter Miles Davis established his career by departing from the frantic bebop lines of his contemporaries, utilizing silence as an important means of expression. Davis set up an expectation for sound and deprived us of it to produce a profoundly dramatic experience. The decision to omit sound in a scene often defines the skill and maturity of the sound designer. Silence can be used effectively to punctuate a scene, provide contrast, grab our attention, provide relief from a thick texture, establish a new location, or comment on action. Silence is often used just prior to a loud event to provide the necessary contrast without having to push volume levels to the extreme. Audiences instinctively tune in when the sound track gets quiet, providing an excellent opportunity to use the sound design to imply rather than show important narrative elements. Silence must be handled carefully because audiences are somewhat uncomfortable with it.

C. Digital Audio

Digital audio has simplified many technical aspects relating to the recording, editing, synching, and storage of sound to image. For these reasons, digital audio is a popular choice for many sound designers. One advantage to digital audio (over analog) is that multiple copies of an audio file can be made without degrading the basic quality. This greatly impacts the sound design process, where file sharing necessitates frequent copying. Digital audio is not without its drawbacks, however, and it is important to understand its basic characteristics and potential for sound track development.

1. CAPTURING AUDIO

The process of capturing acoustic energy and converting it to digital values is referred to as digitizing. An analog signal is digitized with the help of specialized computer chips known as analog-to-digital (A/D) converters (Figure 1.12).

Once digitized, the audio (referred to as a *signal*) can be imported and manipulated in a computer environment. Playback of the digital signal is made possible through a process known as *D/A conversion*. Conversion chips are a primary component of sound cards and audio interfaces for digital audio systems.

2. SAMPLING RATES

The visual component of animation is represented by a minimum of 24 frames per second. As the frame rate dips below this visual threshold, the image begins to look choppy (persistence of vision). Similar thresholds exist for digital audio as well. Frequency is cap-

tured digitally by sampling at more than twice (approximately 2.2) the rate of the highest frequency present, referred to as the *Nyquist frequency* (Figure 1.13).

If the sampling rate is less than twice the frequency, the resultant audio will become filled with numerous undesired *alias* (false) frequencies. The frequency range of human hearing is approximately 20 Hz to 20 kHz, extending upward to 22.05 kHz in some cases. When the specifications for CD audio were being developed, a sampling rate of 44.1 kHz was selected to effectively represent 22.05 kHz. DVD utilizes sampling rates of 48 kHz and 96 kHz. One reason for extending the sampling rate beyond our hearing range is that overtones that exist above this range contribute to the waveform and the resultant sound. In addition, higher sample rates produce warmer and more spatial audio like that associated with analog recordings. To facilitate fast downloading and to reduce file sizes, audio bit-depths and sample rates are often lowered at the expense of audio quality; consequently, many of the sounds available as free downloads do not meet the quality standards for professional audio. Table 1.1 provides a list of sampling rates associated with various release formats.

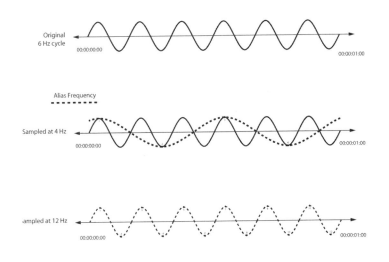

FIGURE 1.13. Nyquist frequency.

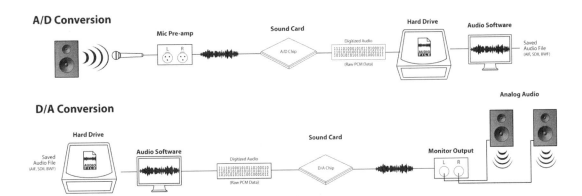

FIGURE 1.12. Analog-to-digital conversion.

TABLE 1.1 Sampling Rates

Sampling Rate (kHz)	Application
44.1	CD
48	DV tape, DVD
96	DVD-V
192	DVD-A

TABLE 1.2 Bit-Depths

Bit-Depth (Bit)	Quantization Resolution (Levels)	Application
4	16	None
8	256	Internet
16	65,536	CD, DV tape
20	1,048,576	DVD-V, DVD-A
24	16,777,216	DVD-V, DVD-A

3. BIT-DEPTHS

The amplitude of a wave is captured digitally by sampling the energy of a wave at various points over time and assigning each point a value in terms of voltage (Figure 1.21). The term *bit* (binary digit) is used to describe the increments of voltage measured in decibels. *Bit-depth* refers to audio resolution. The term *resolution* accurately describes the impact that bit-depth has on the ultimate shape of the wave. At a bit-depth of two, the energy of a wave is sampled in four equal increments (Figure 1.14).

Notice that all portions of the wave between the sampling increments are rounded up or down (quantized) to the nearest value. *Quantization* produces a sonic pixilation that is perceived as noise. As the bit-depth is increased (Figure 1.15), the resolution improves and the resulting signal looks and sounds more analogous to the original.

In theoretical terms, each added bit increases the dynamic range by 6 dB (16 bit = 96 dB). Many files downloaded from free sound-effects libraries are 8-bit files, which are useful for Internet applications but are well below the standard for professional audio. The standard for CD quality is 16 bit, and 24-bit is an option for DVD. Table 1.2 provides a list of bit-depths used in various release formats.

FIGURE 1.14. Low bit-depth.

FIGURE 1.15. High bit-depth.

4. LINEAR PULSE CODE MODULATION

The most common type of digital audio is linear pulse code modulation (LPCM). PCM audio is not compressed and supports a wide range of bit-depths and sampling rates. The music industry adopted raw PCM sample data at 16 bit and 44.1 kHz (Red Book) as the standard for music on compact disc. By current standards, 16-bit, 44.1-kHz PCM represents the minimum specification for professional digital audio. Most commercial SFX and production music libraries are delivered in CD format. Audio must first be extracted (ripped) from a CD and appended with a file extension before it can be used in a computer environment. The most common file formats include the WAV file (native to the PC), the AIFF file (native to Mac), and the SDII file (developed for Pro Tools®). The BWF (Broadcast Wave Format) includes meta-data that optimize the file for cross-platform use. File sizes for noncompressed audio is based on the bit-depth and sample rates and number of channels. The information provided in Table 1.3 is for noncompressed mono; to determine the stereo or multichannel size, simply multiply the size-per-minute number by the number of channels.

TABLE 1.3
Audio Resolution andResultant File Size (Mono)

16 Bit-Depth (Mono) (kHz)	File Size per Minute (MB)	24 Bit-Depth (Mono) (kHz)	File Size per Minute (MB)
44.1	5.0	44.1	7.6
48	5.5	48	8.2
88.2	10.1	88.2	15.1
96.2	11.0	96.2	16.7
176.4	20.5	176.4	30.3
192	22.0	192	33.0

5. MULTI-CHANNEL AUDIO COMPRESSION

Although the DVD has delivered significant increases in storage capacity, multi-channel audio and high-resolution video readily consumed these gains, and 5.1 audio has become the standard for theatrical and consumer releases. Six channels of non-compressed audio are not feasible for full-length projects in either film or video formats. As a result, several compression/decompression schemes (*codecs*) have evolved to overcome storage and transmission limitations. The two most popular multi-channel audio codecs for film are the Dolby® AC-3 file and Digital Theater System's DTS® file. Both codec's uses *perceptual encoding* to reduce the file size. Perceptual encoding exploits the limitations of human hearing such as frequency masking and equal loudness to achieve data reduction. The encoders analyze the audio data and encode only those components believed to be perceptible. AC-3 files can achieve up to 12:1 reduction in data with minimal reduction in the audio quality. The AC-3 file is the standard for theatrical releases and consumer video and has recently been adopted as the audio standard for high-definition television. AC-3 supports up to six channels of discrete audio. DTS also reduces file size by taking advantage of *redundancies* that occur in the audio material. DTS encoding can achieve up to 4:1 data reduction. Debate continues as to whether DTS is better than AC-3; however, the decision to use Dolby over DTS often is based more on practicality than quality. All DVD-V players are required to play AC-3 files, and additional licensing fees are required to manufacture a DVD-V player that can decode a DTS file. Most animators are sensitive to the qualitative changes that occur as a result of video compression; however, their sensitivity to audio compression is less developed. Animators and sound designers can gain valuable insight by comparing compressed audio with non-compressed audio.

6. MPEG-1 LAYER 3 AND aacPLUS

The MPEG-1 layer 3 (commonly referred to as mp3) type of audio compression has become a very popular and useful codec for the Internet. Some people believe that mp3 files sound comparable to PCM files; however, full-range speakers such as those found in theaters reveal the quality issues inherent with mp3 compression. Mp3 files are not release-format quality. Many SFX and production music companies allow mp3 versions of their products to be downloaded for temporary purposes. They know that sound designers will ultimately want audio files that are non-compressed and have higher resolution. Both mp3 and the newer MPEG-4 aacPlus are useful codecs for file sharing over the Internet. The aaC has become the standard compression mode for the iPod.

Sound 2
Design Theory

No theory is good except on condition that one use it to go beyond.
—Andre Gide

A. Overview

The success of *Steamboat Willie* (1928) encouraged Walt Disney to synchronize sound to *Plane Crazy* and *Gallopin' Gaucho*, both released earlier as silent shorts. This conversion proved more difficult than anticipated, and Disney quickly realized that the relationship between sound and image was more synergetic than one might think. Narrative animation is most effective when image and sound are allowed to fully participate in the story telling. The sound track has historically taken a back seat to image in terms of resource allocation, allotment production time, and screen crediting; however, many experienced animators credit sound with contributing as much as 70% of the success of a project. Experienced directors understand that a successful sound track is more often felt than heard. They understand that the audience will notice poor sound design even though most cannot articulate what was lacking. The psychological pairing of audio and visual is part of our everyday experiences. People visualize while listening to radio drama, and they audiate while reading. If deprived of either element, audiences will create their own, ultimately redefining the work. In narrative animation, we attempt to guide the audience's perceptions through effective use of all narrative elements. In order to guide the audience, we must first understand the unique relationship of sound paired with image.

B. Sound Classifications

When both the characters and the audience hear the sound, it is referred to as *diegetic*. The sound heard exclusively by the audience is referred to as *nondiegetic*. When we see the source of the sound, it is referred to as on-screen. It is interesting to note that sound can be both diegetic and *off-screen*. Off-screen sound is often used to establish on-screen visuals or to cause the audience to visualize. The phrase "starve the eye and feed the ear" is the basic premise for off-screen sound. When discussing music, we generally substitute the terms *source music* for diegetic and *underscore* for nondiegetic. *Establishing sound* is the common practice of starting a music cue or ambience prior to introducing or transitioning to a scene. Sound effects that are linked to on-screen objects are referred to as *hard effects*. Michel Chion classifies sound into three basic categories: causal, semantic, and reduced. Chion's typology provides us with a valuable theoretical framework for discussing sound effects. *Causal* (literal) sound effects are aptly named, as they reinforce cause and effect (see a cow, hear a cow). There is a practical need for causal effects, especially when realism is desired; however, in animation, reality is often subjective and lit-

eral sounds often sound out of place or not dramatic enough. The term *semantic* is used to describe sound in which a literal translation is more important than timbre. Native speech is an overt form of semantic sound, whereas foreign dialog and Morse code are examples requiring translation. The terms *reduced* and *acousmatic* describe a thought process in which sound is freed from the object that created it so it might be reattached to other objects for dramatic purposes. Sounds are broken down, or reduced, to their fundamental elements, which can later be used as raw materials to create new sounds. Creative sound design is largely a product of reduced sound.

C. Differences in Visual and Audio Processing

The eye takes a person into the world. The ear brings the world into the human being. —Lorenz Oken

In photography, there is a saying that a picture is worth a thousand words. In radio (theater of the mind), sound is worth a million pictures. Animation exploits both image and sound to produce an art form that is greater than the sum of the two. There are, however, fundamental differences in our abilities to process visually and aurally. For example, audiences process, assign meaning to, and store audio information more rapidly than they do visual information. Complex visuals require multiple viewings before a complete impression of the scene can be formed. On the other hand, complex sounds are readily understood after limited hearings. When combined, sound facilitates complex visual processing and memory. Animation consisting of rapid movements and transitions becomes more reliant on effective sound design. To demonstrate this point, screen a classic Warner Brothers' animation without the

benefit of sound for a test audience. Develop and administer a follow-up survey with questions relating to plot and visual detail. Now screen the same animation with sound for a new test audience. A comparison in responses of the two audiences will reveal that sound facilitates and accelerates the audience's ability to develop meaning and commit the scene to visual memory.

Through sound, we are guided from one point of view (POV) to another, the plot is clarified, and our emotional responses are heightened. Visually complex scenes are often necessary to achieve dramatic goals; however, at specific points in a story it is critical that the viewer look at specific details within a scene. A well-designed sound track directs the viewer's attention to those points within the complex visuals. Our field of vision is limited to roughly 180°, so visual cuts and panning are necessary to extend our vision beyond 180°. Sound, on the other hand, is experienced in 360°, facilitating on- and off-screen action. Sound design can help the audience accurately perceive complex visuals; however, it can also make basic visuals feel more complex. Car crashes are potentially quite complex to animate, depending on the level of realism desired. An equally effective representation of the car crash is possible with less detailed animation if the sound design allows the viewer to hear that which cannot be seen. For example, when the sound of screeching tires is heard off-screen we anticipate a crash. The car appears just moments before the crash. The crash visually occurs in a few frames and we are left with a relatively static image. Contributing to this event are the complex glass sounds, which add complexity to a simple visual crack in the windshield. The sound of metal twisting syncs with the visible damage while also portraying the unseen damage. The sounds of passengers screaming provide a perspective of those inside the vehicle. The car engine and radio cut off and the car horn sounds. Only fragments of these sounds have to be visually represented if sound is allowed to complete the picture. If the sound design is effective, audiences will recall visual details from a scene that only existed sonically.

D. Influence of Sound on Time Perception

Sound uniquely influences our perception of time. To demonstrate this principle, watch a chase scene without sound. You may notice that at many points in the scene the visuals are relatively static. Close-up shots on moving vehicles or characters' faces deprive us of important visual indicators of movement. Without sound, each of the cuts within the scene appears to have its own visual pacing. Add linear sound (such as music) and the momentum of the scene is maintained and the visual cuts appear more unified. Flashbacks, replays, and fast forwards are time concepts that require special handling. Visual cross-fades, rewinds, and wipes are effective visual means of representing these devices. Their sonic counterparts include audio cross-fades, fast-forward playback, and rewind playback. Each of these devices is an effective means of establishing or reinforcing time concepts. Slow motion is another time-based narrative that can be enhanced with effective sound design. One approach is to simply slow the music or rhythmic sound effects proportionate to the image. In the film *The Matrix*, the music depicts slow-motion leaps from building to building with a series of overlapping chords that fade in and out of each other. Another means of depicting slow motion is combining signal processing, such as reverb, with lower mix levels. Visual accelerations and decelerations are often portrayed through music or rhythmic sound effects. In the film *Sneakers*, the tempo of the underscore progressively increases with each successive phone trace. Period music, sound effects, and ambience are effective means of establishing time travel both past and future. This concept is very evident in the source music of the films *Back to the Future* and *Pleasantville*. If done effectively, the contrast between the two separate designs will quickly facilitate our acceptance of the time-related narrative. Finally, audiences have increasingly limited attention spans, a fact that influences their perception of time outside of the narrative.

Great movies can take hours to view yet feel short, while bad movies can be relatively short and feel as though they drag on forever. When reviewers talk about the length of the film, they often are talking about the quality of the film. Sound elements are essential means of extending attention spans while leaving the audience with the feeling that time has been suspended.

E. Influence of Sound on Spatial Perception

When television arrived, filmmakers and exhibitors scrambled to create a cinematic experience that could compete with this new medium. One strategy involved increasing the size and width of the screen. IMAX® theaters pushed the limits of peripheral vision to produce the most encompassing visual experience available theatrically. Holographic projection systems are currently being developed to extend the image toward the audience. Virtual reality also offers new possibilities for the audio/visual experience. These technologies may one day be integrated into the cinematic experience, but today animation is still tied to the screen. With the arrival of multichannel audio (surround sound), sound has extended the narrative boundaries of the cinematic experience beyond the screen. When used effectively, sound can enhance spatial concepts such as depth, width, and height. Sound defines these dimensions through signal processing, panning, and mixing. Signal processes such as reverb model sound characteristics of theoretical rooms, unifying the sound track spatially. Equalization (frequency manipulation) plays an important role in establishing depth, as well. High frequencies are more readily absorbed over distances than low frequencies; therefore, as cameras zoom out, high frequencies (EQ) might be reduced to promote realism. Volume also influences our perception of depth, as louder sounds are generally perceived as

being closer. Pitch variation is also used to enhance front to back (depth) movement. Though not based in reality, pitching sounds up as the camera moves in has become fairly conventional. Panning is used to widen or restrict the perceived width of the scene while allowing sound to move in visual sync with the image (dynamic panning). For example, if we want a scene to take place in a confined space (such as a submarine), we can reinforce this concept by panning everything close to the center. As characters exit the submarine, the stereo image is expanded to surround to imply a larger narrative space. Height perspective (*periphony*) can also be implied through sound, as well. For example, low frequencies are known to travel up our bodies through our feet. We can use this physiological response to enhance our visual perspective by progressively adding *low-frequency effects* (LFEs) as an image descends. Musical lines are frequently used in animation to dramatize the height perspective. As the image ascends or descends, the melody moves in the same direction. We can automate all of these parameters and mix levels to effectively move the sound from space to space.

F. Drawing the Audience into the Narrative

An animation starts with 30 seconds of black. During this time we hear upbeat Renaissance music, horse-drawn carriages moving through mud-filled streets, and *Walla* (ambient group conversation) containing occasional spikes of dialog, all of which define a 15th-century English setting. Though deprived of visuals, the audience has already developed visual impressions and expectations for the first scene. In this example, the sound track works like a hypnotist's ball, gradually separating the audience from reality and drawing them into a narrative that will play out on-screen. The people sit-

ting in the theater are unknowingly transformed from spectators to participants (audience). The sound track described above is an example of *establishing sound*, accomplishing with great economy what would have taken considerable time and resources to animate. As the narrative unfolds, sound is used to provide closure to an existing scene or to draw the audience into the next scene. The use of sound elements to introduce a new scene is referred to as a *pre-lap*. At the conclusion of the film, music is often used to promote closure and to transition the audience back to reality in the same way a hypnotist brings his patient back by counting down from ten.

G. Sound for Character Development

Animators create characters, not actors. It is the voice talent that brings the character to life. It is important to select an actor who can properly develop the character. To avoid disconnect between the visual and the audio, the voice must be plausible when synced to the character. Once the basic sound of the character's voice matches, it can be manipulated by signal processing to further enhance character development. Pitch shifting is often used to alter the age, size, and gender of a character. Volume is used to strengthen (louder) or weaken (softer) the intensity of dialog. In some cases, additional sounds are added to a voice to enhance the character. For example, in *Jimmy Neutron: Boy Genius*, a "caw" sound is layered with the teacher's voice to emphasize her beak. For centuries, composers of opera have used musical themes (*motifs*) to represent specific characters. The pairing of a musical theme to a specific character is called *leitmotif*. Characters such as Darth Vader (*Star Wars*), the Great White (*Jaws*), and James Bond all have readily identifiable leitmotifs. Harmony and instrumenta-

tion are also used for characterization. For example, music in a minor key is often used for villains, and clown-like characters are represented by the more lighthearted sounding bassoon or tuba. Once a leitmotif is established, we can anticipate or experience a character on- or off-screen simply by hearing that character's leitmotif. Character development in animation is not limited to people. Virtually any character or object can be personified by adding speech, movement, and the expression of emotions. The idea that all objects have the potential to display human characteristics is called *anthropomorphism*, or personification. Animation is rich in examples of anthropomorphisms, providing many challenges for sound designers, who must develop plausible sounds for these objects.

H. Plausibility *Versus* Reality

It is ironic that a recent feature animation titled *Final Fantasy* appeared to be driven toward realism; however, most animation does not strive toward this goal. Instead, each animation develops its own sense of reality based more on internal logic than subscription to the laws of the physical world. Therefore, plausibility rather than realism remains a strong aesthetic principle in animation. This aesthetic is achieved through analogy, contrast, and exaggeration. These concepts apply equally to sound design. Recall the voice of Charlie Brown's teacher being mimicked by the sound of brass instruments played with toilet plungers. This clever analogy minimizes the presence of adults and effectively keeps the audience grounded in the child's world. In *Beauty and the Beast*, the final conflict between the villagers and the house servants is covered with an upbeat reprise of the song "Be Our Guest." This choice of music contrasts with the visual violence of the scene, effectively de-emphasizing the violence and making the scene

more playful and age appropriate. In *A Bug's Life*, the sound of water drops falling to the ground is exaggerated with rockets and explosions. These exaggerated sounds help the audience experience the raindrops from a bug's subjective point of view. Ironically, the real sound of a source is often less convincing or entertaining than the exaggerated substitution. Music, narration, and ambience are effective elements to establish fantasy. When plausibility is effectively established, the audience will willingly suspend their disbelief of technical concerns and maintain their involvement with the narrative.

I. Metaphoric Sound

Many of the plots and gags used in animation are rather serious in nature if analyzed from a literal perspective. To avoid literal interpretations, sound designers often substitute dramatic sounds for the actual sound that an object produces. Nonliteral, or *metaphoric*, sound is often more effective for dramatic purposes than sound that literally matches the object represented. Many objects in animation do not exist and therefore have no literal sound; consequently, metaphoric sound is vital to the characterization and plausibility of the object. Animation uses sound to exaggerate visual events. For example, the blink of an eye is silent in reality, yet it is common to add xylophones to blinks to add emphasis or meaning. Metaphoric sound favors entertainment value over realism, and it is an important tool for shaping the audience's perception of events. Imagine an audience's response to a literal sound design of a coyote hitting a canyon floor after falling hundreds of feet. Suppose, instead of a playful cartoon hit, we twist celery and crunch LifeSavers® to represent bones breaking. The sound of raw meat being slapped on a table adds organic texture to the hit, and fruit is squished to represent gurgling blood and guts. Obviously, this literal approach to

sound design would produce a much more intense response from the audience than the metaphoric cartoon hit. In contrast, a playful cartoon hit appropriately satisfies the narrative intent while promoting a "softer" interpretation of the event.

J. Off-Screen Sound

The ears are the guardians of our sleep. —Randy Thom

Sound is often used to represent that which is not practical or tasteful to portray visually. As noted earlier, sound differs from light in that it can represent narrative elements off-screen. Any action too costly, time consuming, or controversial to produce visually can be effectively depicted with *off-screen* sound. In the early 1930s, the film industry adopted the Hayes Act, which imposed strict limitations on subject matter. Over the years, sound has proven less subject to censorship than visuals. Filmmakers such as Alfred Hitchcock recognized this and frequently used off-screen sound to depict controversial themes such as sex, violence, and drug abuse. When the object or action appears *on-screen*, sound further clarifies the source; however, when the object or action is not seen, sound excites the visual imagination of the audience to generate the associated image. Greater attention, then, must be paid to the off-screen sound design to ensure that the audience can accurately visualize off-screen objects or action. Metaphoric and off-screen sound invites the audience to see with their ears.

K. Tension and Release

Much of the structure and pacing of a narrative animation can be understood in terms of *tension* and *release*. Sounds by themselves or in combination with each other can elicit tension or release. Film composers use harmony to create dissonant (tension) and consonant (release) chords. Tonal music has a sonic gravity that requires resolution. To demonstrate this, sing a scale from the bottom up using numbers and stop at the number seven. Notice how the seventh note wants to resolve upward. An unresolved scale is a powerful means of creating tension. Atonal music does not create this perception of tonal gravity. In addition, audiences cannot readily perceive the form of atonal music; consequently, it can be easily cut to fit the narrative needs. Instrumentation can also be used to create tension or release. For example, a distorted electric guitar seems to produce more tension than an alto flute. Melodic lines that are jagged rather than smooth produce tension. The rhythmic elements of music propel action forward and cease when resolution is required. The musical score has the potential to produce strong physiological responses such as increased heart rate and symptoms of nervousness.

Tension and release are not created exclusively by music; for example, a dramatic (interpretive) reading of dialog can easily be contrasted with a monotone reading. This point can be easily demonstrated by listening to many of the great historical speeches recorded over the past century. Sound effects are powerful tools for creating tension in the audience, especially if the sound is identifiable with a tension-producing event. For example, air-raid sirens, emergency vehicles, and growling animals all evoke tension to some degree. Sounds such as crickets, waves, and rain can produce a calming effect on most audiences. Volume and panning can also create tension. Extremes in volume evoke tension in an audience, and dynamic panning can introduce a level of unpredictability, which also produces tension. Sound designers carefully consider the implications that sound and sound processing have for creating tension or release and exploit them to create tension and release that match the narrative intent.

L. Smoothing Visual Edits

With the exception of dreaming, our day-to-day visual experiences are linear; however, our cinematic experiences are primarily nonlinear, a product of the way the film is edited. The picture editor cuts and edits to direct the flow of images, establish a rhythm, and facilitate the narrative. As a result, we experience uniquely cinematic visual progressions such as jump cuts, parallel cuts, and dissolves. Audio frequently provides the linear element that smoothes the effects of these nonlinear progressions of image. Dialog, source music, and hard effects are synced to the image; therefore, it might seem logical to cut them with the picture. In practice however, these elements (dialog, in particular) often continue beyond the cut to their natural conclusion to complete the narrative and provide continuity. Nondiegetic sounds, such as underscore, narration, and ambience, are primarily linear. They are rarely interrupted within a scene regardless of visual edits. As such, they effectively serve as a smoothing element for visual edits while also promoting continuity. Knowing when sound should advertise or smooth a cut is essential to the design.

M. Developing Continuity

In animation, continuity is not a given; it must be constructed. In Disney's *Treasure Planet*, director Ron Clemons developed a 70/30 rule to guide the design for the production. The result was a visual look that featured a blending of 18th-century elements (70%) with modern elements (30%). Dane Davis, sound designer for *Treasure Planet*, applied this rule when developing SFX and dialog to produce an "antique future" for this sound track. A ratio rule can be developed and applied to virtually any element of the sound track.

The adherence to this design principle by both animators and sound designers produces continuity. The need for continuity in the score is so critical that the job of composing music for a film is typically assigned to only one composer.

N. Interpreting Picture Edits and Film Conventions

The length of a film should be directly related to the
endurance of the human bladder. —Alfred Hitchcock

In the early years of animation, picture editors handled many of the tasks now handled by sound editors. Recently, we have rediscovered the value of this dual role through the works and writings of Walter Murch, who is both a picture editor and a sound designer; consequently, his work transcends the barriers created by departmentalization, providing an impartial perspective for sound to image. Other distinguished sound designers such as Ben Burtt and Dane Davis also have extensive picture editing backgrounds. Collectively, these sound editors demonstrate the importance of understanding the grammar of picture editing and its implications for sound design. Picture editors make edits to develop the story, set the pacing, and maintain the audience's attention. Because much of the basic editing for animation is determined as early as the storyboard, it is important for the sound designer to develop an understanding of picture editing prior to working on an animation. One of the primary aspects of sound design is to determine whether sound should *smooth* or *advertise* the edit. The most elemental unit of animation is the *frame*. Frames are combined in succession to produce a *shot*. Multiple shots are combined to form a *sequence*. Related sequences define a *scene*, and related scenes define an *act*. Most animated shorts consist of one act. Following

is a selected list of picture edits and film conventions that influence the sound design process.

Since the introduction of color animation, *black and white* has become a means of suggesting flashbacks. Flashbacks are presented from a character's POV and are often achieved through music.

Camera moves are one means of directing the flow of the animation. A *tilt shot* consists of fixed vertical movements. The animations of Warner Brothers and MGM cover tilt shots with ascending and descending musical scales, pitch bends, evolving rhythmic elements, and volume. A *pan shot* consists of fixed horizontal movement; music and ambient tracks often underscore a pan shot to sustain interest in the linear movement. A *tracking shot* follows the character's movement, keeping the character in the center of the frame at all times; this type of camera movement eliminates the need to pan the sounds associated with the followed object. A *zoom shot* moves front to back to create a sense of depth; the visual perception of depth is greatly enhanced by pitch and volume changes. As we zoom in, the pitch often goes up and the volume increases. A *fly-through shot* creates the illusion that an object is passing through the audience; this type of shot is effectively reinforced by panning the audio to and from the rear speakers of a 5.1 monitoring system.

A *close-up* (CU) is designed to provide detail and to emphasize important narrative elements. Close-ups remove peripheral visuals and focus on details. Panning, volume levels, instrumentation, and ambience can either support or contrast the close-up shot.

Cuts are visual transitions created in editing in which the pictures quickly transition. Elements of the sound track can be used to smooth or advertise the cut. Cuts that involve a shift in location or timeframe present opportunities to shift the sound design.

A *cutaway shot* moves the audience away from the main action to experience a related action. A typical example of a cutaway is a group shot moving to an individual shot for the purpose of showing a reaction or reminding us of the individual's presence. From a sound design perspective, the question arises as to whether the visual object needs to be emphasized or exaggerated with sound.

A *visual dissolve* is a gradual scene transition using overlap similar to an audio cross-fade. Dissolves are used to indicate a change in time or location. Dissolves are typically handled with audio cross-fading of linear sound elements such as music or ambience. An *iris* (circular) and a *wipe* (pushing one shot off and pulling the next shot into place) are also used similarly for scene transition.

An *establishing shot* is typically the first in a sequence taken from a distance to establish the location, feel, and magnitude of the scene. This shot is used to educate and acclimate the audience. An establishing shot emphasizes the environment rather than specific details or characters; consequently, music, ambience, and off-screen sounds often used for establishing purposes.

A *fade* uses black to transition the audience in and out of scenes. Fades indicate closure and are timed to allow the audience to process and prepare for the next scene. Sound is often introduced during the black to transition the audience into the new scene. Sometimes music sustains over the fade-out and through the fade-in for continuity.

Freeze frame is suspending the action by holding the image in place. Freeze frame is used to suspend time or punctuate an action or reaction. Slow motion is a similar temporal effect. Both are sonically reinforced by altering the speed of linear sound (such as music) or by processing the audio to achieve greater contrast.

Inserts (often a close-up) emphasize objects, actions, or reactions that were presented earlier in the master shot. An insert is used to allow the audience to view subtle details (like a written note) important to the narrative. Inserts reinforce links between objects and their associated characters or narrative purpose. Inserts are often covered with hard effects such as a watch ticking. Inserts involving written text are sometimes covered by voice-overs. Inserts involving a reaction often call for musical hits for emphasis.

Jump cuts are designed to move the audience forward or backward in time or place. Jump cuts are frequently covered with music to smooth the cuts and create a sense of continuity. When a picture

editor creates a jump cut during a cyclic event such as a walk cycle, the sound designer is forced to smooth the edit.

The *master shot* is a global shot for a scene. The master shot is referenced throughout a scene to provide continuity. The master shot provides a linear sense to nonlinear picture editing; therefore, linear sound such as music and ambience are often associated with the master shot.

Matched cuts join two shots for which the compositional elements match but are approached from different angles. The goal of a matched cut is continuity, and the sound design should reflect this goal.

A *montage sequence* consists of rapid visual edits designed to lead the viewer to a desired conclusion, often representing time lapse or compression. Montages typically use melodic underscoring or songs to smooth the edits and develop continuity.

Over-the-shoulder shots focus on the character facing the camera and are frequently followed with a close-up of the character previously facing the camera. Over-the-shoulder shots are prime candidates for nonsyncopated (nonsync) dialog. In fact, nonsync dialog is often the linear element that provides continuity for the edit. In addition, over-the-shoulder shots provide an opportunity to add or alter dialog at the postproduction stage.

Parallel editing is the development of two narrative themes that are presented through editing to suggest that they are occurring simultaneously but in different locations. Parallel action can be treated with linear sound to propel the scene forward or it can also be treated with contrasting sound design such as leitmotifs to advertise the movement to and from each perspective.

In a *POV shot* we experience the action subjectively through the eyes of a specific character. We might also be hearing the thoughts of that character or listening through the character's ears. POV suggests sound design specific to character development such as leitmotifs or specific prop sounds. The underscore for a POV could provide some insight into the character's emotional state. If the POV is the camera, then we pan audio to the camera's perspective.

If we are looking through the eyes of a character, then panning should reflect their inner perspective.

A *sequence shot* is an extended take with no cuts. Music can help the audience maintain their interest during these extended scenes.

O. Guided Perception

Images presented within a scene are often ambiguous in nature, forcing the audience to search for nonvisual clues in order to derive meaning. These types of images or scenes present opportunities to use sound design to guide the audience's perception. Chion refers to the symbiotic pairing of sound and image as *added value*. Sound design is, to a great extent, the application of this concept to moving images. Figure 2.1 through 2.5 are examples of guided perception.

P. Conclusion

Sound guides our perception of image, and image guides our perception of sound. This reciprocal nature suggests that both elements must be developed in tandem, with sound designers integrating visual thought into their process and animators integrating aural thought into theirs. The preceding discussion dealt with global theories of sound to image. In the next three chapters, we will apply these concepts to each of the stems.

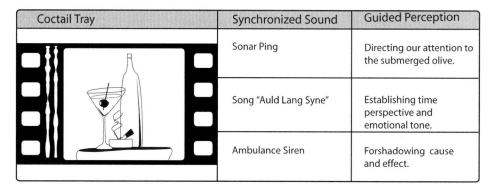

Coctail Tray	Synchronized Sound	Guided Perception
	Sonar Ping	Directing our attention to the submerged olive.
	Song "Auld Lang Syne"	Establishing time perspective and emotional tone.
	Ambulance Siren	Forshadowing cause and effect.

FIGURE 2.1. Cocktail tray.

Emotional Ambiguity	Synchronized Sound	Guided Perception
	Screaming	Clarifies the emotion.
	Laughing	Clarifies the emotion.
	Crying and funeral music	Clarifies the emotion.
	Sneezing	Clarifies the emotion.

FIGURE 2.2. Emotional ambiguity.

Suspension Bridge	Synchronized Sound	Guided Perception
	Harp Gliss panned from left to right	Playing off the visual similarities with the harp.

FIGURE 2.3. Suspension bridge.

Telephone Lines	Synchronized Sound	Guided Perception
	Dial up modem	Causal or implied communication
	Morse Code	Semantic (requiring translation)
	Phone Conversations one for each wire (futzed)	Semantic yet direct

FIGURE 2.4. Communication.

Typewriter	Synchronized Sound	Guided Perception
	Typing sound with narration treated with reverb	Dialog enhancement
	Typing morphing to guns	Transitional device
	Typing at varied speeds	Foley and character development

FIGURE 2.5. Typewriter.

The Stems: Dialog, Music, and Effects (DM&E)

The room within is the great fact about the building. —Frank Lloyd Wright

The ability to synchronize sound to film (talkies) helped to liberate the theatrical means of storytelling. Dialog, music, and sound effects (SFX) played an important role in liberating actors from the exaggerated expressions and gestures needed in the silent era. Original music (score) was written for specific scenes, replacing the informal musical practices of the silent era. Sound-effect techniques from radio drama were quickly adapted to film. Sync sound gave rise to off-screen action, ambience, and source music. All sound used in animation is the result of decisions made by those responsible for creating the sound track. Because sound is often needed to guide the animation process, many of these decisions cannot be delayed until postproduction. The cost and time involved in creating a sound track require that each sound be carefully considered for its narrative potential. Each element of the sound track is categorized by its stems (dialog, music, and SFX). In the following chapters, we will define each stem, discuss related terminology, and explore the individual and collective implications of stems for the sound track.

Dialog 3

Is this the party to whom I'm speaking? —Lily Tomlin

A. Overview

With the arrival of television in the late 1940s, dialog gradually replaced pantomime as the driving narrative element in studio animation. Dialog is the most direct means of storytelling, contributing greatly to the implied reality. Audiences seem to focus on dialog more than music or sound effects. Dialog comes in many forms. *On-screen dialog* can be either *synchronous* (lip sync) or nonsynchronous (such as over-the-shoulder shots). Because *sync dialog* is visible to the audience, it is prerecorded and videotaped to provide a complete model for the animation process. *Off-screen dialog* implies character interaction without providing a visual reference. *Voice-over* includes any nonsync speech where the speaker is unseen and cannot be revealed through changes in camera angles. Examples of voice-over include phone conversations, talk radio, and public address announcements. *Narration* is the telling of a story from a different time or location than implied on-screen. In narration, it is understood that the narrator is not interacting with the on-screen characters. *Walla* is a specialized verbal sound that can be either *language specific* or *neutral*. Language-specific Walla is typically included in the dialog stem and is often customized with short recognizable phrases called *free and clears*. Neutral Walla is less recognizable and more ambient and is often

placed in the SFX stem. Walla is frequently introduced prior to a scene change, thereby serving as a transitional element and an establishing sound.

B. Narration

Narration is the cinematic version of oral storytelling which uses invisible storytellers to deliver important story points while avoiding time-consuming voice animation. Narration, like underscore, is directed exclusively at the audience and requires their suspension of disbelief. Many of the Disney animations use a narrator to deliver the opening prolog, establishing a storybook quality of the film. Back stories are also delivered using voice-over narration. Narration can be delivered in first person or third person. Narration that is an extension of the character's thoughts is narration in the first person. Jean Shepherd's telling of *A Christmas Story* is a good example of first person from a historical perspective. The third-person narrator

is typically an observer rather than a character participating in the story. Boris Karloff's soliloquies in *The Grinch Who Stole Christmas* is a classic examples of narration in the third person. When used effectively, audiences will identify with the narrator and feel invited to participate in the story.

C. Historical Speeches

Historical speeches fall into one of two categories, depending on their narrative function. If the speech delivers important story points, then it is typically included in the dialog stem; however, if a speech is used to develop ambience, then it is typically included in the SFX stem. Like found footage, many historical speeches are subject to copyright protection and must be cleared before they can be used legally in a project.

D. Synthetic Language

Some animations call for a *synthetic language*, such as the interplanetary languages heard in *Star Wars*. Synthetic dialog is often achieved by reversing existing languages to create dialog that has logical structure but lacks intelligibility. Various forms of signal processing are also applied to the dialog for character development—for example, the familiar robotic sound achieved through harmonization and ring modulation. The purpose of synthetic dialog is to establish a plausible communication in the context of a fantasy. At times, it is necessary to deliver story points through synthetic dialog. This is accomplished by adding fragments of recognizable dialog referred to as *reality hooks*.

E. Dialog and Character Development

Dialog can be used in many ways for character development. In *Stuart Little*, cat hisses are added to Nathan Lane's dialog to enhance the character of Snowbell, the family cat. In the Disney feature *The Lion King*, James Earl Jones' voice (Mufasa) morphs seamlessly to a lion roar at the end of the line "Are you threatening me?" In *The Adventures of Ichabod and Mr. Toad*, the frog's croaks are blended with the word "Ichabod" and the raven caws morph into the warning "Beware!" In *Finding Nemo*, the phrase "mine, mine" is seamlessly blended into the calls of the greedy sea gulls. Later in the same film, Dory attempts to communicate with a whale by vocalizing her dialog with whale nuances. In *Aladdin*, Robin Williams' voice morphs from a genie into a sheep while vocalizing "you baaaaaaad boy." Animation is filled with examples of *animal speak*. Perhaps the most widely recognized examples of animal speak are the dog-like vocalizations of Scooby Doo created by Don Messek. Ethnicity is another aspect of a character that can be reinforced through regional and national accents. In *Lady and the Tramp*, the Scottish terrier, the English bulldog, and the Siamese cats are all voiced with their national accents. The Disney animation *Music Land* creates a world inhabited by lifelike musical instruments. Rather than mime the story, director Wilfred Jackson chose to represent dialog with musical phrases performed in a speech-like manner. *Music Land* is an entertaining attempt at making us believe that music is truly a universal language.

F. Dialog and Music

The score contains many elements that can either conflict with or enhance dialog. The ability to score for dialog is an essential skill for a film composer to possess. A melody is a linear narrative element with the power to draw attention away from the dialog; therefore, film composers often avoid writing active melodies when important dialog is being delivered. Exceptions to this practice include the dramatization of speeches through underscores, where the music often hits at specific points in dialog for emphasis. One such example occurs in *Anastasia* when Comrade Phlegmenkoff (director of the people's orphanage) says, "And be grateful, too." Each word in this dialog is supported with descending minor chords to add emotional weight to the delivery. The underlying chords work with the dialog much like a built-up sound effect. Effective underscore enhances the subtext of dialog without interfering with intelligibility. Unlike an underscore, songs contain lyrics, which can easily compete with dialog; therefore, songs are often reserved for sequences that do not involve dialog. In musical animations, a *recitative* (blending of speech and music) approach is often used to deliver story points. Much of the narrative for *The Nightmare Before Christmas* and *Alice in Wonderland* is delivered in recitative style.

G. Historical Voice Talent in Animation

Animation has enjoyed a long history of unique and talented voices bringing life and personality to their respective characters. In addition, they have established a style of dialog that is unique to animation. Mel Blanc is perhaps the most well-known voice talent.

He created the iconic voices for many famous Warner Brothers characters, including Bugs Bunny, Pepe Lepue, Porky Pig, Speedy Gonzales, and Tweety Bird. Daws Butler developed many of the voices for Hanna–Barbera characters such as Yogi Bear, Quickdraw McGraw, Captain Crunch, Elroy Jetson, and Barney Rubble. Don Messick also worked extensively with Hanna–Barbera to supply voices for Dr. Quest and Bandit from the episodic animation *Johnny Quest*. In addition, he pioneered the "dog speak" style for Astro (in *The Jetsons*) and Scooby Doo. June Foray is the queen of voice talent, responsible for the voice of Natasha on *The Bullwinkle Show* and the prototype Witch and Granny characters heard in many of the Warner Brothers shorts. Her most recent role was Grandmother Fa in the Disney feature *Mulan*. Paul Winchell developed one of the most distinct voices in animation, Tigger from *Winnie the Pooh*. Thurl Ravencroft developed the distinctive sound of Tony the Tiger for the famous cornflake television commercials. He was also the singing voice of the Grinch for the 1966 animation. To learn more about the voice actors behind animated characters, log onto www.voicechasers.org/actors.

H. Casting Voice Talent

The next time you are listening to a radio personality, take a moment to imagine what he or she might look like in person. This process of visualization is common for audiences of both radio and animation. We develop expectations for characters' physical traits based on their voice characteristics (timbre). As a result, voice casting and character animation are interdependent. When auditioning voice talent, it is important to focus on acting ability, dramatic interpretation, and sound quality and to allow voice talent the freedom to improvise within the context of the script. It is a good idea to think outside of the box when looking for talent to cover chil-

dren's roles. If the role is extended over time, a child's voice will mature while the animated character will remain fixed in time. For this reason (and many others), adults are typically cast for children's roles in episodic animation. For example, Nancy Cartwright has voiced the character of Bart Simpson for nearly two decades of *The Simpsons*. Stereotyping is an important means of developing characters that are not human or normally capable of speech (*anthromorphisms*). For example, a gruff Scottish voice actor is used to reinforce the attitude and nationality of the Scottish terrier. A sultry female voice adds allure and excitement to the dialog delivered by a slender red sports car. An old weathered tree is voiced by a tired, elderly sounding voice. It is common practice in feature animation to cast well-known voice personalities to take advantage of their built-in familiarity. Independent animation that lacks the financial resources for such an approach should consider using local radio announcers who already possess microphone techniques and routinely voice characters for commercials. Advertising agencies, recording studios, and community theaters usually have a comprehensive list of voice talent. When casting voices for an animated musical, remember that the singing voice and the speaking voice must match, and in many cases they are not provided by the same person.

I. Working with Voice Actors

The audio engineer is responsible for the objective elements of the session such as voice quality, accuracy with lines, intelligibility, and appropriate signal levels. The director is responsible for the subjective elements, such as interpretation and character development. If the director is not present, the audio engineer is responsible for both. Interpersonal skills and experience are invaluable during this process. It is important to guide the talent with any information that might help them get into their characters, but directors and audio engineers should resist the temptation to over-direct the talent. They should not bring the session to a stop every time an error is made. By recording through mistakes, we avoid "paralysis through analysis" and the session flows better and produces more usable material for future editing. Directors can keep the session positive by effectively communicating with the talent and playing back successful takes from time to time to foster confidence. The human voice changes slightly as the day progresses and even more from day to day; therefore, all material related to a particular scene should be recorded in one session. If multiple sessions are needed, every effort should be made to replicate the exact conditions and parameters of the previous recording session. Much can be gained by allowing the voice talents to interact while recording (replicating the conditions of a table reading); therefore, recording the characters together but on separate microphones might be an option to consider. In addition to facilitating better interpretation of the lines, the picture editor also gets more natural timing information to use to block out the overall timings for each scene.

J. Recording Dialog

Recording dialog in a recording studio offers many advantages. Professional studios provide high-quality microphones, well-designed recording spaces, and experienced engineering; however, a quality DAT or hard disc recorder can be used effectively, as well. Another cost-effective option is to convert a computer into a portable digital audio workstation (Figure 3.1).

FIGURE 3.1.
Portable digital
audio workstation.

K. Microphones

Microphones are the principle means of capturing a voice. Microphones *transduce* (convert) acoustical energy to electrical energy (signal). There are many analogies between the design features of a microphone and the physical properties of the human ear. The housing of the microphone is analogous to the outer ear and serves to collect and focus the sound toward the diaphragm. The diaphragm is like the middle ear, vibrating mechanically at frequencies and intensities to produce a signal analogous to the acoustic wave. The accuracy of the resultant signal is based largely on the materials and design of the microphone. Two basic types of microphones have emerged for professional recording: the *dynamic microphone* and the *condenser microphone*. Dynamic microphones operate on the electromagnetic principle. A diaphragm is placed on top of a *moving coil* that is surrounded by a magnet. As the coil moves in and out in response to sound pressure, a disturbance is created in the magnetic field. This disturbance causes electrons to move in a pattern analogous to the presenting waves, hence the term *analog*. Waves with greater force push the coil further in, producing a louder signal. Dynamic microphones are useful for capturing loud sounds from close distances without distortion. Condenser microphones rely on an electrostatic charge to generate a signal from presenting waves. The electrostatic charge used in condenser microphones is not permanent and therefore requires a constant source of low voltage. This voltage is supplied by batteries or a *phantom power* source found on most professional recording equipment. The transduction mechanism of a condenser microphone is much lighter and more responsive to high frequencies and sudden attacks (transients). In addition, condenser microphones are capable of gathering sound from a greater distance than is possible with a dynamic microphone. Condenser microphones are by far the most popular type of microphone in use for dialog.

L. Polar Patterns

The pattern by which the microphone captures or rejects sounds is called the polar pattern (Figure 3.2).

Microphones are physically designed to obtain various patterns of directionality including omni-, cardioid, and bidirectional. The *omnidirectional* polar pattern picks up sound uniformly at 360°. It is less susceptible to the proximity effect, plosives, and wind noise. The omnidirectional pattern is a popular choice for individual voice-over and dialog recording sessions. *Cardioid* polar patterns are more directional, rejecting sound progressively as the object moves off axis. The two variations of the basic cardioid pattern are the *super-cardioid* and *hyper-cardioid*. A hyper-cardioid pattern is the most directional, rejecting sound at a rate over twice that of an omnidirectional polar pattern. The *bidirectional* polar pattern is similar to two cardioid capsules placed back to back. The bidirectional pattern is equally sensitive from both sides.

M. Microphone Placement

Voice talent is generally recorded with close microphone placement (approximately 8 inches). The microphone is usually pointed at a downward angle with the diaphragm placed just above the nose

A *pop-shield* is often placed between the talent and the microphone to reduce the effects of plosives (air hitting the diaphragm). The script is placed on a music stand or a hanging clip, positioned off to the side to prevent unwanted reflections or paper rustling. Dialog is typically divided into individual sentences or short phrases. Multiple takes of each line are then recorded in a process called *looping*. Once recorded, the dialog or picture editor will

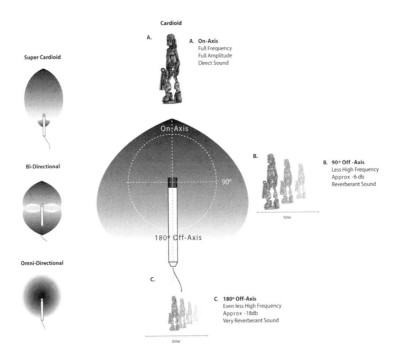

FIGURE 3.2. Polar patterns.

edit and *composite* the takes and import them into an animation program such as FlipBook or Maya. These dialog tracks will become essential references for lip sync animation. When possible, videotape the dialog sessions. The video derived from a dialog session provides helpful visual reference material that can also be useful in the animation process.

N. Evaluating Recorded Dialog

A dialog recording session has many objective elements in a dialog recording session:

- *Sibilance*—Words that begin with *f*, *s*, *z*, *ch*, *ph*, *sh*, and *th* all produce a hissing sound that, if emphasized, can detract from a reading. Whenever necessary, it is preferable to rerecord the passage rather than using a de-esser (software) in postproduction. Emphasizing a different portion of the word in a subsequent reading can control most sibilance. For example, changing the emphasis from the "s" as in "ssssnake" to the "a" as in "snaaaake" maintains the length and minimizes the offending sibilance. Moving the microphone slightly above or to the side of the talent's mouth will also reduce sibilance. In rare cases, sibilance can be a useful tool for character development. Such was the case when Sterling Holloway developed the hissing voice treatment of Kaa, the python in the Walt Disney feature *The Jungle Book*.

- *Plosives*—Place your fingers directly in front of your mouth and speak words that begin with the letters *b, p, k, d, t,* and *g* (as in "Goofy"). These consonants produce a rapid release of air pressure that is built up prior to the delivery. Notice the explosive air that cools your fingers. The resulting burst of air hits the diaphragm of the microphone and produces wind distortion, or plosives. Plosives can occur at the beginning or end of a word and are a common problem for untrained voice talent. Plosives are difficult, if not impossible to remove; therefore, phrases with plosives are often rerecorded. Plosives can be reduced or prevented by placing a pop-filter (Figure 3.3) between the talent and the microphone. Other solutions include backing the talent away from the microphone or moving the microphone slightly

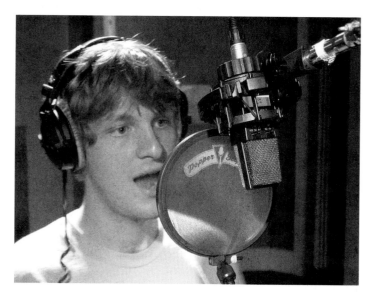

FIGURE 3.3. Microphone angle and pop-shield.

to the side (off-axis) of the talent. In addition, a high-pass filter set below the frequency of the dialog is often used to make minor corrections. Unlike sibilance, there are no dramatic uses for plosives in the context of dialog.

- *Proximity effect*—When voice talent is being miked closely using a directional microphone, there is the potential for the microphone to emphasize the bass response, causing a subjectively boomy sound that can lack clarity. Proximity effect is sometimes used to advantage to create a fuller sound. One means of reducing an unwanted proximity effect is to move the talent farther away from the microphone. Selecting an omnidirectional microphone pattern will also reduce excessive low-end response.

- *Nerve-related problems*—Recording in a studio is intimidating for many actors. The sense of permanence and a desire for perfection often produce levels of anxiety that can impact performance. Signs of anxiety include exaggerated breathing, hurried reading, and glottal shocks. Glottal shocks are cough-like sounds produced in the throat as a result of voice talent releasing their air at the throat. The surest way to worsen nerve-related problems is to direct the talent to "relax." It is often helpful to show the talent how editing can be used to composite a performance. Once they learn that the final performance can be derived from the best elements of their performances, they typically relax and take the risks needed to generate a compelling reading.

- *Lip and tongue clacks*—Air conditioning and nerves can cause the actor's mouth to dry out, which causes the lip and tongue tissue to stick, creating an audible sound when they separate. To avoid dry mouth, encourage the voice actor to refrain from drinking dairy products prior to the session. Always provide water for the talent throughout the session.

- *Cloth and jewelry sounds*—As the voice talent shifts his or her weight, audible cloth and jewelry sounds may be captured by the microphone. Because the talent is so close to the mike, even

the softest sounds such as a watch ticking can be picked up. It is best to remove jewelry or other items that may create problems during the recording session.

- *Headphone leakage*—Dialog is often recorded to a reference or guide track that may include original dialog, temp music, and SFX. Due to the close proximity of the talent to the microphone, audio from the guide track can easily bleed from the headphones onto the dialog track. Headphone leakage can greatly complicate dialog editing. Common solutions include turning down the guide track level, using tight-fitting headphones, or moving the talent away from the microphone. If the talent uses only one side, or "can," of the headphone pair, the guide track can be panned exclusively to that side.

- *Phase issues*—Phase issues arise when the voice reflects off a surface (usually a script or music stand) and back into the microphone. The reflective sound combines with the original out of phase, sounding hollow or synthetic. Repositioning the script (or, in some cases, the voice talent) should alleviate this problem.

- *Extreme variations in dynamic range*—Variations in volume within a vocal performance contribute greatly to the expressive quality and interpretation. Unfortunately, dialog performed at lower levels often gets lost in the mix. Equally problematic is dialog performed at such high levels as to distort the signal at the microphone or preamp. A compressor is used with make-up gain to correct both of these problems. Compressors will be covered at greater length in Chapter 7.

- *Handling noise*—Handling noise results when the talent is allowed to hold the microphone. Subtle finger movements against the microphone casing translate to thuddy percussive sounds. The actors should not handle microphones during a dialog session. Instead, the microphone should be hung in a shock-mounted microphone cradle attached to a quality microphone stand.

O. Compositing and Editing

It is the job of the recordist to capture a compelling performance that is free of sonic flaws. Once recorded, individual takes are selected and edited to create a composite track representing the best possible performance. The job of editing dialog for timings falls to the picture editor. Dialog editing requires attention to discrete aural details. Subtle sounds are produced as the mouth forms to begin and end words or phrases. These sounds contain essential material that is often too low in amplitude (volume) to show up in wave editors. If these are removed, the words that remain sound unnatural. Words that do not begin with a consonant often begin with the preparatory breath, making it difficult if not impossible to determine where the breath ends and the word begins. Breathing is a natural element of dialog that can be minimized, if needed, but should generally remain a part of the dialog. Zooming in on a specific track and optimizing the viewing height will help prevent low-level signals from being edited out.

P. Synchronization

The quality of lip sync is determined largely by the style of animation. For example, mouth movements in *Anime* (Japanese animation style) have a stylistic look that is simplistic in comparison with dialog animated in three dimensions. Animating dialog is an expensive and time-consuming process; consequently, most animation for television is simplified to cut costs and meet tight production schedules. The picture editor has the most global understanding of both the dialog and the actions that occur in between; therefore, the job of editing dialog and placing it in the timeline goes to the picture editor. In addition to working out timings, the picture edi-

tor must also learn to recognize audio waveforms in relation to important dialog sync points. *Transients* are the most readily identifiable element of a wave and are useful in mapping sync points for primary visuals. Software such as FlipBook and Magpie Pro allow the animator to develop lip sync to audio within a digital environment, thus eliminating the need for paper-and-pencil bar and dope sheets. As a general rule, dialog is either hard synced or slightly early but never late.

Q. Signal Processing

Signal processing is applied to dialog (typically at the final mix during postproduction) as a corrective measure, for sound shaping, and to place the sound in the space of the action. The following are specific suggestions for each.

1. CORRECTIVE MEASURES

- *To improve intelligibility*—Certain areas of the frequency spectrum promote or detract from dialog intelligibility. The frequencies centered around 250 Hz are referred to as the *mud range*. If dialog is sounding boomy due to proximity effect, it might be wise to consider cutting a few decibels in this range; on the other hand, if the dialog is lacking warmth, boosting in this range a few decibels can often help. Frequencies centered at 4 kHz are referred to as the *presence range*. Boosting at this range will improve intelligibility as well as bring the voice to the foreground in the mix.

- *To eliminate noise*—With the exception of very low male characters such as Boris Karloff or James Earl Jones, most dialog does not contain any fundamentals below 100 Hz; therefore, all frequencies below this range can typically be rolled off with an equalizer. A gate can also be used to remove quieter noise that occurs in between dialog.

- *To prevent frequency masking*—Oftentimes, the underscore contains frequencies that compete with the dialog. EQ can be used to cut a sonic hole in the underscore. This is accomplished by creating a notch filter with a center frequency that matches the dialog. The notch is set to a narrow bandwidth and applied to the underscore tracks so the dialog no longer has to compete with frequencies in the music mix.

- *To control dynamic range*—Dialog generally consists of a narrow frequency range, relying more on dynamic range and inflection to create interest. Dialog recorded with excessive variation in dynamic range is difficult to mix. If we set the microphone levels to avoid peaking, we risk capturing the desired signal at low levels, resulting in a poor signal-to-noise ratio. A well-trained voice talent controls dynamic range by adjusting their physical position to the microphone as they speak louder. For less experienced talent, the audio engineer may use dynamic compressors (Figure 3.4) to even out the extreme variations in dialog levels.

 Compressors reduce the occasional peaks of dialog to achieve a more consistent and predictable upward level. The additional headroom gained from effective compression can then be reapplied to the entire signal, raising the volume of softer passages to a more audible level. This is referred to as *make-up gain*. Compressors automate level changes and even out large differences in volume; however, compression reduces the expressive subtleties made possible through dynamic variation. If it is necessary to use excessive compression to hear the dialog, lowering the output levels of competing tracks should be considered.

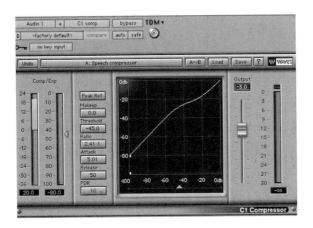

FIGURE 3.4. Vocal compression.

2. SOUND SHAPING

Some processors are used to reshape the voice quality for the purposes of exaggeration or character development. As previously discussed, reversing an existing language is a common approach to creating synthetic languages. Vocoders, harmonizers, and specialized plug-ins such as Digidesign's SciFi are commonly used to create robotic speech effects. Time compression is routinely used to develop the rapid legal disclaimers heard on television and radio commercials. The possibilities for sound shaping are endless, but always keep in mind the importance of intelligibility.

3. FUTZING VOICE-OVER

In a process known as futzing, various treatments are applied to the voice to imply that the voice is being reproduced mechanically. Table 3.1 shows some basic parameters that are manipulated to produce futzed voice-over effects.

TABLE 3.1 Futzing Voice-Over

Playback Device	Frequency Cuts
Car radio	Cut (bandlimit) the low frequencies dropping below 100 Hz and the high frequencies rising above 5 kHz. Apply dynamic compression. Add road and engine noise. Reduce the signal from stereo to mono. Add additional hiss associated with AM transmission. For emergency radio, try Bomb Factories Cosmonaut plug-in. Cosmonaut provides a quick way to futz a signal while also adding squelch and transmission noise.
Television	Cut the low frequencies dropping below 40 Hz and the high frequencies rising above 10 kHz. Apply dynamic compression and bring up the levels for dialog. Reduce the signal from stereo to mono and add room tone.
PA (public address) system	Frequency response varies greatly from system to system, but generally cut the highs to account for high-frequency absorption. Add delays to emulate the effects of speaker proximity and reflective environments. Include a healthy dose of environmental noise. If the signal is stereo, such as music, reduce it to mono.
Telephone) (off-screen voice	Cut the low frequencies dropping below 300 Hz and the high frequencies rising above 3 kHz. Apply dynamic compression to the voice. Add cross-talk and other types of interference. Reduce the signal to mono.

Music

CHAPTER 4

People sing when they are too emotional to talk anymore —
Lynn Ahrens (Lyricist, *Anastasia*)

A. Overview

Consumers use the term *sound track* to describe CDs and tapes associated with film music; however, the film industry uses the same term to denote the completed audio mix that includes the dialog, SFX, and music stems. The music stem is also referred to as the *score*. A score is composed, and a sound track is constructed. Every score consists of a series of cues (musical selections), each corresponding to a specific scene or action. Cues are categorized as underscore or source. Underscore is provided exclusively for the audience, and the characters within the story do not perceive or respond to it. Underscore contributes to the fantasy and requires a willing suspension of disbelief on the part of the audience. It is also an effective means of developing the subtext of the narrative and is often felt (ambient) more than heard. Both the characters and the audience perceive and respond to source music. Source music can be either on-screen (such as a band playing) or off-screen (such as elevator music). Source music commonly utilizes songs selected for their narrative lyric. Some sound tracks are comprised entirely of songs. These song scores are differentiated as original song scores (containing five or more original songs) and adaptation scores (utilizing preexisting music). Animated musicals such as *The Little Mermaid* and *Beauty and the Beast* are examples of original song scores. *Lilo and Stitch* and *Jimmy Neutron* are examples

of adaptation scores. All songs that are integrated with on-screen visuals must be prescored, providing essential timings for the animation of dance sequences and singing. Disney's *Silly Symphonies* utilized a prescore for narrative development and for visual timings, as well.

B. The Role of Music in Animation

Music can slow up an action that should not be slowed up and quicken a scene that shouldn't be, knowing the difference is what makes a film composer. —Max Steiner

If animation is the process of breathing life into a character, then music infuses emotion into that life. Music is a powerful means of eliciting emotional response. Music philosophers believe that music is symbolic of our subjective feelings. Audiences gravitate toward music that reflects their personalities and current emotional state, essentially underscoring their daily lives. Certain musical selections become symbolic links to their personal experiences and emotions, causing individuals to recall specific events and

feelings associated with their past. One reason to have an original score is to avoid these associations and control the audience's experience.

Even before sync sound, filmmakers recognized the unique influence that music had on their films. During the silent era, music publishers began cataloging their libraries by dramatic implication. Over the years, certain conventions have evolved regarding the elements of music and their implications for image. *Melody* provides both linear and narrative elements to animation, especially when used as a leitmotif. Harmony is often used to develop the subtext, represent the emotional POV, or guide and elicit emotional response. *Tonal music* has a sonic gravity that creates tension when unresolved. In an eight-note major scale, the seventh note creates the greatest amount of tension as it gravitates toward the eighth note (which is resting). *Atonal* music does not create tension in the same manner; as a result, atonal music is nonlinear and easily cut to fit the scene. *Rhythm* influences the audience's perception of the pacing of a scene and promotes continuity in montage sequences. *Dynamics* are useful for sudden emphasis or gradual changes in intensity. *Instrumentation* and *style* suggest ethnicity, time period, genre, and magnitude.

Music for pure listening derives its *form* independent of image, whereas film music derives its form from the narrative of the film. Therefore, when using music designed for listening, one runs the risk that the music will impose its own sense of order on the scene. Audiences accept that underscore is not occurring within the scene. Because underscore is not completely tied to the image, there is more flexibility as to when a cue must begin or end; therefore, underscore can *prelap* or *overlap* scenes with relative transparency. It can also transform to source music and back with the same transparency. In Michel Chion's typology, underscore can be seen as reduced (effects scoring), semantic (subtext scoring), or causal (leitmotif). Source music is causal and sometimes semantic as well.

C. Historical Figures in Animation Scoring

In 1928, Walt Disney released his first sound animation, *Steamboat Willie*, which features the folk song "Turkey in the Straw." In that same year, Dimitri Shostakovich composed his *The Golden Age* ballet, in which the "Polka" foreshadowed a musical style that would become synonymous with early animation. Within a decade, Carl Stalling and Scott Bradley had established "cartoon music" through their respective work with Warner Brothers and MGM animated shorts. Cartoon music of that Golden Age features harsh dissonance, exaggerated performance techniques, frantic rhythmic lines, and quotations from popular tunes. Stalling and Bradley both had a propensity for hitting the action with music, an approach referred to as *Mickey Mousing*. Many of the early animations featured *wall-to-wall* (nonstop) music that was often a blend of underscore and musical sound effect. The narrative for these animations changed rapidly, requiring a nonlinear style of music that could transition in pace with the action. The music created to meet these demands pushed the technical limits of the composer and musician alike. Not all animation of the Golden Age featured this type of music or approach. Paramount's animations were dialog driven and contained fewer sight gags. The musical treatment for these animations reflected the live-action approach to scoring of the time. Winston Sharples composed and arranged much of this music, which featured *thematic scoring* (the recurrence of melodic themes) to give the animation continuity. He also utilized the operatic concept of *leitmotif*, which assigns specific themes to specific characters.

The arrival of television in the late 1940s signaled the end of the Golden Age of animation. As animation moved from film to television, decreased budgets and compressed timelines gave rise to a new approach to animation scoring. Hanna–Barbera emerged as the primary animation studio for television. They employed Hoyt

Curtain to create the musical style for their episodic animations. As a jingle writer, Curtain had a talent for writing melodic themes with a strong hook. He applied this talent to create some of the most memorable title themes, including *The Flintstones, Johnny Quest,* and *The Jetsons.* He also created in-house *music libraries* used consistently from episode to episode. These libraries accelerated production time, cut costs, and gave each animation a signature sound. Other notable thematic composers include Henry Mancini (*Pink Panther*) and Vince Guaraldi (*Charlie Brown*). In 1989, Disney released *The Little Mermaid,* which featured an original song score by composer Alan Menkin and lyricist Tim Rice. In that same year, Alan Silvestri composed the score for *Who Framed Roger Rabbit?*. In this score, Silvestri combined modern live action scoring with classic animation scoring modeled after Carl Stalling. Both animations renewed studio interest in feature-length animation. In 1995, Randy Newman created the first scores for Pixar's *Toy Story.* By the mid-1990s, Alf Clausen had established *parody scoring* as a familiar element of *The Simpsons.* Clausen's skill at parody is well represented in the episode entitled "Two Dozen and One Greyhounds," which features the song "See My Vest," a parody of Disney's "Be Our Guest." See Chapter 11 for more information on parody.

D. The Temp Track

The *temp track* is the most effective means of communication between the director and the composer. They are created to facilitate early screenings with test audiences. As the name implies, a temp (temporary) track is constructed from preexisting music. These tracks are synced to a work in progress to provide the composer with a model for the permanent score. Temp tracks are also used in test screenings to influence the pacing and feel of the unfinished project. The job of making a temp track often falls on the music editor. The music editor selects music that matches the style and dramatic needs as represented in the storyboards or animatic. Temp music is edited and synced to customized preexisting music for each cue. Because the temp track is for internal use only, copy-protected material is often used. In many cases, the music editor creates a temp track that is so compelling that the director becomes too attached and does not want an original score.

E. Underscore

Sound effects often represent a character's outer world, whereas underscore often signifies that character's inner world. Underscore invites the audience to perceive and respond to the emotions suggested by the narrative. In the early years of sync sound, many directors believed that audiences would not accept underscore. As a result, they went to extremes to provide visual justification for any music accompanying a scene. In reality, audiences readily accept underscore as a normal part of the cinematic experience, so underscore became the dominant element in the music stem. Underscore is almost always original music tailored in length and character to promote the narrative. Underscore is *thematic* (containing strong melodies) or *ambient* in nature. It is often used as a substitute for ambience, providing a sonic background that promotes fantasy and elicits emotional response. Because there is no visual reference for underscore, it does not have to conform to changes in scenes or camera positions. In and out points for music cues are selected to smooth edits, draw the audience into the scene, or provide a sense of closure. A common use for underscore is as an emotional signifier. Language is often a cumbersome and inaccurate means of describing inward feelings. Music can signify the emotional intent of a scene with just a few notes, avoiding the need for extended psychological dialog.

F. Source Music

Source music is music that is experienced by both the audience and the characters. Common sources include radios, televisions, live performances, and public address (PA) systems. Source music promotes a sense of realism. It can be on-screen or off-screen and is typically comprised of songs that are both linear and thematic. Source cues are usually introduced in progress to suggest parallel action. Another common technique is to introduce the cue prior to a scene change (prelap) as a means of drawing the audience into the new scene. Unlike underscore, source music is typically a mono signal, is signal processed or worldized, and is panned to the on-screen position. It is common to establish a theme through source music and gradually transform it into underscore. *Source to underscore* is a common means of moving from a dialog-driven scene into a montage sequence. When lyrics are present, the contents of these lyrics usually have some connection with the narrative; however, *narrative lyrics* should never compete with the principal dialog. Popular music is often used for source music, capitalizing on preexisting cultural and literal meanings. These songs are often rearranged and recorded (covered) by new groups, customizing the cue and avoiding the expense of master licensing fees (see Chapter 11).

G. Music Effects and Effects Scoring

The early animations of Warner Brothers and MGM Studios utilized sight gags to great effect. During this period, musical instruments were often substituted for traditional SFX in a design approach that is sometimes referred to as *effects scoring*. Chords of varied volume and dissonance were often used to exaggerate actions while also deemphasizing any implied violence. Melodic themes followed the up or down motion of on-screen objects or actions (*isomorphism*). Perhaps the most familiar isomorphism is the sound of eyes blinking, played on a xylophone in minor thirds. The rhythmic component of music is often exploited to cover linear events such as walk cycles. The musical *sneak steps* heard in *Scooby Doo* double as underscore and Foley. The pitches and harmony used for each footstep are varied to provide contrast and emotional feel. Ascending or descending musical lines are used to promote direction, while volume is used to imply proximity and intensity. In Disney's *Tarzan*, the roles of music and SFX are reversed, and the rhythm section for the tune "Trashin' the Camp" is comprised almost exclusively of sound effects rather than traditional instrumentation.

H. Music for Emotional Treatment

Music expresses that which cannot be said and on which it is impossible to be silent. —Victor Hugo

Music is an effective tool for adding emotional (mood) and psychological (attitude) treatment to specific characters or action. Music is perhaps the most direct means of signifying and eliciting emotions. The use of music for emotional effect presumes that there are innate elements contained in music that elicit universal response. We recognize that there is consistency in emotional responses among varied audiences; however, it is not clear why this occurs. Music philosophers suggest that music symbolizes our subjective emotional experiences. Others have suggested that we have developed emotional associations with specific music as a result of prior synchronization in animation. Perhaps the pairing

of music with image sufficiently reduces subjectivity to a level where the music can both elicit and direct our emotional responses. It is also possible that the consistent pairing of scenes with music has produced this cinematic convention. These associations have become more universal as film has developed into a worldwide medium.

Underscore often signifies the subtext of a particular scene, like an emotional chameleon, rapidly changing mood to follow the narrative. *Anempathetic* music contrasts the implied emotion of a scene to exaggerate or deemphasize its intensity. The contrast provided by anempathetic music often increases an audience's empathy for the protagonists. Anempathetic music can also be used to reduce the intensity of a scene. For example, the violence portrayed in the final conflict of Disney's *Beauty and the Beast* is deemphasized with the upbeat instrumental rendition of "Be Our Guest." One of the classic uses of underscore is to misdirect the audience. *Misdirection* is a classic device in horror movies where the score builds to a false conclusion. The selection of music for psychological treatment is far from an exact science.

I. Subtext Scoring

As the characters in a narrative develop, they typically undergo some form of inward transformation regarding attitudes and values. This transformation is often implied visually, and the director must rely on the score to complete the underlining message. Music written for this dramatic purpose is referred to as *subtext scoring*. Subtext scoring conveys inward transformation without the need for exposition or dramatic visual gestures.

J. Music for Continuity and Time Perception

Music can promote continuity for an animation in many ways. When the mood and character of the cue are maintained, the cue helps tie the many visual edits together to define the scene. The *leitmotif* (a musical phrase consistently paired with a character, object, or event) is yet another means of promoting continuity. The recurrence of leitmotifs provides a familiar element to a story that usually is in a state of change. Instrumentation can be tied to a specific character in much the same manner as a leitmotif is used; for example, in *Lethal Weapon*, Michael Kamen consistently scored scenes featuring Mel Gibson with a blues guitar and scored Danny Glover's scenes with a saxophone. Music has a powerful influence on our perception of time, the fourth dimension of film. Contrasting scores associated with flashbacks and jump cuts suggest leaps in the time continuum. The sense of real time is also influenced by the tempo of a cue synced with the image. This is especially true of chase sequences in which individual shots imply vastly different pacing. In this situation, the tempo of the underscore superimposes a consistent momentum that is not apparent throughout the scene. Another means of promoting continuity is to have one composer create the entire score rather than hiring several of them to do it.

K. Music To Establish Setting and Scale

Music is an effective means of establishing setting and scale. Many musical styles are named after the location or time period in which they originated such as Italian Baroque or French Impressionism.

Each style, when performed with traditional instruments, helps establish a setting. The underscore is also a strong means of establishing scale. For example, a large orchestra is proportionate to the setting of an epic story, whereas chamber music or solo instruments portray a more intimate setting. A disconnect can occur if the orchestration does not match the implied scale of the image.

L. Acoustic and Synthetic Instrumentation

Acoustic instruments are often associated with organic environments, while synthetic instruments are associated with mechanical or technological environments. In *RoboCop*, acoustics and synthetic instrumentation are used to contrast man and machine. Acoustic sounds such as the piano or violin have become universally accepted and can therefore be used to create a score that is timeless and transparent. Synthetic sounds are useful for a variety of narratives; however, they can also sound dated over time.

M. The Spotting Session

The spotting session occurs soon after the film is *locked* (no further picture edits). This is the point in postproduction where the director meets with the composer to identify, define, and develop time references for each cue. The session consists of a series of starts and stops followed by discussions in which the cues are defined. During this process, the music editor takes detailed notes regarding each cue (Figure 4.1).

Music Spotting Log

Date. _____
Page No. _____

Project Title: _____ Composer: _____
Music Editor: _____

Cue #:	Cue Name:	Notes:
Start Time:	: : :	
End Time:	: : :	
Total Time:	: : :	

Cue #:	Cue Name:	Notes:
Start Time:	: : :	
End Time:	: : :	
Total Time:	: : :	

Cue #:	Cue Name:	Notes:
Start Time:	: : :	
End Time:	: : :	
Total Time:	: : :	

Cue #:	Cue Name:	Notes:
Start Time:	: : :	
End Time:	: : :	
Total Time:	: : :	

Cue #:	Cue Name:	Notes:
Start Time:	: : :	
End Time:	: : :	
Total Time:	: : :	

Cue #:	Cue Name:	Notes:
Start Time:	: : :	
End Time:	: : :	
Total Time:	: : :	

FIGURE 4.1. Music spotting log.

These notes are used to generate a cue sheet that serves as a blueprint for the score. It also provides an accurate total for the number of minutes required. This timing information is critical in the development of a scoring schedule and budget. Cues are often named after the narrative event to which they are synced.

Suggestions for the spotting session include:

- Determine the importance of music for the scene.
- Be selective in the use of music; two additional stems support the narrative, as well.
- Stay focused on the narrative.
- Decide when the music should hit, comment, or play through the action.
- Look for opportunities in the scene where music can be brought in without drawing attention to itself.
- Place melodic notes in between words or phrases (*counterpoint editing*); avoid active melodies and competing frequencies during moments when dialog is critical.
- Use prelaps (early entrances) to draw the audience into the next scene; placing the cue on the cut advertises the cut and links the cut to the scene.
- When the picture edit feels jumpy, consider underscore as a smoothing element.
- Be open to all musical styles; allow the image, rather than personal taste, to influence your decisions.

N. Creating an Original Score

Directors seek an original score that is exclusive, tailored, and free from preexisting associations. Composing with dramatic sensitivity is one way film composers distinguish themselves from classical composers. Film composers must be able to write in all styles. They are often asked to model the score after the temp track while avoiding plagiarism. Chord progressions, rhythmic patterns, and instrumentation are elements that can be copied quite literally to capture the essence of the temp track. They are often used to provide the foundation for an original melody or theme resulting in a similar yet legal cue. Most underscore is created as a *work for hire*, requiring the composer to surrender copyright to the production company. The composer commonly retains 50% of the net income on any subsequent use and title credit for authorship. Creative fees are negotiated based on experience, amount of music required, and associated tasks involved in producing a score. These tasks include orchestration, contracting musicians, conducting, and music editing. Independent production companies often contract the composer to handle all aspects of score creation. This type of contract is referred to as a *package deal*, in which the composer is paid a lump sum that covers all fees associated with producing the score.

O. Demonstrating the Score

Once the cue sheet is completed, the composer begins writing cues. One approach to this process involves sketching out themes. Composers often use sound modules or pianos to *demonstrate the score* to the director. Scores are best demonstrated in the context of the film; therefore, if possible, sync the sketch score to the work print. Once a cue is approved, it is fully orchestrated and prepared for a scoring session. In the case of an *electronic score*, each cue is fully sequenced (MIDI) and realized with sound modules and sample libraries (Figure 4.2).

The blending of sequenced music with live musicians is becoming a common practice for all types of projects. Sequenced music provides the timing cues (*click track*) during the scoring session.

FIGURE 4.2. Samplers
and sampling libraries.

P. Production Music Libraries

Production music is a low-cost means of developing a score. The music tracks contained in commercial libraries are *precleared* for use on audio/visual productions. As with most production elements, the quality of the music varies with cost. Production music is growing in acceptance and can be found on large and small budget projects. Shows such as *Ren and Stimpy* and *SpongeBob Squarepants* rely heavily on production music for their basic underscore. Hoyt Curtain developed an in-house music library for each of the animation series developed for television by Hanna–Barbera. Production libraries feature precut versions, mix options, and underscore versions. Musical elements (such as solo

percussion) can be added to an existing cue to customize the score with hits. The three basic types of production music libraries are named for their licensing specifications: buy-out, blanket, and laser-drop. Buy-out libraries are purchased for a one-time fee and grant the owner unrestricted use. *Buy-out* libraries are common for local radio and television stations because they are inexpensive and easy to use. Buy-out libraries are typically designed for commercial rather than dramatic applications. The second type of library is the *blanket license*. The two types of blanket licenses are *annual blankets* and *production blankets*. Annual blankets require a yearly fee for access and limited use. These types of licenses are most common for educational institutions. Production blankets require a fee to cover all cues used in an animation. *Laser-drops* (formally *needle-drops*) are the third and most expensive type of library. Laser-drop libraries charge a fee per use based on length and nature of use. Recently, needle-drop libraries have taken advantage of Internet online delivery. Users log into a website where they can search, preview, and download low-resolution files for cue approval. Once approved, the cue can be purchased online and downloaded at broadcast quality. Search engines such as Gallery's M-Tools and mSoft's MusicCue support most major production libraries. Though expensive, the music found in these libraries is of the highest industry standard.

Advantages of using production music include:

- It is faster and less expensive than an original score.
- Cues are approved prior to purchase.
- What you hear is what you get.
- Music can be used as temp track and remain if the cue is approved.
- Online delivery helps meet production deadlines.
- The selections are precleared for synchronization, master, mechanical, and videogram licensing.

Disadvantages of production music include:

- Most cues are delivered in stereo interleaved format; therefore, discrete elements of the score are not available for editing or mixing.
- The tempo does not always work with the pacing of the scene.
- It is nonexclusive; the same cues could show up in competing projects.
- It is not written for the scene, so it must be edited.
- There are limited variations of the cue, making variation with continuity more difficult.

Q. Selected List of Production Libraries

The following libraries contain anywhere from 600 to 4000 hours of cleared music appropriate for projects of all genre. Each of these libraries allows the user to search, preview, and download (not broadcast quality) music for the purposes of creating a temp track and cue approval. Once the selection is approved, the broadcast-quality version can be obtained either online or via CD or hard drive formats. Users can search music by emotion, musical style, cinematic genre, or instrumentation. In addition, subscribers receive free assistance in selecting music appropriate for specific cues. Each website contains a project management system that allows the music editor to organize cues into specific projects (Figure 4.3).

All music contained in these libraries has been cleared for synchronization, master rights, and videogram licensing. Licensing rates vary by company and include production blankets, laser drops, and prorated fees for festivals and—predistribution screenings.

FIGURE 4.3 Project management.

- **APM** (www.apmmusic.com)—Associated Production Music has been operating since 1983. APM represents 16 production music libraries. KPM is the European distributor for the same library. The library consists of over 3200 discs. APM offers a portable drive and search engine for over 200 hours of music. Registration is free but rather involved. Rate schedules are available from an account representative. APM has a complete online preview that allows users to download low-resolution files that can be added to projects for client approval.

- **DeWolfe** (www.dewolfemusic.com)—DeWolfe is one of the oldest production libraries, dating back to 1909. This library consists of over 600 discs that are specifically geared toward cinematic and commercial production. DeWolfe is a cost-effective library for educational institutions as it offers a blanket license for student projects and festivals. A variety of licensing is available including nonbroadcast, broadcast, theatrical, and distribution and sale for visual media. Clients can receive up to 50 discs at any time. Individual discs can be exchanged to reflect changes in project and client needs. The entire collection can be shipped on a 500-gigabyte Harmony Music hard drive. The Harmony system includes proprietary management software that facilitates searching and transfer to many of the popular digital audio workstations. The entire system is a cost-effective approach to score development. Figure 4.4 provides an example of their online reporting.

- **First Com** (www.firstcom.com)—First Com is a comprehensive production music library well suited to most dramatic applications. First Com was established in 1980 and adds approximately 100 disks per year; their current library contains 1700 disks. First Com provides an online search and can be previewed using First Com's MusiQuick. QuickTraxSM and LiquidTrax® provide custom mix options such as adding, deleting, and adjusting levels on the melody or percussion tracks.

- **LicenseMusic** (www.licensemusic.com)—LicenseMusic claims to have the largest library of precleared music in the world from over 20 affiliate libraries. The Aircraft library utilizes a program called CoPilot for many of the disks. CoPilot gives the user access to the discrete tracks needed to remix the cue to meet specific instrumental needs. LicenseMusic is a great source for popular sounding cues. They offer a needle-drop license for backgrounds, source, and feature themes. Special rates are available for festival and predistribution screenings. Student film rates are negotiable, and the average fee for student films is $50 per cut.

- **Flashkit** (www.flashkit.com)—Flashkit is a popular website for royalty-free music. Much of the music found in this library is loop based and tends to be more popular than dramatic. The music can be previewed and downloaded free of charge.

- **The Hollywood Edge** (www.hollywoodedge.com)—The Hollywood Edge is a buyout library designed specifically for dramatic production. The entire set includes over 50 hours of music organized in a manner similar to larger needle-drop libraries. Individual disks are not sold separately, and the entire collection is over $5000.

R. Developing a Vocabulary for Scoring

1. BY EMOTION

Music is subjective and is best described using a unique vocabulary. Directors must develop a strong vocabulary of emotional terms in order to effectively communicate to composers what they require from the score. It is the composer's job to translate this language

FIGURE 4.4. Online reporting.

License Application Page 1

Specify every clearance needed by completing the following form and then click the "Go on to Page 2" button below.

Non-Broadcast Production:
Programs or presentations that are linear and non-broadcast (and will not be transmitted either by broadcast signal or cable). Includes up to 500 copies for internal use.

Select: ▼

If "Point of Purchase", enter number of locations: ☐
If "Other", describe: _____

Productions for Distribution/Sale:
Audio/video cassette or disc produced in a linear fashion for distribution or sale to the general public or a select audience.

☐ Visual Medium ☐ Audio Medium

Number of Units Distributed: Select: ▼

Broadcast Production: National ▼

Cable TV Production: Select: ▼

TV Commercial: Select: ▼ Tags: ☐ Quantity ☐ Unlimited

Cable TV Commercial: Select: ▼ Tags: ☐ Quantity ☐ Unlimited

Radio Commercial: Select: ▼ Tags: ☐ Quantity ☐ Unlimited

Internet Usage: Select: ▼ Other (describe): _____

Theme Use For One Year: ☐

Theatrical: Film Festival Clearance ▼

Other use (please specify): student film

Music Selections:

Title of Selected Music	Catalog Number	Number of Uses	License Fees
Humoresque	DWCD0290_25		$
Squirrels On The Spree	DWMIL008_34		$
Humorous Links 1	DWMIL012_39		$
Xmas Nuthouse	HRCB010_67		$
			$
			$

into music cues that match the desired production value. The following is an extensive list of emotional terms that are useful for defining a cue or narrowing an online search. These terms were derived from a variety of production music libraries. Many of these terms are used infrequently in daily conversation; therefore, it may be useful to review them prior to a spotting session.

Abstract	Destructive	Gloomy	Playful	Spacey
Adventurous	Determined	Haunting	Pleading	Sparse
Aggressive	Delirious	Heartfelt	Plodding	Spiky
Agitated	Delicate	Hectic	Poignant	Spirited
Ambient	Depressing	Heroic	Polite	Stately
Amorous	Descending	Hesitant	Pompous	Steady
Amusing	Disillusioned	Important	Pounding	Stealthy
Anemic	Dissonant	Imposing	Powerful	Stirring
An-empathetic	Disturbing	Impressive	Primitive	Strained
Angry	Docile	Inquisitive	Private	Strange
Animated	Doomed	Innocent	Proud	Strident
Anticipatory	Doubtful	Intense	Psychotic	Stubborn
Anxious	Dramatic	Insistent	Pulsating	Suggestive
Apprehensive	Dreamy	Inspiring	Punchy	Sultry
Assured	Drifting	Intricate	Pushy	Surreal
Banal	Driving	Intriguing	Questioning	Suspenseful
Beautiful	Drone	Intrepid	Quiet	Suspicious
Bizarre	Drunk	Invigorating	Quirky	Sustained
Boisterous	Dynamic	Joyful	Racy	Sweeping
Bold	Easy	Laid back	Random	Sympathetic
Boring	Ecstatic	Lamenting	Rapid	Synthetic
Bouncy	Edgy	Lavish	Raunchy	Tearful
Brash	Eerie	Leisurely	Rebellious	Tender
Brave	Effervescent	Lively	Reckless	Tense
Bright	Effortless	Light	Refined	Terrifying
Building	Elegant	Lonely	Reflective	Thankful
Busy	Elevating	Longing	Regal	Tired
Calming	Emotional	Looming	Relaxed	Tragic
Campy	Enchanting	Lustful	Religious	Trance-like
Carefree	Encouraging	Lyrical	Resolute	Tranquil
Careful	Energetic	Macabre	Resolved	Thematic
Caring	Epic	Mad	Restless	Thoughtful
Casual	Erotic	Majestic	Restrained	Threatening
Cataclysmic	Evocative	Mechanical	Reverent	Tortuous
Catastrophic	Ethereal	Meditative	Risqué	Touching
Cautious	Exciting	Melancholic	Romantic	Traditional
Ceremonial	Exhilarating	Mellow	Rustic	Transparent
Chaotic	Exotic	Melodic	Sad	Trashy
Charming	Expectant	Menacing	Scary	Triumphant
Cheeky	Expressive	Moody	Schmaltzy	Tuneful
Cheerful	Exuberant	Mournful	Seasonal	Uncomplicated
Childlike	Fearless	Moving	Secretive	Uneasy
Chilling	Flirtatious	Mysterious	Sensual	Unfriendly
Climatic	Folksy	Mystical	Sexual	Unnerving
Cold	Foreboding	Nervous	Shocking	Unpredictable
Comforting	Forceful	Nightmarish	Silly	Unresolved
Comical	Fragmented	Noble	Sentimental	Uplifting
Complex	Frantic	Nostalgic	Serene	Urgent
Confident	Frenzied	Neurotic	Serious	Valiant
Confrontational	Friendly	Neutral	Simple	Vengeful
Confusing	Frightening	Ominous	Sincere	Vibrant
Conservative	Fun	Optimistic	Sinister	Vigorous
Contented	Furious	Organic	Sleazy	Violent
Cool	Gentle	Orgasmic	Slick	Vulnerable
Courageous	Glamorous	Over the top	Sneaky	Weary
Curious	Glitzy	Passionate	Snobbish	Weird

Daring	Horrific	Pastoral	Soaring	Whimsical
Dark	Humorous	Peaceful	Solemn	Wild
Defeated	Hypnotic	Pensive	Somber	Wistful
Desolate	Idyllic	Percussive	Sophisticated	Worried
Determined	Imminent	Perilous	Sorrowful	Yearning

B-movie	Gangster	Sports
Caper	Holidays	Surrealistic
Children/family/kids	Horror	Swashbuckler
Classics	Law/crime/courtroom	Teen
Comedy	Love/romance	Thriller
Coming of age	Monster	Tragedy
Detective/police/crime	Mystery/suspense/thrillers	War/combat/military
Documentary	Mythology	Western

2. BY MUSICAL STYLES

A comprehensive listing of styles could take an entire chapter, and many of the descriptors would be unfamiliar. It is important to broaden one's listening to include a wide range of musical styles. For a timeless production, the use of trendy music should be avoided. Figure 4.5 provides an example of APM's search engine for musical styles.

3. BY CINEMATIC GENRE

Genres are useful in generalizing narrative content and dramatic approach. Referencing other animations within the same genre is a valuable means of conceptualizing potential sound design treatment. In many cases, genres are mixed, such as action/adventure or comedy/romance.

Action	Disaster	Parody/spoof
Adventure	Drama	Psychological
Animated musical	Epic	Satire
Animation	Fantasy	Sci-fi
Anime	Farce	Slasher
Biographical	Film noir	Social drama

4. BY MUSICAL INSTRUMENTATION

Instrumentation is a strong cultural or ethnic signifier. Instruments are categorized in a variety of ways. Some instruments produce sound acoustically, while others produce sound synthetically. Acoustic instruments are further categorized as woodwind, brass, percussion (hammered), stringed, and plectrum (plucked). Additional distinctions can be made for instruments of definite pitch and indefinite pitch.

Alpine horn (Switzerland)	Didgeridoo (Australian)	Koto (Japanese)
Bagpipe (Scotland)	Dobro (Southern/Blues)	Lute (Medieval/Renaissance)
Bajan (Russian)	Conga (Cuban)	Mandolin (Appalachian)
Bamboo flute (Asian)	Dulcimer (Appalachian)	Pan pipe (Peruvian)
Barrel organ (circus)	Djembe (Zimbabwe)	Penny whistle (Africa)
Bell tree (dream)	Fife) (colonial military	Rain stick (Africa)
Bottle neck guitar (rural south)	Hawaiian steel guitar (Polynesian)	Recorder (Medieval/Renaissance)

FIGURE 4.5. APM search engine.

Castanet (Spanish)	Hichiriki (Japan)	Sitar (India)
Celeste (Christmas)	Hunter horns (European Aristocracy)	Tabla (India)
Celtic harp (Celtic)	Jews Harp (Southern)	Theremin (synthetic/sci-fi)
Cimbalon (Hungarian/Gypsy)	Jug Band (rural South)	Uilleann pipes (Ireland)
Conch shell (Polynesian)	Kalimba (Africa)	Wood blocks (Asia)

S. The Music Editor

The *music editor* is responsible for editing and synchronizing the score to image and is often responsible for building the temp track. The music editor produces the cue sheet for the project from detailed notes taken at the spotting session and serves as the main liaison between the director and the composer. If original music is recorded, the music editor assists the composer with the *scoring session* (recording). When the scoring session is completed, the music editor cuts the music to image.

T. Sound-Editing Terminology

Music editors abbreviate their spotting notes using the following abbreviations:

Term	Definition
BG	Backgrounds
Dead cue	Specific location on a film that will be accented with music (often referred to as a *sync point*)
Dubbing	Final mix of the film utilizing all stems
ET	End title (the final music cue in a picture)/end title credits
FB	Flashback (any film device used to denote a passage backward in time)
FG	Foreground
FI	Fade in
FO	Fade out
HIT	Time code location to receive extra musical emphasis
Intercut	Process of editing music to remove mistakes, make corrections in timing, or improve performance; differs from picture edit intercut
MOS	Without sound
MT	Main title
OC	Off camera
Overlap	The process of laying two music cues together
Pick-ups	Short sections of recording that can be intercut to account for late editing decisions; cutting the ending of an extended production cue and moving it closer to the beginning
Prelap	When music starts just prior to the scene
Prescore	Any track that is recorded before filming
Punches	Bursts of light that have been punched into film for the purpose of keeping the conductor oriented to the music
Sneak start	Start of any music cue that is brought in under a sound effect (masked *sync point*); if no sound effect is available, the orchestra will probably fade in
Spotting	Process of deciding where music is to start and stop
Streamer	Line scribed on the film that visually guides the composer to a dead cue
Sync point	Place in the action that a composer wants to accent; also called a hit
Wild	Recording music without a click, streamers, or punches

U. Music Editing

The *fade tool* (Figure 4.6) is a staple in the music editor's reper-
toire. Fade tools are used to smooth amplitude differences and
eliminate pops that occur at the *edit seam*. Cross-fades are cus-
tomized to smooth out differences in volume levels, tempo, or
instrumentation.

Often, when working with production music libraries, it is nec-
essary to cut music in progress. If not treated properly, the cut will
call attention to itself. When cutting music at loud points, it is use-
ful to introduce reverb just prior to the cut. The resulting *reverb tail*
creates an artificial sustain with a natural decay that smoothes the
cut (Figure 4.7).

Pitch shifting adds variation to a cue. Loops can be pitch shifted
to synthesize harmonic motion. If the formant can be fixed as the
pitch moves, the resulting sound will be more natural.

FIGURE 4.6 Creating fades.

FIGURE 4.7 Artificial reverb tails.

Time expansion or compression applications allow the user to change the speed of a cue globally. This is a useful application for making music conform to a specific length. WaveMechanic's Speed™ and Serato's Pitch N' Time plug-ins allow users to create key-frame automation within the plug-in (Figure 4.8). They can be used by the music editor to create acceleration and deceleration effects with preexisting music. These plug-ins are also useful for making slight adjustments in timings to conform the cue to a picture re-edit.

Music intercut involves the removal of portions of an existing cue to tailor the length and hits of the resultant cue to a particular visual (Figure 4.9). This technique is required for both production music and the repurposing of an original score. If transparency is the goal, it is preferable to maintain the natural beginning and end of a musical selection, cutting in the middle to achieve the desired length. Several musical factors must be considered when performing an intercut, including lyrics, form, and key signature. Cuts involving key changes are much more difficult to smooth. It may be necessary to pitch shift an edit to match the original key or to create a smoother key relationship. Changes in tempo, orchestration, and signal processing call attention to the edit as well.

Backtiming is the process of syncing a specific musical event (in progress) to a visual sync point and allowing the cue to play up to that point (Figure 4.10).

FIGURE 4.8. WaveMechanic's Speed™.

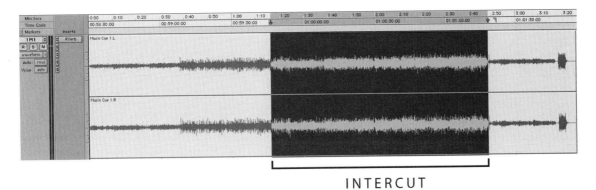

FIGURE 4.9. Music intercut.

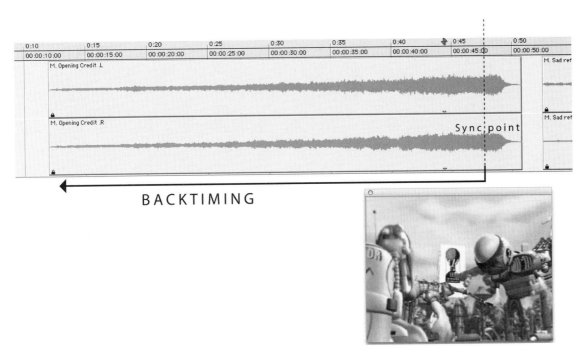

FIGURE 4.10. Backtiming a music cue.

Sound Effects 5 (SFX)

A. Overview

Sound effects (SFX) are subdivided into a variety of *elements* (*units*), including hard effects, soft effects, Foley, and ambience. *Hard effects* are narrative sounds that are synced to on-screen objects or actions. They can be further broken down into editorial and designed effects. *Editorial effects* are literal sounds added to on-screen events such as doors opening or drive-bys, and *design effects* are created to cover objects or events requiring nonliteral sound treatment. *Foley* is recorded to the on-screen image or with a specific on-screen image in mind, adding performance value to sound props or footsteps. Ambience (background) is nonsynchronous sound used to define the environment in which the animation takes place; an example of ambience would be the sounds of the city coming through the window of a hotel room. *Room tone* is the subtlest element of ambience and includes such elements as air handlers, fluorescent lights, and appliance motors. Many effects are *built-up* or *sweetened* with additional sounds to enhance their narrative value.

B. Functions of SFX

Sound effects are an effective means of establishing narrative elements such as time period, location, and character development. For example, seagulls imply the ocean, traffic implies an urban setting, and machinery implies factories. World War II air-raid sirens and steam-powered trains are historical icons that establish the action in a specific time period. Characters are often developed through associated props, such as a typewriter (journalist) or a whistle blast (traffic cop). The abstract nature of animation often calls for a *metaphoric sound* treatment. For example, in *A Bug's Life*, the scratchy sound of a violin being bowed covers the action while also describing the physical and emotional state of the street bum scratching his leg. Many sounds elicit emotional responses from an audience due to the associative nature of the sound. Examples of this concept include the rattle of a snake, the roar of a lion, thunder, and the cries of infants. These sounds are often added to an existing effect to guide or heighten emotional response. Sounds are also brought to the foreground to reveal the underlying (subtext) meaning of a scene. For example, the pairing of a gavel with a cash register leads us to conclude that justice is for sale. The sound of a

ceiling fan can morph into the sound of a helicopter blade, transitioning the audience from a bedroom scene to a flight deck. Sound effects are often used for comic effect and to soften the perception of violent or suggestive visuals. They are also an effective means of depicting off-screen events and objects, implying rather than showing the audience relevant story points. These off-screen depictions have the potential to enhance or complete the narrative.

C. Conceptualizing SFX

In narrative animation, we are presented with a multitude of visuals that are known to produce sound. Even inanimate objects are called upon to vocalize in the animated world. One purpose for spotting a film is to decide which objects will be *covered* with sound. The following are a few design considerations:

- Is the sound object made from organic or synthetic material?

- How does the sound object move or interact in the environment?

- Is the sound object narrative (story point or character development) or ambient?

- Are any models available on which to base the design?

- Is the sound object intended to support realism or subjectivity?

When developing sound effects, it is important to analyze the object or event to identify sound components that can contribute to an associated effect. Most library effects require additional editing, layering, and signal processing to work in context. The sound envelope (Chapter 1) can be a useful tool for conceptualizing a layered or built-up effect. For off-screen sounds, it is helpful to think in narrative terms, creating a sound design that evokes strong visuals consistent with on-screen action.

D. The History of SFX

I have always preferred radio to television; the images are better. —Roger Payne

The use of sound effects for dramatic purposes can be traced as far back as ancient Greek theater. Radio theater effectively exploited SFX as a means of storytelling. In the early years of sound animation, effects were often recorded in a *Foley stage* using *sound props* similar to those used in radio theater. The picture editor often handled SFX for early animation, as picture editors were frequently the only members of the production crew with the skills needed to record, edit, and synchronize SFX to film. Treg Brown is one of the few individuals credited for sound design in the early years. His collaborative efforts with composer Carl Stalling resulted in a seamless blending of SFX and music. Many of our modern sound designers recognize the value of working in tandem with the composer, but, unfortunately, they are rarely given such opportunities. In the early years of animation, voice talents also played an important role in the development of SFX. Their *vocalizations* blurred the line between dialog and effects, proving that many of the best sounds can be found right under our noses. No artist better epitomizes vocal effects than Wes Harrison. His work can be heard on a multitude of animations by both Disney and MGM Studios. When Hanna and Barbera left MGM, they brought a large portion of the SFX library used for *Tom and Jerry* with them. With the help of Pat Foley and Greg Watson, Hanna and Barbera developed one of the most iconic SFX libraries in the history of animation. Contemporary sound designers such as Gary Rydstrom (Pixar) and Dane Davis (Dane Tracks) continue the strong tradition established by Treg Brown.

E. SFX Spotting Session

The *spotting session* is the most definitive point in the production path for defining elements for the SFX stem. SFX spotting sessions can occurs at various times throughout the production. During the spotting session, the director and supervising sound editor view the project to determine the types of sounds needed, editing considerations, and placement within the timeline. Careful notes are taken at the spotting session (Figure 5.1) to generate a SFX *cue sheet*. The cue sheet guides future sound effects development, editing, and synchronization efforts and promotes continuity throughout the sound track. Cue sheets are also used at the final mix as time code references for the approximate placement of individual effects.

F. Sources of SFX

Production companies develop vast SFX libraries by purchasing commercial libraries and by employing sound editors to record and create private libraries. SFX are recorded in both the studio and in the field. In addition to recorded effects, sound designers also create original sounds through a process known as *synthesis*. Never before has it been so easy and cost effective to develop a substantial effects library.

SFX Spotting Log Date. _____ Page No. _____

Project Title: _____ SFX Editor: _____

SFX #		Notes:
Name:		
Start Time:	: : :	
Length	: : :	

SFX #		Notes:
Name:		
Start Time:	: : :	
Length	: : :	

SFX #		Notes:
Name:		
Start Time:	: : :	
Length	: : :	

SFX #		Notes:
Name:		
Start Time:	: : :	
Length	: : :	

SFX #		Notes:
Name:		
Start Time:	: : :	
Length	: : :	

SFX #		Notes:
Name:		
Start Time:	: : :	
Length	: : :	

FIGURE 5.1. SFX spotting log.

G. Commercial SFX Libraries

Commercial SFX libraries are a practical reality in postproduction audio (Figure 5.2).

Commercial libraries are expedient and cost effective, as they contain hard-to-obtain sounds such as military equipment, dangerous animals, and historical artifacts. Most professional libraries are organized by specific SFX types, such as nature, explosions, or sports. In addition, the various SFX search engines support most of the major commercial SFX libraries. Numerous delivery formats are in use for commercial sound effects, including *CDs, preloaded hard drives,* and *on-line delivery* (Figure 5.3). The Hollywood Edge and Sound Ideas are two of the most popular and readily available SFX libraries on the market. Both libraries can be purchased on CDs. Each disc can be purchased for an average cost of $100 per disc. Individual SFX can be purchased online at www.sounddogs.com and www.audiolicense.net.

FIGURE 5.2. Commercial SFX libraries.

Ultimate Sound Archive offers an online subscription to their sound effects and music for $16 a month, giving the designer unlimited access to their library for the entire month. This site contains a substantial collection of useful SFX that are broken up into 30 categories. All of the major commercial libraries are licensed as *buyouts,* which means the SFX can be used on any media project at no additional cost. A word of caution about free SFX downloaded from the Internet: many of these effects are reduced in quality to facilitate Internet storage and transfer. The true quality of these files is often not revealed until they are played back on high-quality monitoring systems like those found in theaters. The use of commercial effects or sounds from private libraries is recommended for best results.

H. Foley (Performance) Effects

You are presented with a sound recording of a character walking a staircase. The gradual slowing of each step combined with the increased volume indicates that the character is tiring from the upward climb. The sound quality and volume of each step provide subtle clues to the relative size, age, and gender of the character and the material from which the stairs are constructed. Further listening reveals details such as clothing material, jewelry, and props. All of this information combines in our minds to paint a detailed image of the scene. Jack Foley took the art of radio SFX performance and applied it to animation to develop sound effects that meet the needs of synchronization and character development. Foley techniques are used to handle complex linear elements such as walk cycles, fight sequences, and prop handling. In addition, subtle elements such as clothing rustles, breathing, hand pats, and kissing are also prime candidates for Foley. Foley artists are sometimes called *Foley walkers* because they are often asked to cover walk cycles.

FIGURE 5.3. Online SFX delivery.

Foley is typically recorded in studios fitted with specialized recording spaces called *Foley pits*. Each pit is filled with materials consistent with the surfaces appearing on-screen. Foley walkers, like live musicians, breathe life into SFX in a way that is not possible with cut effects. Foley is also recorded in the field for added realism and variation, allowing the Foley artist to move rather than walk in place. Sound designers also use MIDI and sampling technologies to perform complex layered SFX to image. With this process, the sound designer is able to perform complex SFX with organic feel, pitch variation, and an acceptable level of synchro-nization. Gary Rydstrom used this approach to create the composite effects for the T-Rex in *Jurassic Park*.

I. Ambience (Backgrounds)

Perhaps the least obvious or understood component of the SFX stem is *ambience*. Ambience provides the sonic backdrop for dia-

log, hard effects, and music similar to the way computer graphics are used to replace a green screen. Ambience can be used to establish realism or promote fantasy. It can also be used to smooth visual edits (sonic glue), it contributes to continuity, and it defines physical boundaries. Ambience can also be used to set the tone for a scene. Ambience is typically built-up from a variety of non-synchronous elements. It is typically panned in the stereo (LR) or surrounds and is mixed at levels that prevent it from competing with critical narrative elements. Ambience can be used to advertise a change in perspective. For example, in *Jurassic Park*, the ambience (primarily rain) in the T-Rex scene varied from shot to shot. When used creatively, ambience can enhance character development as well. For example, in Pixar's *Toy Story*, the ambience heard behind Andy's playful interactions consists of crickets, birds chirping, and lawnmowers. In contrast, the ambience for Sid's sadistic interactions consists of mosquitoes, barking dogs, and emergency vehicles.

J. Searching and Auditioning SFX Libraries

The SFX cue sheet is to sound designers what the shot list is to animators, providing a comprehensive list of the sounds needed for each object or action within a scene. Specific vocabulary is critical when searching a SFX library. The Hollywood Edge and Sound Ideas both ship their libraries with printed catalogs to facilitate searches; however, software-based search engines are faster and more comprehensive. Commercial SFX management tools such as Soundminer facilitate the cataloging, searching, previewing, and transferring (spotting) of SFX (Figure 5.4 and Tables 5.1 and 5.2).

TABLE 5.1
Commercial SFX Management Software

SFX Management Software	Developer	Platform	Preview	Contact Information
mTools	Gallery	Mac	Yes	www.gallery.co.uk
NetMix	Creative Network Design	Mac/PC	Yes	www.net-mix.com
Soundminer	Soundminer	Mac	Yes	www.soundminder.com
DigiBase	Digidesign	Mac/PC	Yes	www.digidesign.com

TABLE 5.2
On-Line Search Engines

Search Engine	Preview Option	Download Option	Contact Information
The Hollywood Edge	No	Very limited	www.hollywoodedge.com
Sound Ideas	No	Very limited	www.sound-ideas.com
SoundDogs	Yes	Yes	www.sounddogs.com
Sonomic	Yes	Yes	www.sonomic.com
Gefen	Yes	Yes	www.gefen.com/kvm/sfx
Ultimate Sound	Yes	Yes	www.ultimatesoundarchive.com
AudioLicense	Yes	Yes	www.audiolicense.net

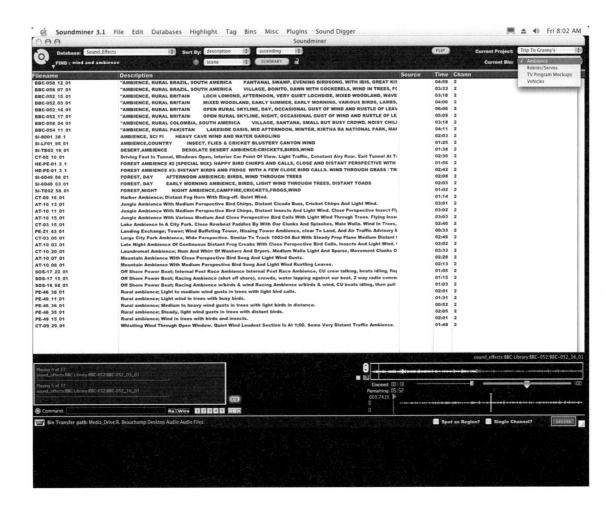

FIGURE 5.4. SFX management software.

Many sound effects are searchable with Boolean search methods. To narrow a search and to make the search results dependent on the presence of multiple keywords, use AND in conjunction with keywords (*e.g.*, GLASS AND BREAKING). To expand a search utilizing independent keywords, use OR in conjunction with keywords (*e.g.*, GLASS OR BREAKING). To narrow a search and exclude specific keywords, use NOT in conjunction with keywords (*e.g.*, NOT BREAKING). Parentheses allow users to combine AND, OR, and NOT in the search; for example, GLASS AND (PLATE NOT EYE) will produce a more refined result. Placing quotations on a group of terms focuses the search to specific phrases that contain all keywords in sequence; for example, GLASS AND BREAKING can yield a multitude of off-target results, but "GLASS BREAKING" greatly limits the search. You can combine keyword searching with phrase searching as well (*e.g.*, LAUGHTER AND "LARGE AUDIENCE").

Animals/nature	Weight	Power up/ power down
Sports	Perspective	Hollow/dense
Speeches/events	Ethnicity	Accelerate/decelerate
War	Gender	Ascend/descend
Impacts	Motion	Forward/reverse
Gadgets	Age	Loud/soft
Machines	Strength	Fast/slow
Vehicles	Speed	Close/distant
Musical effects	Make and model	Manual/automatic
Crowds/Walla/reactions	Duration	Long/short
Cartoon/comedy		Single/multiple
Ambience/backgrounds		Random/repetitive
Sci-fi		Modern/historical
Tools		Wet (reverberant)/dry
Vocal effects		

K.　The Vocabulary of SFX

Many of the keywords used in a SFX search are infrequently used in conversational language. Researching an object or action will often help to expand the vocabulary needed to enhance a search. The following is a limited set of terms to assist in refining a search.

Categories	Specifics	Antonyms (Opposites)
Busted effects	Size	Inflating/deflating
Explosions	Materials	Acoustic/electronic
Whooshes	Action	Interior/exterior
Foley	Location/geography	Organic/synthetic
Guns/weapons/action	Mechanical	Open/closed

L.　Creating a Production SFX Library

Sound designers often develop customized SFX libraries for use on specific projects. These libraries are developed by recording original sounds as well as pulling from preexisting effects libraries. Software databases have been developed to assist in the management and use of these expansive libraries. These applications allow the user to search, preview, *tag* (select), and import sounds directly into the audio session at a specified sync point. Multiple effects can be tagged and imported as well (*batch send*). *Pull lists* are printed to document the location of each sound in the event that files are lost or damaged.

M. Developing an Original SFX Library

Commercial libraries are convenient, but they also have their drawbacks. Many commercial effects are derived from audio sources such as archival film stock, aged magnetic tape, and early (low-resolution) digital formats, but the main drawback to commercial effects libraries is that they are available to everyone, and using them can leave a project feeling generic. In addition, some library effects (such as those of Hanna–Barbera) are icons for existing projects, so users run the risk of attaching unwanted associations to new projects. For these reasons, many SFX Editors choose to record original sound effects uniquely suited to the project at hand. Sound effects can be recorded in a studio under controlled conditions or out in the field. A recordist armed with a digital recorder, microphones, and headphones can obtain limitless recordings in the field. Many great sound effects are obtained by accident, but not without effort. Field recording is time consuming, but over the years a designer can develop a unique library that defines and promotes their career. Field recording allows the recordist to capture sound in its narrative environment as experienced by a character on-screen. Walter Murch (*American Graffiti*) coined the term *worldizing* to describe this sound design technique. Programs such as Soundminer help recordists archive their original sounds by imbedding metadata into their files (Figure 5.5).

FIGURE 5.5. Metadata.

N. Tools for Field Recording

1. FIELD RECORDERS

Field recording equipment has improved in quality and has become relatively affordable. The *Nagra* (Figure 5.6) set the standard for analog field recording.

With the advent of digital audio, the stereo *DAT* (*digital audio tape*) recorder came into use (Figure 5.7).

The latest developments in field recording are the *disc-based recorders* that utilize ATA cards (Figure 5.8) and DVD-RAM for storage. These recorders take advantage of high bit-depths and sampling rates. Multichannel recorders are ideal for mid-side and surround sound recording techniques. They can also be used in conjunction with six different microphones placed at various points to capture an object or event from a multiple-microphone perspective.

2. FIELD MICROPHONES

Microphones are to a recordist what lenses are to a photographer. Microphone selection and placement represent the beginning of many creative decisions required to effectively capture SFX. A wide assortment of microphone designs is needed to capture the multitude of sounds in the field. Specific microphones have been developed for certain recording tasks.

Shotgun microphones (Figure 5.9) are designed to reject sound from the sides and the back to achieve maximum forward directionality.

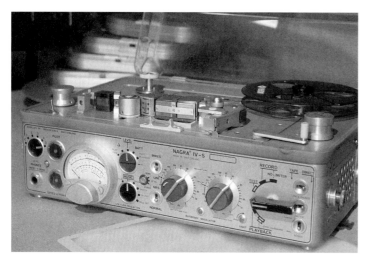

FIGURE 5.6. The Nagra recorder.

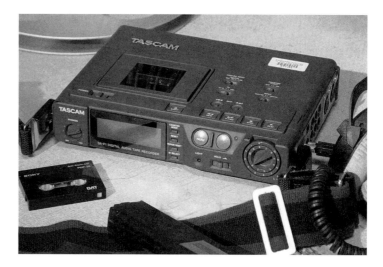

FIGURE 5.7. DAT recorder.

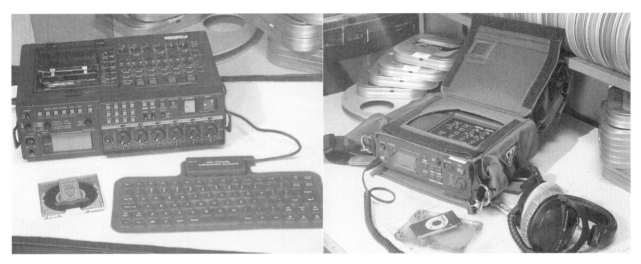

FIGURE 5.8. Disc-based recording.

FIGURE 5.9. Shotgun microphones and wind screens.

The adaptive array microphone (Figure 5.10) is designed to achieve even greater directionality than a shotgun microphone; adaptive arrays are often used for capturing discrete sounds from great distances.

Stereo microphones contain two transducers housed in a single unit for convenience. The *middle/side* (mid-side) (Figure 5.11) microphone is a specialized stereo microphone that allows the user to adjust the stereo width while in the field.

The *hydrophone* (Figure 5.12) is useful for capturing aquatic sounds and liquid effects.

The *dynamic microphone* (Figure 5.13) is of particular use when recording sounds omitting high levels of sound pressure.

Condenser microphones are particularly useful for capturing signals with high-frequency components. Some, like the one shown in Figure 5.14, are able to capture frequencies above 96 kHz.

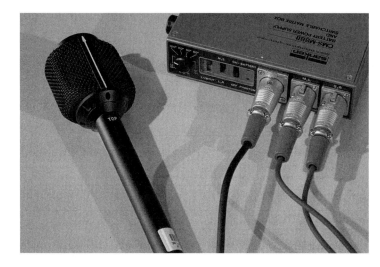

FIGURE 5.11. Middle/side stereo microphone.

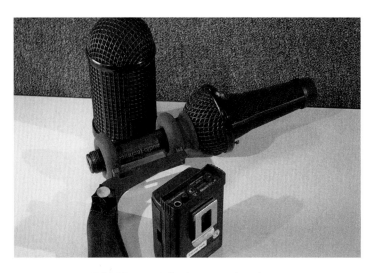

FIGURE 5.10. Adaptive array microphone.

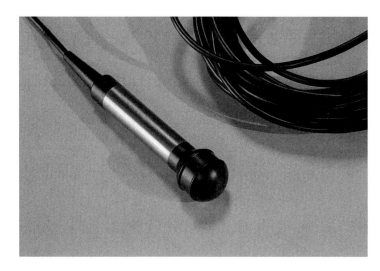

FIGURE 5.12. Hydrophone.

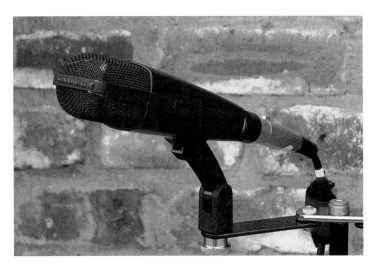

FIGURE 5.13. Dynamic microphone.

3. Field Accessories

Recording in the field presents many challenges to the sound designer. The world is filled with extraneous sounds that can bleed into the field microphone and compete with desired sounds. The balance between the desired sounds (signal) and the unwanted sounds (noise) is referred to as *signal-to-noise ratio* (*S/N ratio*). Selecting remote locations or recording during off-peak hours such as early morning or late evening can alleviate many of these problems. Sound recordists are often challenged by weather, physical barriers, or dangerous situations. The following accessories assist the recordist in overcoming many of these problems:

- A *windsock* (Figure 5.15) improves the quality of the signal by slowing down air movement near the capsule, reducing distortion causes by wind.

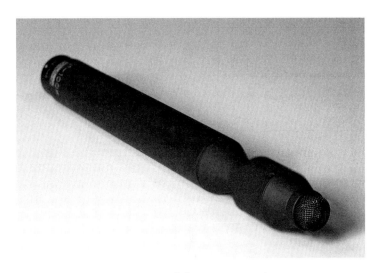

FIGURE 5.14. High-frequency microphone.

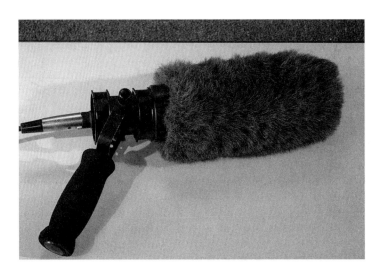

FIGURE 5.15. Windsock.

- Both the *pistol grip* and the *shock mount* are used to isolate the microphone from unwanted vibrations caused by movement or handling (Figure 5.16).
- There are many uses for a boom pole outside of its traditional role in live-action production audio (Figure 5.17). Boom poles are thin and lightweight and can be varied in length to extend the recordist's reach. They allow the recordist to follow the movements of a sound object without changing perspective.

O. Suggestions for Recording in the Field

- Some microphones have built-in high-pass filters to minimize wind distortion and low-frequency rumbles. Microphones with omnidirectional patterns are less susceptible to these types of distortion.

- When recording a familiar sound, consider the context and proximity by which most audiences experience the sound and use that information as a basis for initial microphone placement. For example, we generally do not have our ears next to the waterline of a toilet bowl during a flush. The placement of the microphone too close to an object produces an area-specific frequency response that makes the resulting sound indistinguishable.

- Environmental noise can be reduced by scheduling recording sessions for off-peak times such as late evening, early morning, weekends, and holidays. Close mike placement will also help to reduce environmental noise. The goal of any recording session is to capture audio with the best S/N ratio. It is up to the sound recordist to determine what constitutes signal and what constitutes noise.

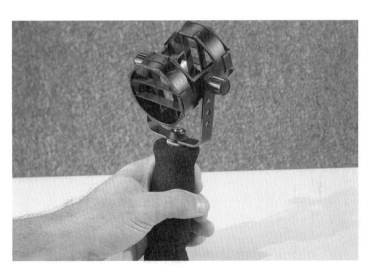

Figure 5.16. Pistol Grip and Shock Mount

FIGURE 5.17. Boom poles.

- Recordists should be familiar with the volume limitations (dynamic range) of their recording equipment and the volume potential of the signals being recorded. *Distortion* results when the presenting signal overloads the capacity of either the microphone or recorder. In digital audio, distortion is not a gradual process; therefore, when setting microphone levels, it is important to create additional headroom (conservative microphone preamplification) in anticipation for the occasional jumps in volume that often occur. The more predictable the signal, the more aggressive the microphone input levels can be set.

- Dynamic microphones are useful for capturing extremely loud sounds while rejecting high-frequency hiss. These transducers are most effective for close microphone positioning. Condenser microphones are effective at capturing sounds containing wide frequency and dynamic ranges (especially soft sounds) and are used to capture sources from greater distances. Directional microphone patterns, such as the cardioid pattern, are useful for isolating a sound, and the omnidirectional pattern is useful for capturing both the sound and the acoustic environment.

- Field recording sessions often generate hours of material that contain a relatively small percentage of desired sounds. To make the preview and transfer of these sounds more efficient, many field recorders provide a means of creating a cue or *memory location* on the fly. Whenever possible, a *vocal slate* should be recorded prior to recording each sound. The vocal slate is an important means of archiving the sound recordings.

- Recordists should always use headphones to monitor the incoming signals. Our ears have a greater frequency response and dynamic range than our recording equipment. Headphones are needed to reveal distortions, such as handling noise, wind noise, and microphone overloading, that are not indicated on the input meters. Headphones also bring to the foreground sounds to which our ears have become desensitized, such as breathing, cloth movements, and footsteps.

- Moisture has an adverse effect on the performance and life of microphones and recording equipment. Humidity and condensation can cause static pops in the signal. Reduced exposure is the best means of controlling the effects of moisture.

- Transients, such as a clapboard or hand clapping, will reveal many aspects of the recording environment. Listen for the quality changes and reflections that take place after a loud event has occurred prior to establishing the microphone distance to source.

- It is a good idea to scout the location before committing to a field recording session.

- For sounds that are not easily repeated, consider using a multiple-microphone approach that takes advantage of varied microphone types, polar patterns, placements, and trim levels.

- Depending on the amount of extraneous sound in the environment, consider moving farther away from the object before using a pad. The *inverse square law* states that as the distance from the microphone to the sound source is doubled, the dB SPL drops by 6 (Figure 5.18).

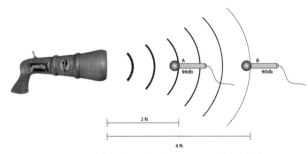

As the distance doubles, there will be approximately a 6dB drop in dB SPL.

FIGURE 5.18. Inverse square law.

Designing Sound for Animation

- Mic-to-source distance is an importance means of obtaining a good S/N ratio. As the microphone is moved farther from the source, the room tone and environmental noise become more apparent.

P. Location Request

Today our world places greater emphasis on security, liability, safety, and copyright. It is, therefore, recommended that you obtain formal permission when recording in the field (Figure 5.19).

Q. Studio Recording

Studio recording is appropriate when a controlled environment is needed and where space limitations are not prohibitive. Every sound presents different challenges to the recording engineer. Experimentation with microphones, placement, and recording levels is required for each sound. Close miking (within a few feet of the source) is the most common approach to studio recording. It is an effective means of controlling extraneous noise that is picked up (leakage) by the microphone. Most effects editors prefer sounds that are free of room tone and reflective sound, which makes it easier to blend these sounds into a perspective developed in postproduction. If the mike is too close, however, it will only capture *area-specific frequencies*, thus making the object more difficult to identify. To determine a good starting position for a single mike, place a finger over one ear (emulating one mike) and move around the sound source to find the area that best represents the sound. As a

Location Request Form

Date _____

Company Name _____

Contact Information _____

Dear Sirs,

We _____ request permission to enter and remain on your
 (Production Company)

property on _____ for the sole purpose of recording audio. While on
 (Date)

your property, we accept full liability for our persons and property and agree to comply with all stated safety procedures. We will not record any conversations without first notifying the participants. The audio obtained from these recordings may be used as sound effects on multimedia projects such as films, videos, and web pages. Unless requested, the source of audio will be kept confidential. Our production company will hold the copyright for all recordings obtained.

Sincerely,

Accepted and agreed to:

By _____ _____
 (Signature) (Print name)

 (Title)

 (Address)

 (Phone)

 (Email)

FIGURE 5.19. Location Request Form

general rule, a full-frequency representation of a sound object can be obtained with a microphone placed at a distance equal to the length of the sound object.

R. Stereo Recording Techniques

Ambient or background sounds are often recorded in stereo. True stereo occurs when microphones capture *inter-level differences* (ILDs) or *inter-time differences* (ITDs). The *coincident* (*x/y*) microphone array (Figure 5.20A) utilizes a matched pair of microphones (typically cardioid) oriented toward the sound source, with the capsules positioned 45° off-axis. The coincident array captures the stereo image through amplitude differences (ILD). This microphone array produces a stereo image that works best with head-phone monitoring; it is less successful for consumer and theatrical playback systems. In the *near-coincident* (*ORTF*) array (Figure 5.20B), a matched pair of microphones (typically cardioid) is oriented toward the sound source, with the capsules positioned 110° off-axis. The ORTF array captures the stereo image through amplitude (ILD) and time (ITD) differences. This array translates well to consumer and theatrical playbacks. The *spaced-omni* (Figure 5.20C) array utilizes a matched pair of omnidirectional microphones spaced several feet apart and pointing forward at the sound source. The spaced-omni array captures the stereo image through amplitude (ILD) and time (ITD) differences. The spaced-omni array is frequently used to record live concert music.

1. MIDDLE-SIDE (M/S) STEREO

Direct sound is captured by a cardioid capsule (middle) and combined with ambient sound captured by the bidirectional pattern

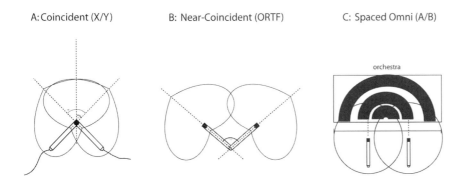

A: Coincident (X/Y) B: Near-Coincident (ORTF) C: Spaced Omni (A/B)

orchestra

FIGURE 5.20. Stereo recording techniques.

(sides). Mid-side (Figure 5.21) allows the sound designer to vary the width of the stereo field in postproduction. The output of the middle microphone determines the depth of the sound in the stereo field (Figure 5.22). As the output of the sides component is increased, the stereo image increases proportionately. When the sides component is set to no output, the resultant signal becomes mono. Mid-side can be used to dynamically open and close the stereo width in relation to camera movements.

Several *stereo mounts* have been developed to assist in stereo recording (Figure 5.23).

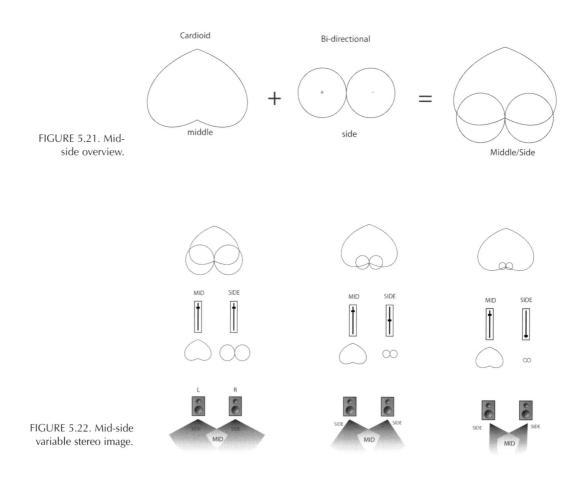

FIGURE 5.21. Mid-side overview.

FIGURE 5.22. Mid-side variable stereo image.

S. SFX Editing and Sweetening

Most effects, regardless of their origin, require some level of editing to customize lengths, to provide contrast, or to construct new effects. Editing involves the removal of extraneous sounds contained within a file or region. The sound designer uses a variety of tools to perform this task, including fades, manual edits, noise gates, filters, and trim tools. Fades are the fastest means of eliminating audible pops or ticks associated with edits that are not made at the zero crossing point. They are routinely applied to the boundaries of digital audio regions for this purpose. When the effect is stripped or cleaned of unwanted elements, it can be adjusted in length to meet the timing requirements established by the visuals. Sound designers have the ability to compress or expand the length of an audio file without altering the pitch. This can be accomplished by applying a variety of *time compression or expansion processes* to the region. In some cases it is necessary to extend the length of the region beyond the range in which time-compression tools remain transparent. In these situations, the sound editor extends the effect by looping material. Visuals that accelerate or decelerate require special treatment. Cutting individual elements to each event is time consuming but often necessary. Programs such as Speed™ or Pitch 'N Time™ can also be used to develop acceleration effects, especially where pitch is also involved. One of the most creative aspects of SFX editing is the construction of new effects through the layering (*sweetening*) of additional sounds. Most listeners cannot hear the individual layers of a built-up effect. Wade Wilson (sound designer for *A Shark's Tale*) refers to these built-up effects as "chords of sounds." When creating a built-up effect, it is important to deconstruct the sound object to identify all related sounds associated with the object or event; for example, a customized gun sound might be derived from any or all of the following key elements:

Ricochet	Bullet trail	Trigger	Projectile
Bullet drop	Cocking	Firing pin	Handling noise
Bullet buzz	Loading	Recoil	Safety release
Bullet zip			

Often a sound is needed for multiple occurrences, so both *variation* and continuity must be considered. This is especially true of Foley sounds such as punches or footsteps. Variation can be achieved through volume, pitch shifting, time shifting, rhythmic manipulation, and compositing. Sounds with similar characteristics, yet different meanings, can be *morphed* to serve as transitional devices. The following are just a few examples of this concept:

Woodpecker (country)	Jackhammer (urban)
Flock of geese (organized activity)	Traffic jam (breakdown)

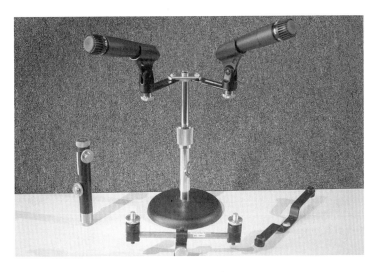

FIGURE 5.23. Stereo microphone mounts.

Alarm clock (internal)	Garbage truck backing up (external)
Telegraph (antique)	Fax machine (modern)
Typewriter (documentation)	Gunshot (flashback to event)

Many of the "stereo" sound effects pulled from commercial libraries are actually dual-mono tracks. In many cases, the sound editor will remove one of the tracks before placing the effect to image to optimize track usage.

T. SFX Signal Processing

With the exception of ambience, most effects are recorded in such a way as to limit extraneous sounds and unwanted perspective. Sounds recorded *free and clear* of noise and reverb are easily processed during the mix stage to work within the context of the full mix; however, many effects (especially design effects) also require *signal processing* for the purposes of correction, sound shaping, and spatial enhancement. *Noise reduction* is commonly applied to SFX recorded in uncontrolled environments. A variety of plug-ins exist for noise reduction, including the Waves C4 and Restoration bundle. Unlike editing, in which the audio is fully removed, noise reduction allows the designer to remove noise both around and within the desired sound while preserving most of the original signal. Sound shaping is a creative use of signal processing that involves deliberate manipulation of the signal to obtain a specific effect. *Pitch shifting* is a common means of providing variation. Most sounds can be shifted several semitones before the alteration becomes noticeable. In many cases drastic shifts are made to synthesize entirely new effects. *Reversing* creates variation and masks the original effect while often preserving a logical rhythmic element. Reversing is applied to effects such as

pressurized air to match the movement of the action, such as doors opening or vehicles taking off. *Reverb* is the most common tool used to establish spatial properties. The application of a common reverb setting placed in the master fader can contribute to a unified feel for all three stems within a scene. Reverb can also be used for contrast where an effect that is occurring in the present is dry and an effect occurring in the past is reverberant. Library effects containing reverb are difficult to match to perspective. This should be considered when recording SFX in the field. *Doppler* exaggerates perspective by altering the pitch, volume, and panning of a signal over time. Doppler is a powerful tool in establishing point of view, realism, and heightened energy through movement. Signal processing is covered in more depth in Chapter 7.

U. Synchronization

Sound effects must coexist with music and dialog and are therefore placed contextually rather than literally to the image. At times, it is appropriate to anticipate or delay the SFX in order to prevent the masking of dialog or music. The decision to delay an effect is often made to allow the audience additional time to process the visuals before processing the audio. *Hard syncing* (placed within one or two frames) has become an audio/visual convention regardless of the distance implied by the image. The spotting log provides timing approximations for each sound. When the *sync point* occurs within a region, it can be identified and tagged to provide a reference for placement other than the region boundaries (Figure 5.24).

Final placement for each sound is reserved for the final mix, where the music and dialog provide the context for panning deci-

sions. On-screen sounds, which are stationary, are panned to a static position (fixed) while those associated with moving objects are panned dynamically. Regardless of whether the effect is stationary or moving, on-screen (sync sounds) are panned to position. Off-screen sounds are panned to imply a position. This often involves the use of surround channels when available. SFX are often established off-screen before appearing on-screen. In complex visuals, all but the key visuals are left nonsynchronous.

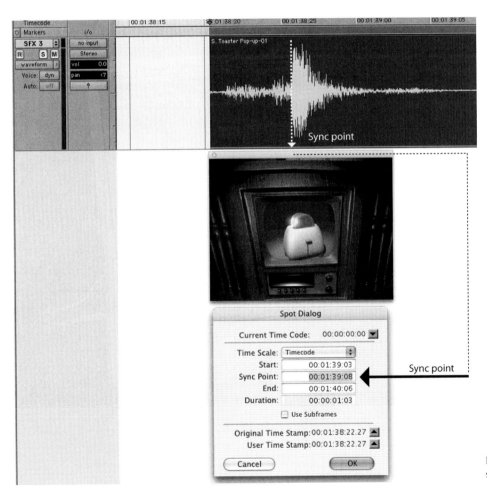

FIGURE 5.24. Spotting to sync point.

Arts Law

Where animation is subjective arts law is objective, requiring the artist to mentally switch gears when assuming the role of producer. In this digital age, it is increasingly difficult to protect intellectual property. To maximize protection and minimize liability, content developers must aggressively adhere to copyright law. Concepts such as licensing, fair use, parody, and public domain must be thoroughly understood when using pre-existing content such as music, recorded speeches, and sound effects in a sound track. This section seeks to clarify misconceptions that exist among professionals and educators regarding arts law and intellectual properties. While this section is not intended to be a substitution for an arts lawyer, it may help you avoid the need for a defense attorney.

A verbal contract isn't worth the paper it's written on. —Samuel Goldwyn

CHAPTER

Developing a Legal Sound Track

A. Overview

"The digital age has provided audiences with unprecedented access to digital media. The ease with which media can be downloaded or copied directly to disc has created many new legal challenges. In a recent radio campaign, Pizza Hut offered a free Disney DVD with the purchase of a large pizza. With audio/visual media being demoted to "Happy Meal" status, it is not surprising that the general population disregards copyright law; however, content developers cannot afford such a view. Animation studios employ music supervisors and arts lawyers to protect themselves and the products they make. It is easy for student and independent filmmakers to feel insulated from the legal issues associated with screening or releasing a project, but the consequences for copyright infringement are substantial regardless of the size or nature of the project. It is important, therefore, to become educated in legal matters pertaining to the contents created for a sound track.

B. Rights *Versus* License

A copyright implies ownership; a license defines limited permission and is granted by the copyright owner. Many aspects of a copyright can be licensed from the copyright holder. The U.S. Copyright Act specifies those rights that are exclusive and those that are nonexclusive.

C. U.S. Copyright Act of 1976

The U.S. Copyright Act of 1976 extends the life of the copyright after the death of the author. Works for hire are copy protected no longer than 100 years from their creation. Audio that is copy protected includes:

- The melodies and lyrics of music
- Sound effects

- Speeches and dialog
- Existing television and radio programs
- The sound track of a motion picture
- Other audio/visual materials

D. Exclusive Rights Granted to Copyright Holders

Several aspects of the copyright are exclusive, and permission to use the work must be obtained from the copyright holder. Copyright holders have the exclusive right to reproduce, publish, or sell the artistic work. In addition, they have the right to set the licensing fees and terms for any materials licensed as well as to deny any requests. The following is a list of exclusive rights granted to the copyright holder by law:

- The reproduction right allows the holder to make copies, transcribe, or imitate the copyprotected work.

- The derivative right allows the holder to modify an existing work to create a new work that is referred to as a *derivative* work. This includes any musical arrangements and music editing (changing the form) required to customize the audio synchronized to the animation.

- The distribution right allows the holder to sell, rent, or lease copies of protected work.

- The performance right allows the holder to exhibit the work in public. Sound tracks are not included in this right.

E. Nonexclusive Rights (Fair Use)

The authors of the Copyright Act of 1976 recognized that exceptions involving nonsecured permission were necessary to promote the very creativity that the Act was designed to protect. The Copyright Act set down guidelines for the use of copyprotected material without securing permission from the copyright holder. These guidelines for nonexclusive rights constitute *fair use*:

> "The fair use of a copyrighted work . . . for purposes such as criticism, comment, teaching . . . scholarship, or research, is not an infringement of copyright."

In determining whether a specific use applies, consider the following:

- The purpose and character of the use, including whether such use is of a commercial nature or is for nonprofit educational purposes.

- The nature of the copyrighted work; ideas and facts are not copy protected but creativity is.

- The amount and importance of the portion used in relation to the copyrighted work as a whole.

- The effect of the use on the potential market for, or value of, the copyrighted work.

If an animation complies with these four principles, there is strong support for claiming fair use. Most independent animation uses music and SFX for dramatic or entertainment value. This type of use does not fall under fair use. When claiming fair use, it is still advisable to:

- Limit the distribution and exhibition of the work.
- Credit the authors.
- Display the author's copyright notice within your work.

F. Parody

Parody is an art form that can only exist by using work that is already familiar to the target audience; therefore, provisions had to be made in the Copyright Act for parody or this form of expression would cease to exist. Parody involves the imitation of a recognizable copy-protected work to create a commentary on that work. The commentary does not have to serve academic purposes; it can be for entertainment value. However, both the presentation and the content must be altered or it is not considered a parody. For example, just changing a few words while retaining the same basic meaning does not constitute parody. Parody must be done in a context that does not devalue the original copyprotected work; therefore, parody is most justifiable when the target audience is vastly different than the original. A parody constitutes a new and copyrightable work based on a previously copyrighted work. Because parody involves criticism, copyright owners rarely grant permission to parody. If you ask permission and are denied, you run the additional risk of litigation if you use it anyway. In the United States, fair use can be used successfully to defend parody as long as the primary motive for the parody is artistic expression rather than commercialism.

G. Public Domain

Works enter the public domain in the following ways:

- The term of the copyright expires.
- The copyright owner failed to "renew" the copyright under the old Copyright Act of 1909.
- The work was created in the United States prior to January 1, 1923.

Use of the copyright notice (©) became optional on March 1, 1989. It is up to the production company to ensure that the copyright notice used to establish public domain is updated and valid. One way to establish public domain is to search the selection at www.copyright.gov. Once material is in the public domain, exclusive rights to the work cannot be secured. It is important to differentiate public domain from *master rights*, which exist to protect the owner of a specific recording regardless of the material or format on which the recording is stored. Although the music contained on a recording may be in the public domain, the actual recording is copy protected.

H. Locating the Copyright Holder

1. U.S. COPYRIGHT OFFICE

If the work is registered with the U.S. Copyright Office, you can search for the current holder of the copyright. A search can be made online by going to www.copyright.gov/records/cohm.html, where you can search by the author or title of books, music, or other registered works.

2. PERFORMING RIGHTS ORGANIZATIONS

Three performing rights organizations provide information regarding songs, composers, and their respective publishers: American Society of Composers, Authors, and Publishers (ASCAP), Broadcast Music, Inc. (BMI), and Society of Stage Authors and Composers (SESAC). All three organizations have websites that facilitate artist and repertoire searches. Advance searches might include the artist, title, composer, or publisher. Most of the important information

can be obtained online; however, some listings are more complicated and may require direct assistance. A direct number for each of the performing rights organizations is provided below for more complicated inquiries:

http://www.bmi.com/search/	212-830-8362
http://www.ascap.com/ace/search	212-621-6160
http://sesac.com/repertory	212-586-3450

The following is a list of performing rights organizations that can help with a publisher search:

- *Always read the terms and conditions.* The phrases "Not available for commercial use," "For personal use only," or "For private use only" are frequently placed on promotional and consumer releases, allowing for private use with limited audiences. "May be used but must be credited" is a condition found on sample and SFX libraries and is intended to credit the creators and promote the product.

- *Identify the owner.* There is a difference between an author and a copyright holder. Many authors sell or transfer their copyright ownership. The copyright notice lists the initial copyright holder.

- *Identify your specific needs.* The three global parameters of usage to consider are (1) exclusivity/nonexclusivity, (2) term of usage, and (3) territory where work will be presented. Depending on the type of use, it will be necessary to request any or all of the following:

 - Synchronization license (right to sync a composition to an animation)
 - Master license (right to sync an existing sound recording to an animation)
 - Mechanical license (right to produce and sell copies of the sound track only)

 - Videogram license (right to produce and sell a DVD with both image and sound track)

- *Complete all paperwork in a timely manner,* so the project does not get held up due to clearance delays. If music is needed as a prescore, failure to obtain a license can hold up the entire project.

- *Negotiate a fee structure and payment schedule.* Music publishers are business agents for the songwriter or the company's collection. They survive on the revenue that their libraries produce. Fees are based on the global aspects defined earlier as well as popularity and length of the cut requested. Music supervisors and arts lawyers are often very skilled at negotiation.

- *Formalize the process through documentation.* Get everything in writing.

I. Synchronization License

A synchronization license grants the production company permission to synchronize and exhibit a musical composition on its project. A license to synchronize is granted at the discretion of the copyright owner, who is typically the composer or publisher. Permission may be denied for any reason. When seeking synchronization or master rights, it is extremely important to clearly define the limits of what you are asking. Because it is likely that you will pay for the rights, there is no use paying for more than you need, especially if you keep the door open for renegotiations. In addition, copyright holders are generally more willing to grant licenses to those whom they believe understand and respect the process. The following are basic guidelines when requesting a quote for synchronization or master rights. Remember, the goal is to facilitate the deal with minimal expense to the production. Some composers will give permission to synchronize for free if you promise to report to BMI/ASCAP.

- *Do your research.* Synchronization rights are usually held by the publisher. The publisher is often listed on the sleeve of the disc. In some cases, the performance right (BMI, ASCAP) notice is all that is provided. In either case, you can contact BMI or ASCAP to ask their research departments to locate contact information relating to the publisher. It is important to obtain the specific name and title of the person who administers the license. Some larger companies have a director of licensing who specifically handles requests. It is a good idea to complete a written quote request prior to calling so you will be prepared to answer all pertinent questions quickly and accurately.

- *Define the territory* (e.g., local, regional, national, worldwide, national television, national cable, Internet, film festival). Decide ahead of time what festivals you will be sending your work to and limit the territory to those festival sites. For example, if the animation will be submitted to festivals in the United States only, limit the territory to the United States. Remember, this point can be renegotiated at a later time to encompass a larger territory. If you plan to submit the project worldwide, you should state that. Overexposure of a piece of music can cause its value to go down.

- *Estimate the amount of time your animation will be on the festival circuit.* If you are a student, then your participation in student films typically is limited to 12 months after your graduation date. If you want to have the rights to use the piece forever, you should request "perpetuity for the term." Remember, the greater the request, the more you can expect to pay and the greater the chance your request will be rejected.

- *Clearly define the nature of use* (e.g., nonbroadcast, broadcast, student festival, for distribution or sale). This information should include the amount of the material to be used (expressed in exact time), where it will be placed in the animation, and the purpose for using it (e.g., narrative lyric quality, emotional amplification, or establishing a time period or location). Some copyright holders will charge less if the music is placed in the background. Make your request clear, so the copyright owner will have sufficient information with which to make a decision.

- *Include production information,* especially if there is positive name recognition. For example, a short film featuring Harvey Keitel may make the copyright holder want to be associated with the film. Of course, this could easily go both ways.

- *Clearly articulate the plot or themes of the animation.* Synchronization licenses are granted or denied on the basis of financial, artistic, and public image issues. Copyright law protects the holder from unwanted association by granting him or her this right to deny use of the piece. It is a good idea to send the copyright holder a copy of the film, assuming the piece is not needed as prescore, in which case writing a short synopsis of the film would be necessary.

- *When stating the budget for the project, clarify whether the published figure is for the production as a whole or for the music only.* The distribution of money varies greatly from project to project. A good starting figure might represent 10% of the total film budget.

- *Consider these requests as formal documents read by lawyers and other trained arts management personnel.* Use formal language, and proof the final draft for potential errors. Phrase all communication in such a way that places you in the best position to negotiate. Remember, the law demands precision.

J. Master License

A master license grants the animator the use of an existing sound recording to be synced to a film for exhibition only. Included in this request is the right to tailor the work to your animation. The procedure for requesting a master license quote is the same as that

Template for Synchronization, Master, or Videogram License Requests

Name of Music Supervisor _____
Street Address _____
City, State _____
Zip Code _____

Month/Day/Year

Synchronization Quote Request

To: [Director of Licensing (use formal name and title)]

From: [Name and Title (e.g., Music Supervisor)]

Re: [Project Title] by [Director's Name]

I would like to obtain a quote for synchronization license of [Writer's Name] composition [Song Title] for use on the above-titled animation. The details and parameters of the request are as follows:

Nature of use:

1. [Specify whether the project is for commercial or educational use.]

2. [Specify the length of the cue in minutes and seconds.]

3. [Specify whether the animation will be exhibited (e.g., student festivals, commercial advertising, broadcast, or Internet).]

4. [Specify the release format(s) and number of copies to be made.]

5. [Specify whether the request is for exclusive or nonexclusive rights.]

6. [Specify whether the cue will be used as source music, underscore, or for the credits.]

Production information:
[The music score is typically less than 10% of the entire budget. Some license administrators will ask you to state the budget for the project. List genre, notable cast members, and the projected release date.]

Term:
[The period of time for which the license applies, such as 1 year (as in the case of student films) or for the life of the copyright (as in the case of a commercial release).]

Territory:
[Clearly define where the animation will be exhibited such as locally, regionally, nationally, or internationally.]

Synopsis:
[Provide a brief summary of the story and discuss how the song contributes to the story.]

Contact information:
Phone _____
Fax _____
email _____

Sincerely,

[Name, Title]

*This format and the information contained within it is also sufficient for requests for master and videogram rights. Make sure your request is specific and accurate. Try to limit the document to a single page, using letterhead when possible. In most cases, a record company rather than a publisher, controls the master rights. Typically, you will be required to fax this information to the party charged with administrating these licenses.

for obtaining a synchronization license; however, there is no point in requesting a master license unless you have already secured a synchronization right. If you are granted a synchronization right but denied a master right, you can still sync the music to the animation, but you must have a different group record the song.

K. Mechanical License

A mechanical license grants permission to manufacture, distribute, and sell recordings of the music contained in the sound track. The mechanical right is compulsory with a maximum fee predetermined by law; however, lower fees are often negotiated. The current statutory royalty rate is 8.5¢ per CD for 5 minutes or less (add 1.65¢ per minute for every minute over 5). Harry Fox (www.harryfox.com) is a popular clearinghouse for mechanical licensing. Publishers are not required to affiliate with Harry Fox; therefore, it may be necessary to contact the publisher directly. Before contacting the publisher, it is advisable to log onto the Harry Fox website to obtain current statutory rates (http://www.harryfox.com/ratecurrent.html; 212-833-0100).

L. Videogram License

Mechanical rights are limited to sound recordings. A videogram license allows you to reproduce the music on DVD or VHS and sell it to consumers for their private use. If you used a preexisting sound recording requiring a master license, then it will be necessary to obtain a separate videogram license for the master as well. Unlike the mechanical license, the videogram license is not com-

pulsory; therefore, the copyright owner has the right of refusal and is free to negotiate fees. As with the mechanical license, the videogram license is dependent on your acquiring a synchronization and in some cases a master license as well. Animators need to be aware that some festivals ask for exclusive or nonexclusive rights to reproduce the work in video format for sale. Read the fine print on all festival applications. If you intend on submitting your work to festivals that will duplicate and sell copies of your work, make sure you articulate this potential use in all of your legal requests.

M. Potential Consequence of Copyright Infringement

I fought the law and the law won. —Sonny Curtis

The owner of the copyright can prevent the distribution and theatrical exhibition of your animation and obtain damages from you for infringement, even if the infringement was unintentional. Statutory awards up to $100,000 are possible for each violation. Criminal penalties can be a $250,000 fine and/or 10 years in jail.

N. Frequently Asked Questions

Who holds the copyright to music?

There is a difference between an author and a copyright holder. In most cases, the author maintains the moral right to be credited for the work; however, in many situations, the authors give up their copyright holder rights when they are contracted (work for hire) to produce the work. It is important to identify the copyright holder for permission and the author for crediting purposes.

Who grants each of these licenses?

This answer has two parts. To use copyprotected music in an animation you must first secure a synchronization license. Either the author or the publisher grants the synchronization license, depending on who holds the copyright. The copyright holder's contact information can usually be obtained by inquiring at www.bmi.com, www.ascap.com, or www.sesac.com. If a synchronization license is granted, you can then pursue a master use license, if so desired. The record company typically grants master licenses.

Do I need permission to use copyright-protected material if I am not charging money for exhibition or distribution?

The copyright law is designed to protect the holder from any unwanted associations that might occur when his or her material is synchronized to image; therefore, obtaining a synchronization license is always required. In some circumstances you can use the work without permission; these exceptions are outlined in the section regarding fair use. Perhaps the most important test for fair use is whether the use will affect potential income. We do not have the right to share or distribute another artist's work for free.

Is it okay to use copyright-protected music without permission for class projects?

Only if it meets the fair use tests discussed earlier in this chapter.

Is it okay to use copyright-protected music without permission if I only use a small portion of it?

If fair use has been established, then small portions of a given work may be used. A general guideline for music is 10% of the work but not exceeding 30 seconds of any individual selection; however, if what is used is qualitatively substantial, even less material may be used. If you are copying material, it is better to get permission or a license. You cannot escape liability for infringement by showing how much of the protected work you did not take.

Is it legal to put copyright-protected work on a demo reel?

Students may incorporate portions of lawfully acquired copyrighted works (you own an original copy) when producing their own educational multimedia projects for a specific course. If the original use of the material complies with fair use, it can be used in a demo reel to demonstrate academic achievement. Fair use does not cover using music solely for entertainment value.

Will festivals allow animations containing noncleared copyprotected music?

Festivals will not knowingly allow animations containing non-cleared copyprotected work. It should be noted that most festivals charge admission fees to attend screenings. These admission fees exceed the parameters for fair use. In addition, some animation festivals distribute and sell copies of their featured works. Works submitted to festivals that produce and distribute copies are subject to videogram licensing. Publishers frequently grant "festival-use only" sync licenses at a minimal license fee. A "festival-use only" license can be written with a built-in option for expanded use, such as theatrical and consumer release. The expanded-use option will often result in a "real" license fee rate.

Are sound effects copyright protected?

Sound effect recordings are copyright protected under U.S. copyright law. Commercial sound effects libraries are typically purchased with a buy-out license. A buy-out license allows the owner to use these SFX royalty-free on unlimited projects as long as they are affixed to animation.

If I alter copyprotected music or SFX, can I use them legally?

Altering copyright protected audio constitutes two violations of the copyright law (with regard to the right to reproduce or modify the work). All changes in the melody or lyrics require permission for derivation.

*If I make an arrangement of the music, can I
record and synchronize it to my film?*

There is no way to get around the synchronization right; however, once you obtain this right, you can make an arrangement of the work that customizes it to the image. Remember, the arrangement cannot alter the basic melody or lyrics. To do this, you must obtain the right to make a derivation from the copyright holder.

*Can I use copyprotected material if I
credit the author in my work?*

Crediting the composer is not a legal substitution for obtaining a synchronization right; it will only keep you from plagiarizing.

Can I use copyright-protected music for a temp score?

The use of copyprotected music for temp score is a fairly safe option as long the exhibition of the temp is limited to the classroom or production company and not the general public.

*Can I legally synchronize a preexisting recording
of public-domain music on my film?*

Public domain does not extend to the sound recording but rather to the music itself. The sound recording is copy protected even if the works contained in it are in the public domain. You will still need to obtain permission to use the recording from the party that holds the master rights. Fortunately, you do not have to ask permission to record a new version.

What can I use from the Internet?

Many people still believe that material obtained on the Internet is cleared for use. In reality, there are few enforced standards as to what can be put on the Internet. As a consequence, abundant copyright infringements can be found on the Internet. Those who use material obtained from the Internet are responsible for ensuring that the material is legal. It should also be noted that copyright notices are no longer required. In general, anything that is formally published is generally more compliant with the copyright laws than materials found on the Internet; therefore, use downloaded material with great caution.

Do I have to get it in writing?

Yes, our legal system does not take anyone at his or her word. Verbal permission is a casual approach to a very formal legal system. Always get it in writing.

*How long does it typically take to get
synchronization and master licenses?*

Many factors will influence the timeline for obtaining any of these licenses. Preparing a focused request is one of the few things you can do to minimize the processing time. When developing the quote requests, call the publisher to obtain directions for submission. Most publishers require requests to be fully completed and faxed to their licensing department. Wait anywhere from 10 days to several weeks before following up on the requests (always note the dates you need the license). Your request will be prioritized based on earning potential. Allow several months to complete the synchronization, master, and videogram requests.

Why was my request denied?

Rejection is a very real possibility for small projects with limited budgets. In some cases, the song may be under exclusive contract or the artist does not want to be associated with the project. Copyright owners may be holding out for bigger budget projects to maximize their profit. The best way to ensure that your request is accepted is to limit the terms of the request.

Do I have to credit the composer in the film?

As a fellow artist, this point should be obvious. Even if you are using buy-out music, it is important to credit all artistic contributions.

Are sample libraries copy protected?

Some companies who produce sample or SFX libraries require screen credit when selections are synced to image. One reason they do this is to promote the concept of owning the library. At least one party in the production should be a legally registered owner of the library.

*Can I synchronize a MIDI version of a
copyright-protected work to my film?*

All aspects of the copyright law apply to MIDI files and the sounds used for their playback. MIDI files do not circumvent the copyright law; in fact, the MIDI file itself can be copy protected.

*Can I record my own version of the song
and synchronize it to my animation?*

If you get a synchronization license but are denied master rights, you can still have the song in your animation. To do this, you will have to secure a group to record (cover) the song. If you fail to secure a synchronization license, the only way you can use the song is if it meets the criteria for fair use.

O. Legal Terms

- *Audio/visual works* are works that consist of a series of related images that are intended to accompany sounds.

- *Certificate of authorship* (C&A) defines who will take legal responsibility for the authenticity of the original music.

- *Clearance* means to obtain written permission from the controlling party to use their copyprotected material in your animation.

- A *compilation* is a work formed by the collection and assembling of preexisting materials. The materials must be arranged in such a way that the resulting work as a whole constitutes an original work of authorship.

- *Copies* are material objects, in which a work is fixed by any method now known or later developed.

- A work is *created* when it is fixed in a copy for the first time; where a work is prepared over a period of time, the portion that has been fixed at any particular time constitutes the work. Where the work has been prepared in different versions, each version constitutes a separate work.

- A *derivative work* is a work based on one or more preexisting works, such as a musical arrangement, dramatization, motion picture version, sound recording, art reproduction, or any other form in which a work may be recast, transformed, or adapted.

- *Derivation (adaptation) rights* are required if you want to change the melody or lyrics of a song. The rights holder will want to see the adaptation prior to approval.

- *Fixation* is when a work is made permanent or stable to permit it to be perceived, reproduced, or otherwise communicated for a period of time that is more than transitory in duration.

- *Knock-off* refers to when you make a copy that is intended to represent the real thing. This violates two copyrights: illegal derivative and illegal use. A sound-alike is a legal version.

- *Motion pictures* are audiovisual works consisting of a series of related images which, when shown in succession, impart an impression of motion.

- *Perpetuity* means the license holder has permission to use the work for the life of the copyright.

- *Registration* means a registration of a claim in the original or the renewed and extended term of the copyright.

- *Sound recordings* are works that result from the fixation of a series of musical, spoken, or other sounds, including the sounds accompanying a motion picture or other audiovisual work, regardless of the nature of the medium (CD or DVD).

- Generally, the copyright is owned by the person who creates the work; however, if an animator hires a composer or sound designer to create music or sound effects on a *work for hire* basis, then the animator can own the copyright. In independent animation, it is often possible to negotiate a lower rate by allowing the composer to keep the copyright; however, this should only be done if a contract can specify that the animator can use the work. Consider limiting the use of the composition to a noncompeting form.

P. Obtaining Copyright Protection

As of March 1, 1989, copyright protection can be granted when an "original" work is "fixed." All works must meet the minimum standards for originality in order to be considered for copyright.

Registration with the Copyright Office is optional; however, you cannot file an infringement suit unless you have registered. The "poor man's copyright" involves mailing your work (with a copyright notice included) to yourself and leaving it unopened until a copyright dispute occurs. Federal mail is legally dated but you still have to prove that the envelope was never opened. The most conservative approach is to register your work with the Library of Congress.

Q. International Copyright Law

If your project will be screened internationally or if you plan to enter into an international distribution agreement, then you will need legal representation by someone fluent in international copyright. The topic of international trade law is far too broad to be handled here. A helpful overview of international copyright (*The Berne Convention on Literary and Artistic Works*) is available online at http://www.cerebalaw.com/berne.htm. Most of the participating countries have copyright laws that are patterned after this agreement.

Tools and Techniques

The following section addresses the tools and techniques used to create a convincing sound track. For the first time in film history, audio production tools have become affordable for sound designers working outside of the major studios. The project studio has become streamlined yet it is still relatively complex to install and operate. Chapter 7 will provide an overview of the hardware and software essential for sound track development. Chapter 8 deals with signal routing and processing within the virtual environment of a digital audio workstation. Understanding signal flow is essential for shaping individual sounds and creating the final mix.

The Project Studio 7

What do you want, a hole or a drill? — Reg Goeke

A. Overview

The purpose of this chapter is to provide an overview of the various types of tools needed to develop an effective sound track. In creating a sound track, sound designers need tools to record, synthesize, edit, signal process, mix, and master audio. To meet these needs, a work environment called the *project studio* has evolved (Figure 7.1).

The project studio utilizes digital technologies to create a streamlined multimedia work environment. The project studio consists of a computer, host audio software, plug-ins, and supportive hardware (peripherals). Professional *loudspeakers* are needed for critical listening and quality *video monitors* are needed for synchronization purposes. *Control surfaces* are included to provide hands-on controls similar to those found in traditional analog studios. All of the tools discussed in this chapter are important, but none can replace artistry as the primary determinant of a successful animation project. As long as we strive to outpace technology with artistry, each tool will remain a transparent means to an end

FIGURE 7.1. The project studio.

B. Platform

The decision to use a Mac or a PC hinges on hardware and software availability and the operator's preexisting comfort level with a specific platform. The question of platform is becoming less important as computer technology becomes increasingly cross-platform. Animators and sound designers can successfully move content across platforms and applications using audio file formats such as the Broadcast Wave File (BWF) and transfer protocols such as Open Media Framework Interchange (OMFI) and the Advanced Authoring Format (AAF).

C. Host Audio Applications

Numerous audio software applications are suited for digital media production. All serve as hosts for a variety of signal processing plug-ins and virtual instruments. In addition, they offer the following: hard disk recording, multitrack waveform editing, video monitoring, signal processing, MIDI, 5.1 mixing, and mastering. Table 7.1 provides a list of the audio applications and features suitable for sound design.

TABLE 7.1
Selected List of Host Audio Applications

Audio Application	Video Application[a]	MIDI	PC/ Mac	Developer's Website
Pro Tools®	Avid®	Limited	Both	www.digidesign.com
Logic® Audio	Final Cut®	Strong	Mac	www.apple.com
Vegas® Video	Vegas® Video	Requires Acid® Pro	PC	www.sony.com
Audition®	Premier®	Playback only	PC	www.adobe.com
Digital Performer®	No companion video	Strong	Mac	www.motu.com
Nuendo®	No companion video	Strong	Both	www.steinberg.net

[a] The video application is not exclusive to the audio application but is suggested for greatest compatibility.

TABLE 7.2
Global Features for Host Audio Applications

Global Features	Available Options
Platform support	PC, Mac, or dual platform
Support for audio file formats	AIFF, BWF (SD II, WAVa)
File transfer	OMF and AAF
Track count	CPU (processor speed/RAM) and external DSP hardware
Hardware	Digital audio converter, I/O (input/output), control surfaces
Plug-ins	Native (host-based) and DSP (external hardware)
MIDI	MIDI interface
Bit-depths	16–24
Sample rates	44.1–192 kHz
Mixing options	Stereo, multichannel

a Legacy audio file formats.

D. Hard-Disk Recording

Hard-disk recording has dramatically changed the way sound designers approach audio recording, editing, and mixing. Digital audio files can be duplicated endlessly without degrading the signal. They can also be edited nondestructively (original copy unaltered), allowing for safer and more aggressive edits. Ever-expanding track counts and hard-disk delivery systems have influenced the way files are organized, shared, and mixed. The entire production path is evolving in response to digital audio. At the heart of the hard-disk audio system is the computer, powered by a central processing unit (CPU). All host audio applications use the CPU (host-based) to provide tracks, signal processing, and playback audio. To avoid the limitations imposed by existing CPUs, Digidesign developed a system that utilizes external digital sound processing (DSP) chips (hardware-based) rather than the CPU to accomplish most audio processing tasks. The power of the DSP chip comes at a greater cost, but it has also made it possible for software companies to develop plug-ins that would overtax a typical CPU. A growing number of users believe that dual processors running at faster speeds will gradually replace DSP, but for now DSP remains the most powerful means of expanding the capacity of a digital audio workstation.

E. Waveform Editing

Audio recorded to magnetic tape does not provide a visual representation of the waveform; consequently, editing tape is both time consuming and risky. In contrast, digital audio systems create visual waveforms similar to those of optical prints. These waveforms provide detailed visual references, making it possible to complete nondestructive edits with a higher level of precision and frame accuracy.

F. Automation

Automation is used extensively when panning, leveling, and signal processing. The ability to automate nearly every real-time editing and mix function is one of the most useful features provided by digital audio software applications. Until recently, full-scale automation was only available on large mix consoles such as those used on major film projects. Automation is an essential means of developing a balanced mix, maintaining continuity, and changing perspective in the context of the dynamic narrative. For more information on automation, refer to the Control Surfaces section later in this chapter.

G. Desktop Media Players

The two most popular desktop media players are Apple's QuickTime™ Player and Microsoft's Windows Media® Player. Both support a variety of audio and video file formats and *codecs* (compression/ decompression). Both players are available for Mac and PC, although QuickTime is most commonly used. Several audio/video file formats are supported by both players, including QuickTime (.mov), AVI (.avi), and Windows Media (.wmv). Data compression is applied to these file formats to reduce file sizes. Some of the popular video codecs include Sorenson®, MPEG-4, Cinepak®, and DV. MPEG-3 is the most common type of audio compression used today. QuickTime™ Pro allows the user to encode or transcode (change) the file formats and codecs. QuickTime and Windows Media Player are convenient means of file sharing for works in progress. These programs allow the sound designer to work with images without having to purchase costly animation software. Conversely, the director can hear the sound track as it is being developed without having to purchase expensive audio systems. Unlike QuickTime and Windows Media Player, RealNetwork's RealPlayer™ is an application used to preview *streaming audio* from the Internet. RealPlayer reduces the playback time associated with downloading and is commonly used to stream nonbroadcast-quality previews of production music and SFX libraries.

H. MIDI Sequencers

MIDI sequencers are software applications that record, edit, and play back MIDI data. MIDI data consist of a set of performance commands that dictate the playback of sound modules. MIDI information is derived from controllers such as keyboards, drum pads, and digital mixers. Musical sequencing can be thought of as a virtual conductor in need of virtual players and their virtual instruments. All of the major host audio applications have MIDI sequencing features built into them to varying degrees. Composers use sequencers to develop, demonstrate, and actualize scores. In many cases, the final score consists of a blending of MIDI-triggered sounds and live musicians. Sound designers use MIDI to trigger sound effects, creating organic composite effects. The MIDI workstation pictured in Figure 7.2 contains a variety of hardware and software associated with advanced MIDI systems.

FIGURE 7.2. The MIDI studio.

I. Virtual Instruments: Synthesis and Sampling

Every animation project presents unique opportunities to create original music and sound effects. Though programs such as Pro Tools® and Logic® are ideal for capturing and editing audio, they are not specifically designed for synthesis (building sounds from scratch). This task is accomplished with two types of *sound modules: synthesizers* and *samplers*. Both types are available in hardware or software (*virtual instruments*) versions. Virtual instruments are available as stand-alone applications or as plug-ins. Additional software such as ReWire™, Direct Connect®, and ESB® has been developed to allow the output of these modules to stream directly into a host application. Sound designers use synthesis to create sounds and samplers and their associated sample libraries to expand their sonic options.

J. Audio Encoding

A multichannel mix must be encoded with Dolby® AC-3 and DTS encoders (Figure 7.3). A growing number of software encoders (Table 7.3) can do an acceptable job of encoding at a fraction of the cost of hardware encoders.

TABLE 7.3
Multi-Channel Audio Encoding Software

Application	File Types	Host Application	Developer	Platform
APAK	AC-3	Stand-alone	Apple	Mac
5.1 surround plug-in	AC-3	Vegas®	Sonic Foundry	PC
SurCode™ Dolby® Digital	AC-3	Stand-alone	Minnatonka	PC
Nuendo® Dolby® Digital	AC-3	Nuendo®	Steinberg	Both
SurCode™ DVD-DTS	DTS	Stand-alone	Minnatonka	PC
SmartCode™ DTS-DVD	DTS	Pro Tools®	Kindaloud	Both
Nuendo® DTS-DVD	DTS	Nuendo®	Steinberg	Both

FIGURE 7.3 Software Encoders

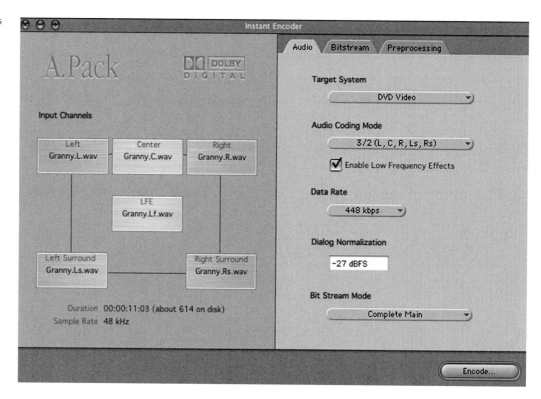

K. DVD-V Authoring

The DVD-V format has become the standard format for home video. It is becoming increasingly popular for demo reels as well. Table 7.4 provides a selected list of DVD-V software authoring solutions:

TABLE 7.4
DVD-V Authoring Software

Application	File Types	Host Application	Platform
Adobe Encore® DVD	AC-3	Adobe	PC
DVD Architect™	AC-3	Sony	PC
DVD Lab Pro™	AC-3 and DTS	Media Chance	PC
DVD Studio Pro® 3	AC-3 and DTS	Apple	Mac

L. Media File Exchange (OMFI and AAF)

As the number of MIDI programs increased so did the need to develop a MIDI file transfer format that was recognized by all MIDI applications. The general MIDI (GM) file format was developed in response to this need. As digital audio software developed, a similar need emerged to exchange media data (digital video and audio files) and their associated metadata such as time stamps and handles. The Open Media Framework Interchange (OMF) and Advanced Authoring Format (AAF) were developed in response to this need. Both allow the user to import and export individual tracks or complete sessions between audio software programs such as Pro Tools and Logic. The ability to transfer metadata with audio and video eliminates the need to rebuild the sequences in the timeline. Most major audio software applications support OMF and AAF importing and exporting. Before exporting a project in either format, it is advisable to consolidate tracks, render effects, and delete unused tracks.

M. Audio Interface

The main connections between the audio software and associated hardware is the *audio interface* (Figure 7.4).

FireWire® and USB cable is becoming the standard means of connecting the audio interface to the computer and moving the signal to and from the software environment. The typical audio interface provides inputs and outputs for analog and digital devices such as microphone and monitoring systems. Interfaces that sup-

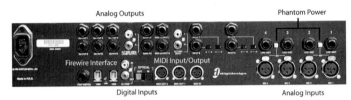

FIGURE 7.4 Audio Interface

port audio recording include built-in microphone preamps and a phantom power source (optional). Most audio interfaces have digital inputs and outputs that permit direct digital transmissions between the interface and audio gear capable of sending and receiving digital signal. For analog signals (such as a microphone signal), the job of the audio interface is to convert analog audio signals (such as microphones or guitars) to digital signals so they can be used by the audio software application. Most audio interfaces allow the user to select and control the volume for a variety of monitoring options, including headphones. In addition to supporting audio, some interfaces also support MIDI and include MIDI in, out, and thru ports.

N. Control Surfaces

As with playing the piano or typing, it is often necessary to look beyond one's hands when performing complex audio edits or mixing tasks. *Control surfaces* provide a touch-sensitive interface that allows users to complete many tasks (in real time) while viewing the video workprint. In addition, they exceed the functionality of a computer mouse by facilitating multiple edit or mix functions. In the early years of digital audio, sound engineers with analog experience had legitimate complaints regarding the lack of tactile controls available for digital signal processing and mixing. Much of their art revolved around fader technique using traditional mixing consoles. The mouse restricted these engineers to either *key frame automation* (drawn) or the use of one fader movement at a time. Key-framed automation is drawn without the benefit of moving image or the context of the full mix. Key-framed automation is most useful in achieving frame-accurate start and end points with linear "in-betweens." The most expressive means of automating is achieved with control surfaces that mimic the conventional mixing consoles of the analog era. A multifader control surface looks, feels, and responds to touch in a manner similar to conventional mixing consoles. The control surface shown below (Figure 7.5) has traditional faders as well as joysticks for surround-sound panning.

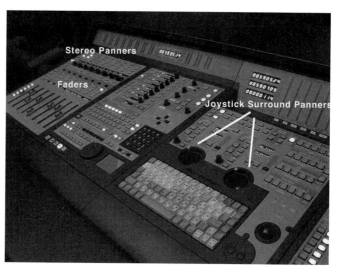

FIGURE 7.5. Control surface.

O. Audio Monitors

The purpose of a good audio monitoring system is to facilitate editing, signal processing, mixing, and mastering. Headphones are particularity useful for field recording and audio editing; however, all other aspects of audio production require an audio monitoring system consistent with consumer or theatrical playback systems. Ideally, loudspeakers should have a wide frequency response and dynamic range, but few loudspeakers actually meet this requirement. Most systems require a *subwoofer* (sub) to produce the lowest frequencies. A sub can reproduce low-frequency signals and reduce the load on the main speakers. Frequency response is to audio what resolution is to image. For example, an MPEG-3 audio file played through a typical consumer computer speaker is analogous in quality to a web-streamed image at 180 × 240 playing ten frames per second. In both cases, the material is so compromised that it is difficult to make decisions that will translate to the wide range of playback systems. The size and power requirements of the monitoring system should be designed proportionately to the size of the mixing room. *Nearfield monitor-*

ing (Figure 7.6) utilizes smaller monitors (speakers) placed near the engineer to minimize the influence of the acoustics of the room on the mix. Nearfield monitoring is useful when developing consumer DVD-V and television mixes.

P. Video Monitors

A digital audio host application must support video playback within the application. When video has been imported into the audio workstation, it can be viewed within the application (dual computer monitors) or streamed to an external video monitor. Dual monitors are often used for sound editing to prevent the video workprint from crowding the audio editing workspace. For recording sessions involving dialog or Foley, a remote monitor is often placed in the studio to provide the talent with a visual guide track. In Pro Tools, video can be streamed via FireWire (using DV compression) from the application to a digital-to-analog video converter (Figure 7.7).

The signal is then converted to analog and sent to a video distribution amplifier, where the signal is directed to the control room and the remote studio monitors. Flat panel displays are generally quieter than CRTs and are often preferred by studio engineers.

FIGURE 7.6. Nearfield monitoring.

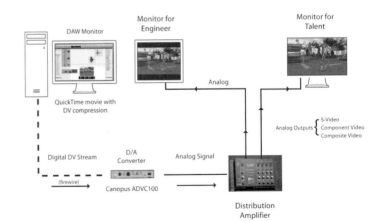

FIGURE 7.7. Digital audio workstation (DAW) to external monitors.

Q. Audio Cables and Connectors

Project studios require specific cables for digital and analog transfer. Professional *analog audio cables* are *balanced* and consumer cables are *unbalanced*. A balanced cable has two signal wires (180° out of phase) and a third shielding wire. Balanced cables (Figure 7.8) are significantly quieter than unbalanced cables.

The two signal wires carry the same signal in reverse phase. Noise or interference is picked up equally on both signal wires. At the end point of the cable, the signal wires are put back into phase restoring the signal and canceling the accumulated noise. Balanced cables fitted with a three-pin XLR connector (Figure 7.7) represent the professional standard for microphone and speaker connections. *Digital audio cables* use the same connectors attached to cable rated for digital signals. AES/EBU (Audio Engineer Society/European Broadcasting Union) and S/PDIF (Sony/Philips Digital Interface) cables are two types of cables used to transfer digital audio signals.

Attached at the end of the cable at either end are various types of connectors. A variety of connector types can be found in the project studio. *Quarter-inch TRS* (tip, ring, or sleeve) and *mini TRS* plugs (Figure 7.9) provide balanced connection for devices as well. These same connectors can also be used to carry stereo signals (headphones), utilizing each of the signal wires for left and right signals. When the connector is wired for stereo, the signals become unbalanced.

The *1/4-inch unbalanced* (TS) connector (Figure 7.10) is commonly used to connect guitars and electronic keyboards to their amps; this plug has only two connectors, making it both unbalanced and mono.

The *RCA connector* (phono plug) is the standard connector for consumer-level audio equipment (Figure 7.11); the same connector, when attached to 70-ohm cable, becomes a S/PDIF cable used for digital audio transfer.

FIGURE 7.8. XLR (balanced) connectors.

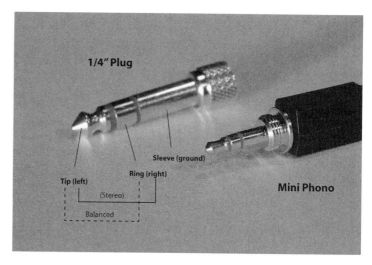

FIGURE 7.9. Tip, ring, and sleeve connectors.

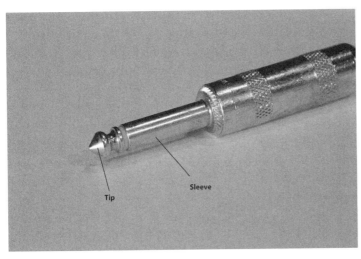

FIGURE 7.10. Unbalanced connector.

The *Toslink* (light-pipe) cable (Figure 7.12) uses fiberoptics to transfer digital audio to and from digital audio devices.

Individual MIDI cables (Figure 7.13) are required to transfer MIDI data to and from MIDI devices; it is important to understand that these cables carry MIDI information (not audio) and are neither balanced nor stereo

R. Media Drives

Loss of media due to poor file management, file corruption, or failed drives results in budget overruns, lost creativity, and missed deadlines. Digital media projects should not be attempted without first developing backup systems and procedures to protect media assets.

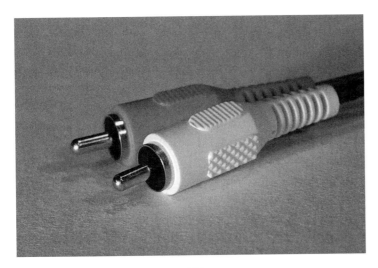

FIGURE 7.11. RCA connectors.

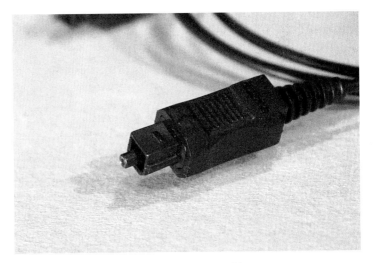

FIGURE 7.12. Toslink cable.

For small projects, an external FireWire drive provides a portable and cost-effective means of storing media assets (Figure 7.14).

Media drives must run at 7200 rpm in order to retrieve and play back media reliably. Consider purchasing two FireWire drives of equal capacity and using one of the drives as a redundant backup system. DVD-R is another cost-effective alternative to file backup. RAID (redundant array of independent disks) systems are currently the standard for high-capacity storage and retrieval (Figure 7.15).

No amount of drives will protect a user from poor backup procedures. Drives must be routinely defragmented to optimize their performance. It is also advisable to run utility programs that correct errors that can cause the drive to fail. Sound designers must back up their work in progress while also creating redundant backups at the end of each session. No single strategy will ensure the safety of media assets; therefore, redundancy is an essential step toward securing and protecting valuable media assets.

FIGURE 7.14. External FireWire drive.

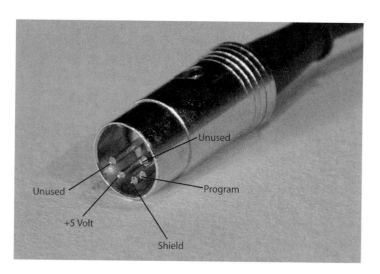

FIGURE 7.13. MIDI cable.

FIGURE 7.15. RAID system.

Signal Path and **8**
Signal Processing

A. Overview

The modern project studio, though digitally streamlined, is comprised of a vast array of hardware and software. These tools have evolved over several decades to manage the ever-growing track counts and sophisticated signal processing needs. Even the most basic project studios often contain outboard gear and control surfaces to complement software applications; however, much of the equipment that used to fill racks in an analog studio has since been replaced by software. As with analog studios, there continues to be a need to direct signals to and from both software plug-ins and hardware devices. The process of moving audio within the studio environment is referred to as *signal routing*. The various routes taken are called *signal paths*. Signals are routed within the studio environment to accomplish mixing tasks and *signal processing*.

B. Signal Path

Many sound designers prefer to work with a visual interface that provides waveform overviews for editing and a video window for synchronization. As a result, they tend to overlook the additional interface that provides a graphic representation of a mixing console; however, it is through the graphic mixer that we gain the most accurate representation of signal flow. *Signal flow charts* (diagrams) are one means of conceptualizing the flow of signals within the virtual mix environment. Signal flow charts provide critical information needed to accomplish various signal routing and signal processing tasks. Figure 8.1 provides a *simplified* overview of the signal path for the Pro Tools® application. In this figure, the path begins with a signal input from either an external source (recording) or a hard drive (playback). The signal moves through the path to the *inserts*. When the signal has passed through the inserts, it continues toward the *sends*. At this point, the signal can be split, with one signal being routed through a send to an *auxiliary input* while the other signal continues on to the *main output*.

1. SOURCE AUDIO

The path begins with an audio source derived from either an external device such as a microphone preamp or an internal device such as audio stored on a hard drive. Audio is introduced to the signal path by way of audio tracks. When an audio track is record armed,

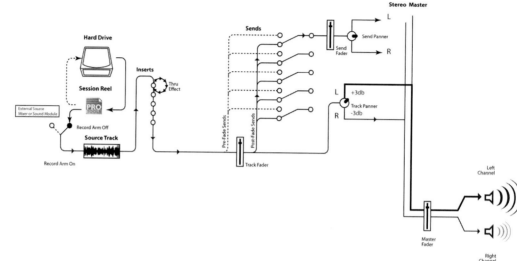

FIGURE 8.1. Signal flowchart
for Pro Tools.

it is made ready to capture any incoming source. When an audio track is set for playback, it is made ready to play any captured audio (digital files) that is placed within.

2. INSERTS

Inserts are a direct means of routing a signal to and from a plug-in or hardware signal processor (Figure 8.2).

Inserts are cumulative, and the order in which plug-ins are placed directly impacts the resulting sound. When a stereo plug-in is placed on an insert of a mono track, the track output is changed to reflect the output of the plug-in, and all mono plug-ins are unavailable from that insert on. Inserts are associated with *real-time* signal processing using plug-ins powered with either a central processing unit (CPU; native) or digital signal processing (DSP) chip (TDM/HD).

3. SENDS AND AUXILIARY INPUTS

Sends and auxiliary inputs facilitate more complex signal routing than is possible with inserts. Together, they provide secondary pathways along which signals may travel. Signal routing with sends and auxiliary inputs is analogous to traveling by bus. People (*audio regions*) from varied points of origin (*audio tracks*) go to a station (*sends section*) to begin their journey to a specific destination. Many buses arrive and depart from a station, so terminals (*sends a–e*) are needed to specify departure points. Many buses are required to deliver passengers to their respective destinations. Passengers from various points of origin board a common bus (*summing*) when traveling toward a common destination. In some cases, passengers need to make a transfer from one bus to another (*auxiliary inputs*). After making their transfers, passengers can continue on toward their ultimate destinations (*main outs*). The two types of sends available for mixing purposes are *prefader* and *postfader*.

FIGURE 8.2. Insert effects.

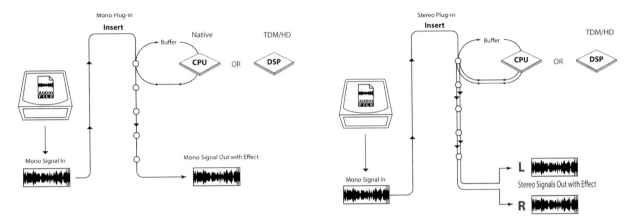

FIGURE 8.3. Prefade sends.

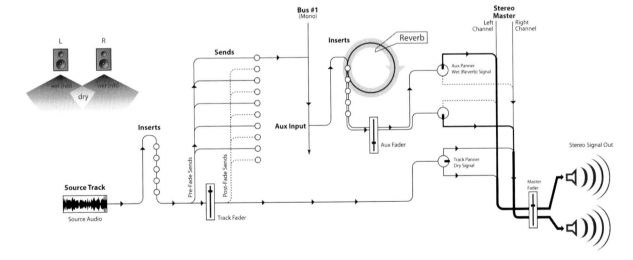

4. PREFADE/POSTFADE

One important distinction between a send and the transportation analogy is that the sends split the signal so it can travel on separate paths. The duplicate signal can be dependent on (*postfader*) or independent of (*prefader*) the source tracks fader. Figure 8.3 diagrams the path of a signal following a prefade send.

Notice that the track fader is located in the middle of the send section. The prefade path begins prior to the source track fader;

therefore, the track fader does not influence signals routed in pre-fade. Audio routed in the *postfader* (Figure 8.4) must first pass through the track fader.

The level of the signal being routed to the postfade send is entirely dependent on the track fader. Prefade is selected when the resulting signals must cross-fade, or morph from one treatment or environment to another. Postfade is selected when the ratios between the resulting signals must be maintained, as in the case of *fade-ins* or *fade-outs*.

5. AUXILIARY INPUTS

Auxiliary inputs (aux tracks) differ from audio tracks in that audio cannot be recorded to them. Instead, they receive their signal from an internal source (bus) or an external device. Audio that passes through the aux track can be signal processed, panned, leveled, and rerouted; however, no wave editing can take place. An aux input is a logical destination for multiple signals (sub-mix) that will share identical signal processing (*send effect*). The common signal processing achieved from this approach promotes continuity while optimizing CPU or DSP usage. The output of the aux is used to *return* the signal to a specified point in the signal path, typically the main out.

6. MASTER FADERS (MAIN OUT)

All tracks contributing to the mix are routed to the master fader. The master fader is the last point in the signal path in which volume changes and signal processing can occur. The master fader has inserts to facilitate signal processing applied to the mix (*master effects*). The output of the master fader is sent directly to the monitoring system for playback.

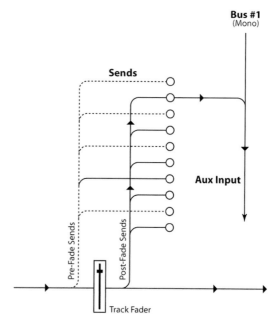

FIGURE 8.4. Postfader sends.

C. Signal Processing

1. PLUG-INS

A plug-in is an application that only works within a host application to enhance its functionality. In analog studios, racks of hardware were needed to process multiple tracks of audio at the same time. Studio owners can now purchase a single plug-in for use on all tracks simultaneously. Native plug-ins are limited by the amount of RAM and the processor speed of the CPU. Plug-ins are a cost-effective alternative to hardware processing. They simplify signal pro-

cessing, save on studio space, and can be updated online. Plug-ins are designed with a user interface, which offer visual controls for all of the parameters available within the plug-in. In addition, these controls can be assigned to a hardware controller to provide tactile control. Plug-ins are either powered by the CPU (native) or by a specialized DSP chip available on hardware-based systems. DSP chips are essentially single-purposed outboard CPUs. As computers expand to multiple processors, there may be less need in the future for hardware-based digital audio workstations (DAWs). Most of the major audio software packages ship with a basic set of native plug-ins. Additional plug-ins are available individually or in bundles from third-party developers. When purchasing additional plug-ins, consider the following: ease of use; compatibility with host software; whether they are native or DSP powered, mono or multichannel; sound quality; supported bit-depth; and sample rate. It is important to consult the manual to determine which plug-ins are supported by the application before purchasing specific plug-ins (Table 8.1).

2. RENDERED EFFECTS

Rendered effects are applied to a specific region by means of processing within the plug-in or by bouncing the track (Figure 8.5).

Rendering the effect creates new audio files reflecting the applied signal processing. When the effect has been rendered, no additional processing by the host CPU is required to produce the effect. Most rendering plug-ins allow the user to preview the audio and adjust plug-in settings before processing (rendering) the effect. The primary disadvantage to rendered effects is that they cannot be automated or set in the context of the full mix.

TABLE 8.1
Plug-in Formats and Compatibility

Plug-In Format	Host Applications	Developer Requirements	System
TDM	Pro Tools® and Logic® Audio	Digidesign	TDM hardware
RTAS	Pro Tools®	Digidesign	Host CPU (native)
Audio Suite	Pro Tools® and Logic® Audio	Digidesign	Host CPU (native)
VST	Nuendo®	Steinberg	Host CPU (native)
MAS	Digital Performer®	Mark of the Unicorn	Host CPU (native)
Direct X	Vegas®, Audition®, Nuendo®	Microsoft	Host CPU (native)
Audio units	Logic® Audio	Apple	Host CPU (native)

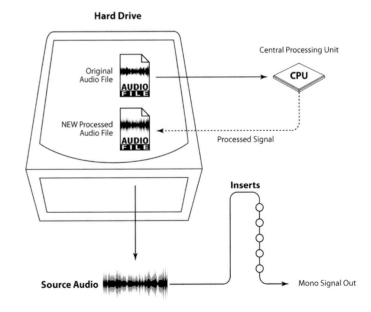

FIGURE 8.5. Rendered effects.

3. Real-Time Effects

Real-time effects can be adjusted and automated in the context of an evolving mix. These effects draw on the power of CPU or DSP chips each time the audio is played. Unlike rendered effects, real-time effect settings can be changed over time (*automated*). Automation can be created by using *control surfaces* (such as faders) or a mouse (*key framing*). Automation utilizing control surfaces allows the engineer to automate multiple tracks while viewing the animation. Individual fader automation can be accomplished without a control surface using the mouse and a virtual fader on a specific track. Key framing is helpful to achieve frame-accurate events. With practice, the engineer can draw the contour of the automation to achieve fairly satisfactory results. When key framing, it is helpful to set anchor points before and after the region that will be key framed. These anchors establish the boundaries within which the automation takes place and preserves the automation outside of these boundaries. There are three points in the signal path in which to insert real-time effects processing: the audio track (*insert effect*), the auxiliary input (*send* or *aux effect*), and the master input track (*master effect*). When real-time processors are placed on the inserts of the source audio track, the entire signal is processed. In this scenario, the ratio between processed and unprocessed signals must be set within the plug-in. When real-time processors are placed on the inserts of the auxiliary input (*send effect*), the ratios between processed and unprocessed signals are set by adjusting the source audio fader and auxiliary track faders. Send effects allow multiple signals to be processed in real time using a common insert. Send effects promote continuity in the mix and maximize the use of the CPU. When real-time processors are placed on the inserts of the master fader (*master effect*), all signals summed to the master fader are processed equally. Limiting, equalization, reverb, and dither are all common signal processes applied at the master fader.

4. The Source-Quality Rule

Sound tracks are built from audio derived from many sources, each made up of different bit-depths and sampling rates. These files must be imported into an audio editing environment at a common bit-depth and sampling rate. Files imported to the final mix session must share a common sample rate; however, bit-depths should be *up-converted* to the highest bit-depth supported by the software. Bob Katz refers to this approach of increasing bit-depth as the *source-quality rule*. The theory behind this rule is that digital audio will degrade to some extent due to signal processing. Processing audio at higher bit-depths maximizes the effectiveness of digital signal processors. When bit-depths are carefully reduced using dither and noise shaping, the resulting signal is superior to a file processed at lower bit-depths.

D. Types of Signal Processing

Signal processing is classified into four basic types: frequency, dynamic, spectral, and time-based. Pitch shifting and Doppler effects are just two examples of frequency-based signal processing. Compressors and gates are examples of dynamic processors. Equalizers fall under spectral processing. Time-based processors include reverb, delay, reverse, and various forms of time compression and expansion. Each of these processes can be used for corrective, spatializing effects, and sound shaping. *Corrective signal processing*, such as noise reduction and corrective equalization, uses a variety of processes to improve audio quality. *Spatializing effects* such as reverb, delay, and Doppler are used to place and move audio within an implied environment. *Sound shaping* processes

such as sci-fi or vocoder effects use signal processing to create new and unique sounds. The following is a selected review of signal processes common to sound design.

1. EQUALIZATION

Equalizers are like sonic erasers or highlighters that target certain frequencies for cutting or boosting. A track fader cuts or boosts the level of the entire signal (global volume), whereas the equalizer cuts or boosts specific components of the sound called *frequency bands* (local volume). *Mixing* an animation for stereo is an exercise in sonic crowd control where dialog, music, and effects are competing for the same space (frequency masking). It is often necessary to equalize specific elements so they do not compete. Dave Moultan refers to this use of equalization as *spectral management*.

Bandlimiting (equalization) is often used in tandem with other sound editing techniques to emulate the realistic characteristics of source audio. As with all sound design, use your ears to determine when the sound is convincing in the context of the animation.

High-pass filters (bass roll-off) cut the lowest end of the frequency spectrum and are often used to eliminate low-frequency hum and rumble. *Low-pass filters* (Figure 8.6) cut frequencies at the highest end of the spectrum and are commonly used to remove hiss and leakage that exceed the frequency of the desired signal.

Both high and low-pass filters are for cutting only. The *cut-off frequency* indicates where the signal begins to slope off. Some filters allow the user to select slopes in intervals of 6 dB per octave (orders), where a sixth-order filter achieves 36 dB per octave. The combination of a high-pass and low-pass filter creates a *band-pass* filter such as those used to futz radio and television.

A *shelving filter* (Figure 8.7) differs from the high- and low-pass filters in two respects. First, the shelving filter allows for boosting in addition to cutting. Second, the shelf filter slopes to a point and

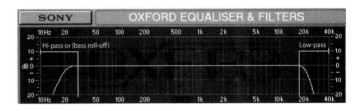

FIGURE 8.6. High- and low-pass filters.

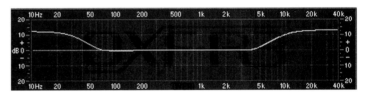

FIGURE 8.7. Shelving filters.

then flattens out, whereas the pass filters slope continuously. The most common type of shelving filter is the *loudness button* located on a stereo. The loudness button boosts the extreme highs and lows during playback to accommodate for the equal loudness curve.

Peak filters (Figure 8.8) are often referred to as *notch filters* as they are used to carve out a notch within the frequency spectrum for boosting or cutting. Peak filters are commonly used for corrective and sound shaping purposes. Peak filters allow the user to select a *center frequency* for maximum boost or cut. Slopes form at both sides of the center frequency to produce a bell-like curve. The width of the bell curve is referred to as the Q. The value for Qs typically range from 0 to 3.0. The width of the Q is determined by

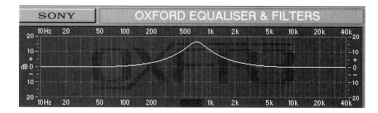

FIGURE 8.8. Peak filters.

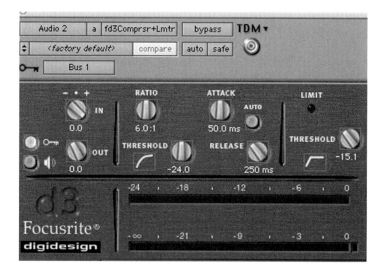

FIGURE 8.9. Compressors.

dividing the center frequency by the Q number. For example, a Q of 2.0 applied to a peak centered at 250 Hz (the mud range) will yield a curve that is 125 Hz wide at each side of the center frequency. In general terms, the larger the number, the narrower the resulting bell curve. It is common practice to *boost* and *sweep* a signal with a peak filter set to a narrow Q to identify specific frequencies that contribute or detract from the mix.

2. COMPRESSORS

A *compressor* (Figure 8.9) is often used to smooth differences in levels and to improve the overall presence of the signal in the mix. The spread between the softest and loudest portions of a signal defines its *dynamic range*. Dynamic range contributes to the expressive qualities of sound but can also cause leveling problems at the final mix. Compression reduces the dynamic range of a signal to a more predictable level, thereby making it easier to mix. Just as the equalizer boosts and cuts volume at certain frequencies, the compressor boosts and cuts volume at certain dB thresholds. The loudest portions of the signal are reduced in level (compressed), while the softer signals are increased in level (*make-up gain*), resulting in an apparent rise in overall level.

Some compressors can be activated with a *key input*. The key input allows an external source to activate the compressor. This process is also known as *side-chaining* (Figure 8.10). Side-chain is commonly applied to elements that compete with dialog.

3. REVERB

Every story takes place in a space that is implied through image and sound. Reverb is commonly applied to individual tracks or the entire mix to portray complex acoustic environments. Reverb consists of a blending of *direct* and *reflective sound*. Direct sound travels in a straight path to the ear and provides accurate timbral, size, and localization cues. Early and late reflected sounds imply the

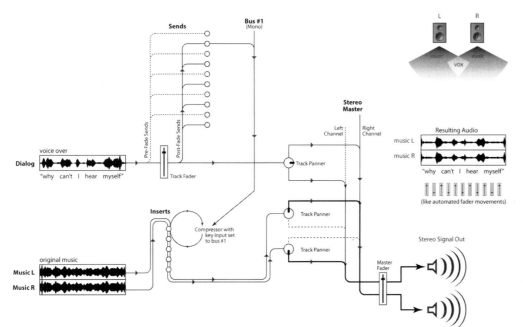

FIGURE 8.10. Side-chain compression.

size, material, and complexity of the space. The terms *wet* and *dry* are used to describe the ratio between processed signals combined with unprocessed signals. Reverb is often used to provide contrast between fantasy and reality. For example, wetting up narration during flashbacks or dream sequences helps the audience separate narration from dialog. Reverb can be applied locally to a specific track or globally to the master fader track. Applying different reverbs to each track allows for great flexibility and is the sonic equivalent of placing each sound in its own room. Applying a common reverb to all of the signals via the master track creates continuity and acts as a sonic glue for the elements of the mix. Reverb lowers intelligibility and clarity (like the blurring of an

image) so reverb is used more sparingly on sounds placed in the foreground of the mix. Unlike corrective and sound shaping processes, which are often rendered, spatial processing should remain flexible up until the final mix.

4. REVERSE

Reverse is commonly applied to SFX and is occasionally used on dialog. Terminating sounds, such as doors closing, are often enhanced by reversed compressed air or other elements to create a

definitive release. Ambience loops are also reversed to avoid audible patterns that become apparent through repetition. The famous pre-verb effect used in the horror genre involves reversing dialog, adding reverb, and re-reversing the dialog so we hear the reverb before the dialog. Dialog is also reversed to create synthetic language with convincing verbal syntax (Figures 8.11 and 8.12).

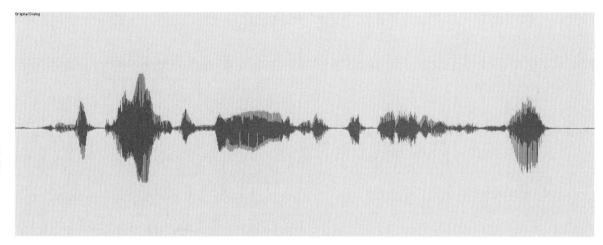

FIGURE 8.11. Original dialog: "So what kind of ahh ya know au- di- tion is this heh?"

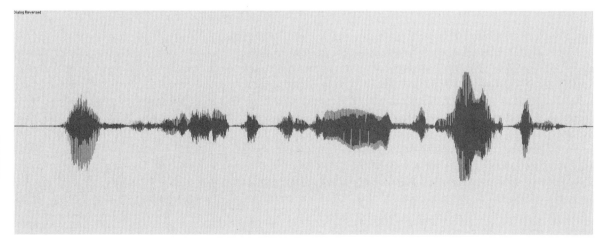

FIGURE 8.12. Dialog reversed: " Haas as in ahh shid no oh dee of vewd nyahd govuse?"

5. PITCH SHIFTING

Pitch shifting has a broad range of applications in sound design. It can be applied to dialog to change a character's age, size, and gender. It is also used to create variation in repetitive sounds. Upward pitch shifting makes sound objects feel smaller, and downward pitch shifting makes sound objects feel larger. Pitch shifting over time enhances acceleration and deceleration effects such as engine startups. Voices and SFX are often pitch shifted to work more harmoniously with the music score. In general, music can be pitched several semitones without adding artifacts. Dialog can be pitched up or down by as much as four semitones and still sound natural. SFX can be more aggressively pitch shifted, as the goal is typically to create a new effect. Some pitch-shifting plug-ins make multiple copies of the original and pitch shift to produce *harmonizing* effects. Harmonizing effects are not limited to music, adding complexity and interest to hard effects and dialog, as well.

6. TIME-SCALING

Time-scaling (time stretching) involves the compression or expansion of audio to match or conform its length proportionate to image. Unlike analog systems, audio regions in digital systems can be scaled in length without changing the pitch. Scaling is accomplished by adding or subtracting samples from an audio region. There are limits to the amount of compression or expansion that can be achieved before digital artifacts are introduced into the signal. WaveMechanic's Speed™ is a plug-in that allows the user to create acceleration and deceleration effects over time. VocAlign® is a time-scaling processor tailored to the needs of dialog editing. It uses transients and discrete compression and expansion to conform rerecorded dialog to the original. This plug-in is useful to sync rerecorded dialog to animation.

7. DOPPLER

The Doppler effect combines pitch variation, volume, and panning to create and enhance motion. Doppler is a perceptual phenomenon that reflects the perspective (point of view) of an observer in relation to a moving object. When an object approaches us, it travels into its own waves, compressing them and causing a perceptual rise in pitch. As the object exits, the waves are pulled farther apart, producing a perceptual drop in pitch. Doppler is also added to off-screen or invisible events such as whooshes to add excitement and contrast. GRM's Doppler plug-in (Figure 8.13) can also generate spinning effects such as tornadoes or the twirling of a weapon.

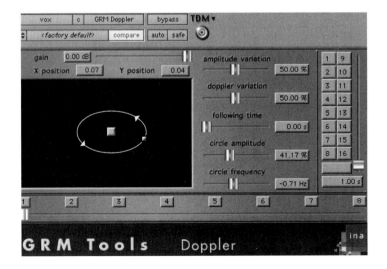

FIGURE 8.13. GRM's Doppler.

8. NOISE REDUCTION

Noise reduction plug-ins like those found in the Waves' Restoration Bundle, achieve noise reduction through dynamic and spectral processes. These plug-ins create a profile of the noise as defined by the user. When the noise has been defined, customized settings are created to remove the noise with minimal loss to the desired signal. Noise reduction is different for each situation, and it is better to apply multiple reduction techniques, which are conservative, than to develop a single yet aggressive approach. Table 8.2 provides examples of noise and some basic equalization settings used to remove them.

TABLE 8.2
Noise and Noise Reduction

Noise	Cause	Noise Reduction Technique
60-cycle hum	Grounding issues and generators	High-pass filter
Low-frequency rumble	Vehicle pass-bys	High-pass filter
Tape hiss	Multiple generations of analog	Low-pass filter
Air movement	Air-conditioning air handlers	Peak filter
Buzzing	Fluorescent lights	Peak filter

The Production Path

The tools and techniques discussed in the previous chapters continue to influence production procedures and workflow. Computer animation has dramatically influenced production procedures as well. Most 2D and 3D work prints are now delivered to the sound designer in digital video formats. Digital video has broad implications for the audio component of an animation. Instead of thinking in terms of "posting" a project, we can now consider designing and creating sound track content as early as pre-production. The following chapters provide an overview of the essential aspects of animation production in the context of developing a sound track. There is an admitted bias towards involving the sound designer and composer from the earliest stages of the production. The digital age has empowered the animator to create a work without the resources or influence of a major studio. With this freedom also comes the challenge to create a production model that can best facilitate the vision for each project.

CHAPTER

Preproduction 9

If you fail to plan, you plan to fail. —Don Bluth

A. Overview

The overall production path is divided into three phases: *prepro-duction*, *production*, and *postproduction*. This sequence of work-flow is referred to as the production path. The saying "You can have it good, fast, or cheap, but only two of the three" summa-rizes the forces that influence audio production. In practice, "good" costs money, "fast" costs money, and there is "no" money (Figure 9.1).

As a result, many sound design efforts are often delayed until postproduction for financial rather than artistic reasons. Having it be "good" is the least negotiable aspect of the production triad. Designing sound starting at the preproduction stage lessens the need to have it fast. A relatively small percentage (approximately 10%) of the total production budget is allocated to the sound design, *yet it contributes equally to the overall production value.* The less time and money you have, the greater your production will benefit from sound design. Some aspects of sound design should be left to the postproduction phase, regardless of resources; however, the integration of sound design can and should occur at all three stages.

FIGURE 9.1. The production triangle..

B. Phases of Preproduction

A movie should have a beginning, a middle, and an end, though not necessarily in that order. —Jean-Luc Godard

1. CONCEPT DEVELOPMENT

Concept development includes the *script*, a written *treatment* (plot summary), and concept art for the project. The script and treatment are often the sound designer's first exposure to the project. The script contains many suggestions for potential sound design. Scriptwriters often highlight suggested sounds within the script. Sound designers can develop sound treatments based on the script in the same fashion that radio dramas have been developed. The following are eight elements of creative script writing and their implications for the sound track.

a. Script Analysis: "Hearing Between the Lines"

Table 9.1 provides the essential elements of script analysis.

b. Concept Art

Concept art (Figure 9.2) can provide insight regarding sound for character development and potential sounds for objects and actions.

TABLE 9.1 Script Analysis

Element	Description	Implication for Sound Design
Plot	The pacing of tension and release (conflict and resolution)	All three stems have the ability to enhance tension and release, further supporting the plot development.
Characters	Hero (protagonist), villain (antagonist), supporting characters, and narrator	Dialog and Foley are strong elements in character development. Signal processing is a good way to provide contrast between dialog and narration. Music portrays the subtext of a character's inner world. A leitmotif can be used to represent a character. Third-person narration implies ambient scoring whereas first-person narration implies subtext scoring.
Setting	Environment, location, time period, and scale	Location and time period provide opportunity for *establishing sound,* which includes referential ambience and SFX as well as period music. The visual setting gives us an indication of the scale of the film. Instrumentation has a strong role in establishing scale.
Props	Emphasize narrative elements, create dramatic interest, and develop the character	Props are often defined and clarified with sound design. Foley is the art of manipulating and recording props.
Imagery	Implicit visuals ("Show me, don't tell me.")	Off-screen SFX and ambience reinforce the implied action while engaging the audience's imagination. Subtext scoring is used to imply the character's inner world, allowing the visuals to be more subtle.
Language	Primary means of delivering the narrative	The interpretation of dialog is of equal importance with voice characterization. Dialog is prerecorded.
Tone	Genre and emotional feel	Music is perhaps the strongest sonic element in establishing emotional feel and genre.
Voice	Signature style	Composers and sound designers develop signature styles that work in the context of the project. Carl Stalling developed the signature music for the early Warner Brothers animations

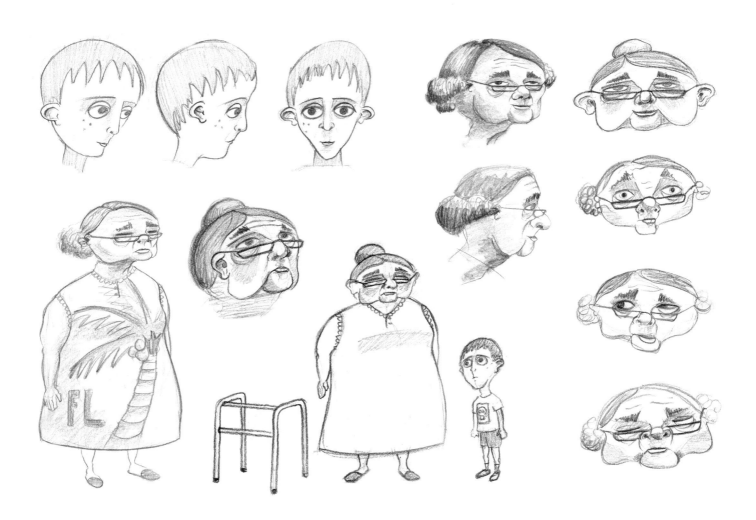

FIGURE 9.2. Concept art.

c. Treatment

A treatment is a short overview of the project used to pitch or promote the project; for example:

A Trip to Granny's

A Trip to Granny's explores the experience of visiting a grandparent through the POV of a young boy. The story utilizes misdirection as a means of moving to and from the implied reality and the child's fantasy world. Television programming is used to deliver story points, to establish time lapse, and to contrast age differences. In the end, we are left to wonder what is real and what is the product of the child's imagination.

d. Understanding Genre

Animation is typically categorized as family, animation, or anime (Japanese style); however, animations often contain conflicts that parallel live-action films and their associated genres. Sound designers will often reference films from the same genre to aid in their conceptualization of the sound track.

2. STORYBOARD

A *storyboard* (Figure 9.3) is a series of still drawings laid out in sequence to visualize the story. Storyboards are usually black-and-white stills with limited backgrounds. They are useful in suggesting movement, identifying production needs, and for brainstorming sessions. A carefully constructed storyboard serves as a blueprint for the entire production (Table 9.3). Carl Stalling reportedly composed storyboards for the classic Warner animations.

TABLE 9.2 Genres

Genre	Description and Examples
Action	Resolution of conflict when opposing forces clash (for example, *Final Fantasy, Small Soldiers, Mulan,* and most anime)
Adventure	A quest in which the principal characters overcome environmental challenges and new worlds (for example, *Dinosaur, Ice Age, Shrek,* and *Finding Nemo*)
Comedy	Situations, sight gags, parody, and comedic dialog to produce humor (for example, *Looney Tunes, Tom and Jerry,* and *The Simpson's*)
Coming of age	Plot revolving around characters facing challenges, growing up, and finding their place (for example, *The Lion King, Stuart Little,* and *Anastasia*)
Crime/gangster	Good guy, bad guy; good triumphs over evil (for example, *Superman* and *Batman*)
Detective/mystery	Uncovering and exposing the truth (for example, *Scooby Doo* and *Johnny Quest*)
Drama	Struggle with injustice (for example, *A Bug's Life* and *Hunchback of Notre Dame*)
Epic	Spanning broad history or great scope (for example, *Treasure Planet* and *Atlantis*)
Fantasy	Characters interacting between a "real world" and a "fantasy world" (for example, *Alice in Wonderland, Toy Story,* and *Monsters Inc.*)
Sci-fi	Technology-driven and futuristic (for example, *Titan AE, Final Fantasy,* and *Jimmy Neutron*)
Thriller	Innocent protagonist against a lethal antagonist (for example, *Chicken Run* and *Small Soldiers*)

FIGURE 9.3 Storyboards

TABLE 9.3
Implications of a Storyboard for Sound Design

Storyboard Elements	Sound Treatment
Key movements (sync points)	Music or SFX hits and basic synchronization
Sound objects	Hard effects and created design effects
Environment	Ambience and signal processing
Dialog	Prerecorded dialog
Emotional tone	Subtext scoring, ambiences, drones
Genre	Music style, level of realism
Types of shots or cuts	Linear or nonlinear sound design elements
Logistics	Prerecorded elements, music clearance, audio research, and score development

3. DEVELOPING THE TEMP TRACK AND PRE-SCORE

Synchronized dialog and pre-scored music are recorded prior to developing the animatic. The picture editor uses pre-sync audio to develop timings for the animation. When recording pre-sync dialog, it is important to listen for intelligibility, interpretation, accuracy, and character development. Each character should be recorded to individual tracks and sent to the picture editor for final edits. Sync audio often reveals visual flaws in cyclic animation such as walking or accelerating objects. The songs contained in animated musicals are written and recorded prior to the animation process. In the case of animated musicals, the songs drive much of the production. All pre-sync material must be cleared prior to animating.

4. PRODUCING THE ANIMATIC

The animatic is a video storyboard with limited animation, possible camera angles, and "locked" timing. Animatics are initially derived from scanned two-dimensional storyboard images. When the images have been scanned, edited, and exported in various file formats such as QuickTime™, AVI, or DivX®, an audio scratch track including dialog, SFX, and temporary music is developed for timing purposes. The animatic serves as a blueprint for the animation, guiding many of the decisions that would be delayed until postproduction for live-action films.

5. ENLISTING A SOUND DESIGNER

> *Capitalism makes networks. It doesn't make communities.*
> *Imagination makes communities.* —Robert Hass

When enlisting a sound designer, some directors may be tempted to offer unlimited artistic freedom to a sound designer. The all-too-familiar statement, "I am going to leave the sound design to you," creates unrealistic expectations for the sound designer. In addition, this statement suggests that the director lacks vision or interest in the sound design; consequently, the relationship starts off positive but gradually decays as the animator systematically strips control from the sound designer. Experienced sound designers do not expect unlimited creative latitude. They are more interested in having creative input on a well-conceived and well-managed project. Directors should clearly articulate their vision for the sound track. They should provide sound designers with copies of representative animations, music recordings, and lists of sounds that typify their vision for the project. In this way, the sound designer can best conceptualize the scope and general approach for the animation.

Directors should foster creativity and ownership in the process within the vision of the project. The likelihood of rejecting a sound designer's work decreases when expectations are clearly established at the beginning of the relationship. The great filmmaker Ingmar Bergman once noted the anonymity associated with the great art and craftwork associated with the great cathedrals of the world. His observation suggests that art and collaboration, rather than ego, should be the driving forces for *all* participants in a creative process. The following is a list of intrinsic incentives for sound designers:

- Development of a relationship that will lead to additional projects
- The appropriate level of creative latitude
- Gaining real-world experience
- Development of a demo reel
- Screen credits

6. Determining the Release Format

The *release format* (video or film) should be decided during the preproduction phase. This decision will determine the number of audio channels, frequency response, and dynamic range available for the release format. When going to video, specify whether the format will be the NTSC (National Television Committee System) or PAL (Phase Alternation by Line) standard. It is also necessary to specify the type of media to be used, such as digital tape or DVD. Most video release formats utilize digital audio that is capable of high-frequency response and wide dynamic range. When going to film, clarify whether it will be released on 16-mm or 35-mm film.

7. Developing an Audio Production Budget

Two elements grow smaller as the production progresses: *budgets* and *schedules*. It is important, then, to define these factors and tie them in with any expectations for sound track development. When the storyboard is complete, budgets and timelines are developed in preparation for the production phase. Input from the sound designer and composer is critical when developing a budget for audio production. Studio rates, musician fees, and creative fees vary by region and experience. Research and negotiation are vital when developing a budget. Sound designers will need an estimated date of picture lock and workprint delivery to develop the postproduction schedule. Several programs are designed specifically for budget, including MovieMagic (www.moviemagicproducer.com) and CreativePlanet (www.creativeplanet.com). Each provides comprehensive listings of current industry audio rates. Table 9.4 provides some budget considerations for audio production.

8. Developing an Audio Production Schedule

If you don't show up for work on Saturday, don't bother coming in on Sunday. —Jeffrey Katzenberg

The sound design is often produced under a very tight schedule. Organization is key to bringing the project in on time. Budget approximately 10 hours of audio production per minute of animation when estimating sound track production timelines. Audio production should be scheduled in tandem with visual production. In commercial film production, the composer is typically expected to write 2 to 5 minutes of music per day. Table 9.5 provides important scheduling concerns for the audio production time line.

TABLE 9.4
The Audio Production Budget

Production Audio Budget Items	Suggestions To Control Costs
Studio fees (studio time, editing, mixing, mastering, and archiving)	Rehearse material prior to the session date.
Musician fees	Develop a recording schedule that maximizes the use of studio musicians and engineers.
Equipment	Consider the cost effectiveness of renting over purchasing gear. This includes Foley props.
Creative fees (composer and sound designer)	Samplers and loop-based programs are often used to develop an low-cost score.
Needle-drop fees (music and SFX)	Production music libraries are a cost-effective reality for animation production at all levels.
Music licensing fees (if applicable)	The greater the scope of use, the more you pay. Narrow your licensing requests to include only that which you need.
Mixing and mastering fees	Optimize your audio by having professional mixing and mastering engineers prepare the final mix. This is not the place to cut costs.
Transfer fees	If the project is releasing on film, the audio will need to be transferred to film. Additional fees such as Dolby licensing may also be incurred

TABLE 9.5
The Audio Production Schedule

Step	Comments
Music licensing	Never animate to copy-protected work without first obtaining all necessary licensing. Allow 1 to 3 months for licensing.
Recording sync dialog and prescored music	This must be completed before the animation stage, as the timings derived from both guide the animation process.
Scratch track production	The scratch track contains both sync and non-sync audio. The scratch track is developed in tandem with the animatic.
Music and effects spotting session	Spotting sessions occur immediately after the picture is locked.
Score approvals, SFX approvals	This is an ongoing process that occurs after the spotting sessions. Once the cues are approved, the composer will fully develop each cue for live or electronic scoring.
Score completion	Scoring sessions are scheduled weeks in advance of completion of the score. Extensions for scoring purposes are rarely granted.
Scoring sessions	Scoring sessions require the most planning, as they involve so many people.
Dialog replacement	The idea behind replacing dialog is that the voice talent can deliver a more convincing performance while watching the final cut of the animation.
Foley session	Many sounds such as footsteps, props, and hand pats are most convincing when recorded to the completed animation.
Preparing premix for each stem	Editing is completed and the tracks for each stem are organized and formatted in preparation for the final mix.
Mixing fees	Mixing is the process of signal processing, panning, and leveling in the context of all three stems.
Mastering fees	Mastering is a process of preparing the completed mix for the release format.
Transfer fees	Once mastered, the final mix is bounced to a digital file or written to tape and delivered to the animator for layback. After the layback occurs, the project is screened to check audio quality and synchronization. If the screening proves satisfactory, the project is sent to a video-to-film transfer or duplication facility.

9. Maintaining Synchronization

Synchronization is an important yet often confusing aspect of animation production. The phrase "picture lock" must be interpreted loosely, as re-edits and conforming have become the norm in postproduction. *SMPTE time code* (Figure 9.4) is the standard means for marking time (hours, minutes, and seconds) and individual frames.

Most synchronization problems arise from a lack of consistency and communication with regard to frame rates and re-edits. In a perfect world, we would animate, edit, and develop the sound track at the same frame rate as our release format; unfortunately, this rarely occurs. Traditional two-dimensional animators work at 24 frames per second (fps), whereas three-dimensional animators work at 30 fps. Both two- and three-dimensional animators create animatics in digital video file formats. If the project is going to film, then a frame rate of 24 fps beginning with the animatic and continuing though postproduction would alleviate most sync issues. If the project is going to video (BetaCam or DVD), then a frame rate of 29.97 fps (nondrop; NTSC) or 25 fps (PAL) would alleviate most sync issues. If the project is going to both film and video, then separate mixes must be prepared that reflect the differences in playback speed for film and video. If the audio for the project was "posted" at 29.97 fps, then the mix for the optical print will need to be *pulled up* (sped up) 0.1%. Likewise, if the audio for a project was "posted" at 24 fps, then the audio must be *pulled down* (slowed down) 0.1% for layback to video. The correction for PAL video is 4%. Pro Tools® allows the user to pull the audio up or down in the "Session Setup" window. It is important for the animator to understand that any changes in frame rates or edits in subsequent work prints will create sync issues. Good working practice suggests that all deliverables such as a workprints and temp tracks be clearly labeled with synchronization parameters (Table 9.6).

TABLE 9.6 Applied Frame Rates

Frame Rates	Application
23.976 p (24 p)	High-definition video
24 fps	Film/two-dimensional animation work rate
25 fps	PAL video
29.97 nondrop	NTSC color video, DV, DVD
29.97 drop	Broadcast television
30	Three-dimensional animation work rate

SMPTE Timecode

Hours (Reel) : Minutes : Seconds : Frames

FIGURE 9.4. SMPTE time code.

10. Project Management

As with any cooperative endeavor, many problems that arise throughout a production can be attributed to breakdowns in communication. The Internet has become a powerful tool for production, allowing the sound designer to work and communicate with the produc-

tion team from a remote location. Message boards are one means of facilitating a collaborative workflow. Free sites are available for production message boards, such as www.xmbforum.com. One means of managing a large collaborative project is to develop a *production website* (Figure 9.5). Each site includes concept art, a plot treatment, a production calendar, a shot list, e-mail links, a message board, and a partitioned drive for assets. In addition, critical standards for many aspects of the production are defined and listed. These include frame rates, naming conventions, and file management issues.

11. SESSION MANAGEMENT

At the onset of a project, files are manageable, but as the project progresses they often multiply and become increasingly difficult to manage. With proper planning at the preproduction phase, the project can evolve yet remain manageable. The preproduction stage requires lip-sync dialog and narration, pre-score and temporary music, and temporary sound effects. These elements are combined and edited in an animatic master session. It is common practice to keep each of these stems separate until the final mix. By doing this, the master session can be assembled in the most efficient manner. Figure 9.6 illustrates a potential approach for the dialog stem.

Notice that the tracks in this session are discretely labeled. This labeling is critical for session navigation and for retrieving lost files. Memory locations are used to quickly navigate from line to line.

12. FILE SHARING

E-mail is not meant for sharing large media files such as those generated in animation. *File transfer protocol* (FTP) is one means of sharing large files over the Internet. FTP is a client/server protocol that allows clients to log in to a remote server, browse the directories in the server, and upload (send) or download (retrieve) files from the site. An FTP site can be accessed through a web browser or by using an FTP application such as Fetch and SmartFTP. These programs allow the sound designer to send uncompressed or unzipped stereo and surround files to the animator for preview and approval. The website www.mac.com offers a 250-megabyte web hosting service that cost $99 per year. It has the advantage of being integrated into the operating system. Digidesign has created the DigiDelivery™ system, a dual-platform, client-based service designed specifically for sharing large media files. Overnight services are a low-tech alternative to file sharing. When sending media files on an external drive, check with clients to make sure all deliverables are sent on drives that are compatible with their operating systems.

FIGURE 9.5. Production
management website.

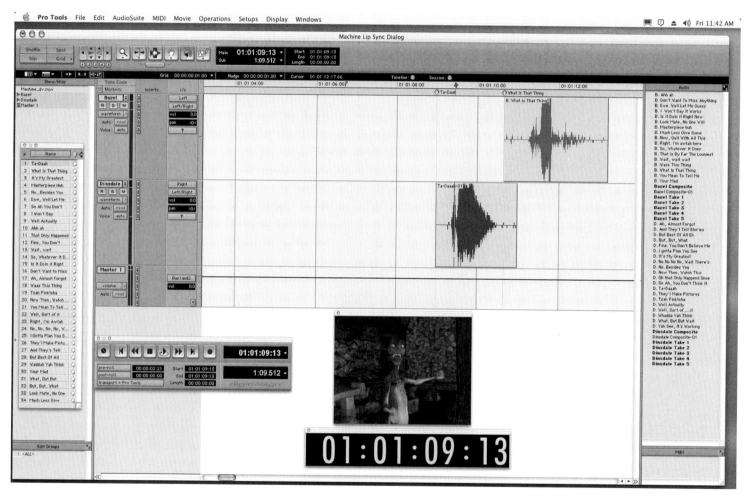

FIGURE 9.6. Session management.

Production

It is a child's play deciding what should be done compared with getting it done. —Alan Brooke

A. Overview

As the animation progresses, significantly more visual detail is available with which the sound designer can work. The following is a simplified overview of two-dimensional (2D) and three-dimensional (3D) animation intended for the sound designer.

B. Production Timeline for Two-Dimensional Animation

1. *Key animation* is the roughing in of key poses and extreme motions for character animation. Dialog must be prerecorded so lip sync can be developed. Subtle animation (such as facial expressions) is added at this point. Animators flip through the key animation sheets to test the overall look and motion.

2. *Effects animation* differs from character animation in that it focuses on complex environmental elements such as crowds, rain, and wind.

3. *Pencil tests* are useful for testing and demonstrating animation for final approval. Pencil tests are also referred to as *motion tests* or *animation tests*. Successful pencil tests are captured and added to build motion into the animatic.

4. *Backgrounds* are illustrated and painted to provide the context for the animation. Backgrounds are the equivalent of ambience for sound design. Backgrounds promote the flow of the animation and emphasize characters. Backgrounds are often looped to save time and money. Most of us are familiar with the recurring backgrounds of Hanna–Barbera's limited animation style. Variations in the sound design can be an effective means of preventing the audience from noticing these recurring backgrounds and increase the overall production value.

5. *In-betweens* are the drawings between the key frames that complete the animation.

6. *Cleanups* are the final drawings made in preparation for digital scanning and ink and painting.

7. *Digital ink and painting* have replaced traditional cel painting for most independent animations.

8. *Compositing* is the process of combining individual layers of animation.

9. Capturing is the process of digitizing (scanning) each frame to prepare it for the final edit.

10. Picture editing is the process of cutting the captured image sequence to further the narrative.

11. Rendering is the process of creating individual files used to create the final edit.

C. Production Timeline for Three-Dimensional Computer Animation

1. *Modeling* is the process of determining the rough characteristics of the characters and objects in an animation. From this, we can gain information about the size, species, and gender to conceptualize the rough sound that the object will produce.

2. *Rigging* involves deciding where and how a model can move.

3. *Animation* is the process of making characters or objects move. This is where cyclic movements and lip sync are animated. Motion tests utilizing temp audio can reveal problems in cyclic animation that are not readily apparent to the eye.

4. *Dynamics* is the phase where complex visuals such as exhaust, jet wash, smoke, and clouds are created

5. *Lighting* enhances the environment, highlights or masks visual details, and helps create a mood.

6. *Compositing* is the process of combining the many layers created in computer animation.

7. *Rendering* is the process of blending all of the computer animation elements together to create individual frames (TIFF or Targa) and the in-betweens.

D. The Evolving Workprint

The 2D *animatic* is the first and most basic workprint consisting of still images that are imported from the storyboard. These stills are gradually replaced with rough animation and preliminary camera work to produce a *previsualization* work print. A title sequence (if used) is added at this point in preparation for picture lock. This print can be used for *initial screenings* to demonstrate the sound track to the director or test audiences. When the animation has been completed, the camera work is finalized, and the *timings* are *locked*, a *temporary work print* is produced. The final stage of animation production includes compositing, lighting, special effects, rendering, and end-titles. When these elements have been added, the *final work print* is generated and the postproduction phase begins. A *countdown leader* and *sync-pop* are placed at the beginning of the final work print for the purposes of resyncing the audio. An audio sync-pop (Figure 10.1) is placed in sync with the "2" frame of the SMPTE countdown leader, hence the term *two-pop*. The sync-pop should consist of a 1-kHz tone at −20 dB lasting one frame in length. A *tail-pop* might also be added at the end of the animation for the same purpose.

FIGURE 10.1. SMPTE countdown leader and sync pop.

A time code *burn-in window* (Figure 10.2) is often added to the temporary workprint to provide a visual sync reference for offline editing systems that do not support SMPTE. It is also used in conjunction with SMPTE to check for sync drift and monitor latency. The workprint should provide sufficient video resolution while not monopolizing the audio work area. If the sound designer is using external monitors, then the workprint can be larger. Sound designers will specify the size and format of workprints that are compatible with their editing systems. The workprint should be labeled with all essential production information including frame rate and codec.

FIGURE 10.2. Time code burn-in window.

E. Production Tasks for the Sound Designer

Many tasks can be accomplished at the production phase of animation. Preliminary work at this stage promotes creativity while maximizing production time; however, it is important to understand that all nonsync sound completed at this stage is subject to final approval. Most of the activity associated with the production phase is a continuation of the preproduction tasks. The following are suggested activities for the sound designer during the production phase of animation.

1. AUDIO RESEARCH

There is a correlation between the animation styles of *Gertie*, *King Kong*, and *Jurassic Park* and the historical discoveries made by paleontologists. Animation studios that recognize the benefits of research provide their animators with opportunities to study existing models. Sound designers also benefit from a similar type of research. An ancient Chinese proverb states, "Learn to read the unwritten books." The unwritten books of sound design include existing films, sound recordings, and active listening to sounds available in various environments. Critical listening to exemplary animation reveals the many techniques and aesthetic approaches used by sound designers. This reverse engineering approach to research is referred to as *reference listening*. When researching a sound object, it is important to develop a comprehensive vocabulary of related terms. This vocabulary will greatly enhance a sound effects search and the development of a detailed spotting log. In addition, audio research prevents errors in continuity that can easily occur when utilizing unfamiliar sound objects.

2. SFX Acquisition

The production phase is an ideal time to build a *customized SFX library*. This involves field recording and pulling SFX from existing libraries. It is important to develop documentation procedures so each file can be easily located in the event media gets lost or corrupted. The acquisition of effects can be guided by the animatic. Sounds that address significant narrative issues have the greatest likelihood of being used in the final mix.

3. Score Considerations

The composer can use this time to sketch potential thematic material for the project. Themes or melodies are often the most difficult aspects of the score to create. They can be developed without image and reworked later to meet specific synchronization requirements. A composer can also develop synchronized cues from a temporary work print provided the picture lock is preserved. The production phase is an excellent time to follow up on *music clearance* issues for all nonsync music. Presync material should have been cleared prior to the production phase.

4. Temp Tracks

Temp music and SFX are added to the work print at various stages of development. Temp tracks serve a variety of purposes, such as suggesting the type of music required for the score. They are routinely used to prepare a work-in-progress for screenings with test audiences. It is not uncommon for the director to become attached with the music in the temp track. This can be problematic if the music cannot be cleared. Directors often ask composers to write in the style of the temp track. Temp audio can also serve as a diagnostic tool for the animation process. The development of visual events that cycle at a steady rate or change at a predictable rate can be aided by temporary sound design. Preliminary sound design can provide an additional level of feedback to guide the timing aspects of the animation. This same approach can also be used to aid picture editors when they are developing the final picture edits. Linear elements such as walk cycles must be edited carefully if the director seeks to avoid exposing the cut. When sound is added to these cycles, the picture editor can both hear and see the results of his edits.

5. Built-Up (Sweetened) Sound Effects

The production phase is a good time to develop and experiment with *built-up sound effects*. As the production phase progresses, many of the characters and objects become fully animated. A fully animated character provides sufficient visual reference with which to begin the initial sound design treatments. Like thematic music, these sound effects are customized during the postproduction phase to meet synchronization requirements.

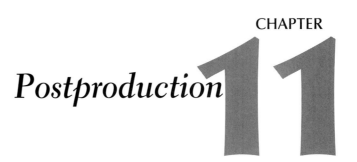

CHAPTER

Postproduction 11

If it weren't for the last minute, nothing would get done. —Anonymous

A. Overview

The delivery of the final workprint (video) signals the beginning of audio postproduction. During this phase, the majority of the sound track is defined, approved, and completed. If additional picture edits occur beyond this point, the sound designer will lose valuable time resyncing (*conforming*) audio to the new edit.

build, edit, and synchronize elements that will eventually comprise the SFX stem. The composer develops and produces the score using live musicians or electronic scoring techniques, often a combination of both. In some cases, dialog is replaced to allow the voice actors an opportunity to improve their performance in the context of the completed animation.

B. Developing the Elements of a Sound Track

The spotting session provides the director with a final opportunity to define and specify the needs of the sound track. Traditionally, spotting sessions for SFX and music are held separately; however, joint spotting sessions provide a more integrated perspective for both the sound designer and composer. When these sessions are completed, spotting notes are generated that serve as blueprints to guide the remaining audio postproduction. These spotting notes document individual placements of elements and track layouts for later use by the rerecording mixers. At this point, sound designers

C. The Premixes

As the postproduction phase nears completion, *elements* (units) are mixed-down to *premixes* (predub). Premixes are developed independently for each of the stems. They are designed to provide organization, reduce track counts, and simplify the final mix process by isolating those elements that may require special treatment or cause conflict. Sound effect elements are mixed-down to multiple eight-channel premixes, reflecting an organization scheme unique to each project. Typical SFX premixes include grouped hard effects, designed effects, Foley props, Foley footsteps, and ambience. Music submixes are created to separate the

orchestral, synthesized, rhythmic, harmonic, melodic, solo, and bass elements. Dialog tracks are prepared individually by character. When developing the premixes, decisions regarding panning, leveling, and signal processing decisions are limited to only those that facilitate the final mix process.

D. The Final Mix (Rerecording)

Films are never released, they escape. —Ben Burtt

Once finalized, the premixes are delivered to the *final mix* where they are played together for the first time. There, in the context of the full mix and image, final panning, leveling, and signal processing decisions are made. In some cases, specific elements within a premix are modified or removed as priorities for the mix are established. When all of the mix decisions are completed, the premixes for each of the stems are mixed-down to create three individual six-channel mix stems. When played together, these stems constitute the completed sound track. Global compression and equalization are then applied to each of the stems (the sound track) to meet the technical requirements for each of the final release formats (*mastering*). If the director approves the final mix, the stems are combined to create 5.1, stereo, and mono *print masters*. The print masters are then combined with the final animation to produce the *release print*.

E. Understanding Channels and Loudspeakers

A sound track can be mixed for a wide range of channel configurations ranging from mono to 7.1. It is important to understand the distinction between *channels* and *loudspeakers*. A channel outputs a discrete audio signal to a loudspeaker that in turn reproduces the signal. For example, the LFE (low-frequency effects) channel is a special one that is reproduced by a loudspeaker (*subwoofer*) designed specifically to handle low frequencies. A one-to-one correlation between channels and loudspeakers does not always exist. Figure 11.1 illustrates a configuration for commercial 5.1 theaters. Notice that the left (Ls) and right (Rs) channels each have multiple loudspeakers to reproduce the same signals. These additional speakers provide additional coverage for the seats located at the back of the theater. The left, center, and right channels (LCR) all have a one-to-one ratio between the channels and loudspeakers. The loudspeakers placed in the front of the screening area are referred to as the *screen channels*. The loudspeakers placed at the

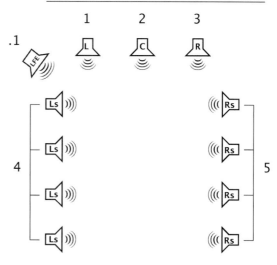

FIGURE 11.1. Theatrical surround setup.

sides (theatrical setup) or the back (consumer setup) are referred to as the *surrounds*. Together they constitute five *discrete* audio channels. A dedicated subwoofer (loudspeaker) is used to play the LFE channel, completing the .1 part of the 5.1 setup.

G. The Stereo Mix

The decision to mix in mono, stereo, or multichannel is dependent on the final release format such as16-mm film (mono) or DVD (5.1). Currently, stereo (two channels) is the standard mix format for festival-release prints and demo reels. A conventional stereo mix (Figure 11.2) consists of dialog panned to the center (mono), music and ambience panned hard left and right, and SFX (including Foley) panned to perspective (fixed or dynamic).

H. The Multichannel Mix

Multichannel mix formats extend the sound field beyond the frontal boundaries of a two-channel mix to include additional rear channels (Ls and Rs), a discrete center channel (C), and an LFE or *boom* channel. These additional channels are used to develop the mono, stereo, and surround components that constitute the multichannel *sound field* (Figure 11.3).

Stereo imaging produces a *phantom image* (the sense that sound is coming from the center even though there is no physical center speaker present). In 5.1, a physical *center channel* is provided that creates a discrete output occurring in the same position of the phantom image (Figure 11.4).

The *surrounds* (Ls and Rs) are often used to reproduce ambient elements and to facilitate front-to-back panning effects. The LFE (low-frequency effects) channel is a unique one created for the purpose of carrying low-frequency effects such as earthquakes, explosions, and vehicle rumbles. LFE signals are boosted by an additional 10 dB and equalized to remove all frequencies above 120 Hz.

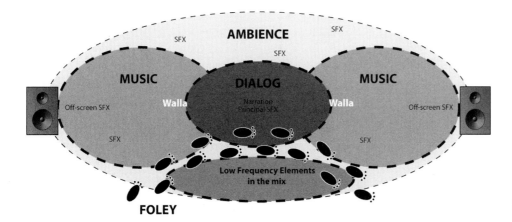

FIGURE 11.2. Stereo mix.

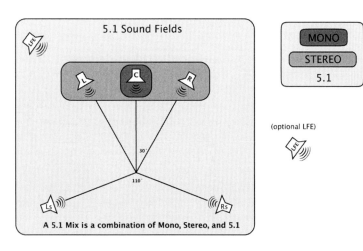

FIGURE11.3. The sound fields.

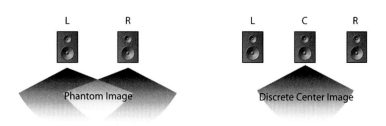

FIGURE 11.4 Center Images.

The LFE is an optional channel for consumer playback systems; therefore, any LFE content essential to the narrative must also be present in the main loudspeakers, as well.

I. Multichannel Panning

Panning is to the film mix as staging (blocking) is to theater. Panning is either *fixed* (static) or *dynamic* (moving). Fixed panning promotes stability in the mix and is used to support static visuals or ambient elements. Dynamic panning is used to maintain perspective with visuals moving on-screen. *Off-screen panning* and *flown effects* are supported by multichannel mix formats such as Dolby SR. Flown effects utilize all of the available full-range loudspeakers.

1. PANNING DIALOG IN 5.1

Dialog carries different information than that found in SFX and music. Michel Chion categorizes dialog as *semantic* (linguistic) while Walter Murch refers to it as *encoded* (perceptual). Regardless of the terminology, theorists generally agree that additional cognitive processing is needed to derive both literal and implied (subtext) meaning from dialog; consequently, audiences focus on the content rather than the placement of dialog in the mix (panning and volume). This explains, in part why dialog is routinely panned to the center (Figure 11.5A) and volume levels are kept fairly consistent regardless of camera angles. In some situations, however, additional panning options are appropriate.

For example, the stereo (L and R) channels are often used for narration or voice-overs, providing additional contrast between nonsync and sync dialog (Figure 11.5B). Walla is often treated as

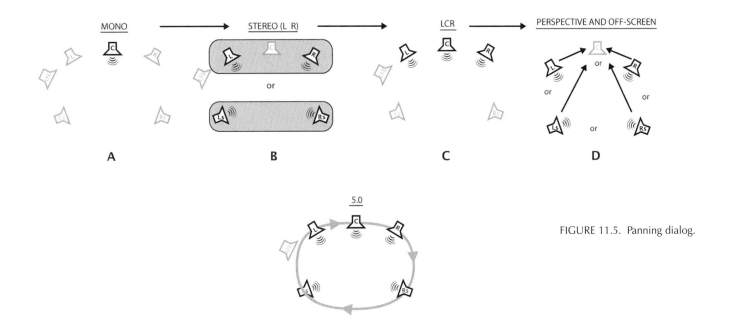

FIGURE 11.5. Panning dialog.

an ambient element and panned to the surrounds (LsRs). Dialog is often included in the screen channels to provide additional coverage for larger theaters (Figure 11.5C). Perspective and off-screen panning are used when the panning position is an essential component of the narrative (Figure 11.5D). An extreme example of perspective panning can be heard in the film *Casper* where the voices are flown (Figure 11.5E). Dialog is rarely included in the LFE. One notable exception can be heard in the Walt Disney feature *Aladdin*; in this example, the cave is personified with an omnidirectional voice carried (but not exclusively) in the LFE.

2. PANNING SFX IN 5.1

Sound effects are typically panned to reflect the on-screen objects or to suggest off-screen movement (Figure 11.6A and B). The addition of the center channel (creating a LCR subpath) helps to smooth the transition of dynamically panned effects moving from left to right in the front channels (Figure 11.6C). In some cases, SFX are panned dynamically between all five full-frequency channels (flown effects; Figure 11.6C). An undesirable panning consequence known as the *exit sign effect* can occur when hard effects, placed discretely in the surrounds, draw the audience's attention away from the screen.

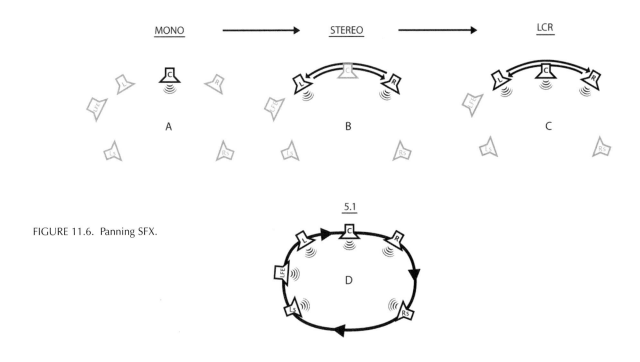

FIGURE 11.6. Panning SFX.

Unlike dialog and underscore, sound effects are routinely panned dynamically to follow the objects they represent. When panned dynamically, sound effects enhance the perception of motion and spatial perspective implied on-screen. Sound effects are often used as transitional devices. By creating subpaths within the 5.1 channel configuration, SFX can be dynamically panned discretely to and from specified channels (Figure 11.7).

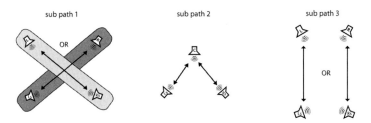

FIGURE11.7. Subpaths and dynamic panning.

3. PANNING AMBIENCE IN 5.1

Ambience helps to define the boundaries of the mix and is routinely panned to any and all available channels (Figure 11.8). When ambience is panned in the screen channels, the audience can be made to feel like spectators. When ambience is placed in both the screens and the surrounds, the audience feels as if they have been placed within the scene. It is not unusual to place separate ambient elements in both the stereo screen channels (LR) and the surrounds (LsRs).

4. PANNING MUSIC IN 5.1

In multichannel formats, the music for title sequences often utilize all available channels for maximum coverage and impact (Figure 11.9A). Then, as the narrative begins, the placement of the score is reduced to stereo (L and R). Underscore is traditionally placed in the stereo screens (Figure 11.9B). Source music (mono) is often panned to an on-screen or implied perspective (Figure 11.9C).

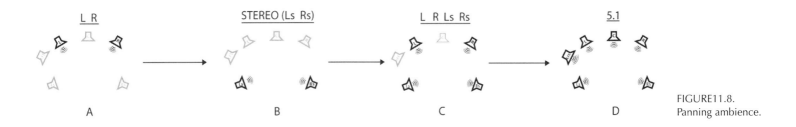

FIGURE11.8.
Panning ambience.

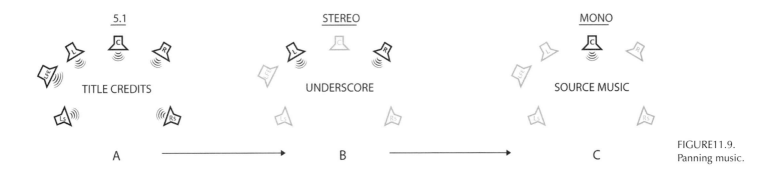

FIGURE11.9.
Panning music.

J. Signal Processing at the Final Mix

Most signal processing takes place at the final mix, allowing the mix engineer added flexibility in creating continuity and perspective. Reverb is a common signal process applied at the final mix stage. Continuity within a scene is promoted by using the same reverb on all tracks; however, as the mix becomes more reverberant, intelligibility decreases. For this reason, dialog is often treated with less reverb than other elements.

K. Setting Mix Levels

Mix levels are the most important means of prioritizing each element in the mix. Rerecording mixers use volume levels to move sounds to the foreground (higher levels) or background (*depth of field*) of the mix. As sounds increase in level, they also occupy more space within the mix; therefore, the proper balance of each element requires multiple level adjustments in the context of the full mix. Mix engineers also control the output levels of individual tracks to avoid clipping (distortion), which can occur when multiple tracks are summed. Sounds with wide dynamic range represent the greatest challenge for balancing mix levels. Compression is commonly applied to individual tracks during the mix stage to control and optimize the output levels, making each element more predictable and easier to mix.

L. Mastering

Mastering is perhaps the least understood process in audio post-production, yet it is critical to the overall success of the sound track. Audio mastering is to the sound track what color correction is to the animation. Where mixing is local (track by track), mastering is global (master outputs), utilizing equalization, compression, and dithering to optimize the mix for the final release. A mix that over-emphasizes a specific frequency range tends to fatigue the audience. Equalization is one means of creating an even spectral balance throughout the mix. When applied globally, equalizers produce sonic results that are comparable with camera filters and lighting. If the overall mix is muddy, a cut between 100 and 300 Hz (the mud range) may remove excess frequencies contributing to the muddiness. A harsh-sounding mix may benefit from a slight cut between 1 and 3 kHz (presence range). Boosting slightly from 12 kHz on up can brighten the mix a bit. If excessive equalization is required, it may be necessary to revisit the premixes to equalize specific tracks. Each release format has a specific dynamic range. For those formats with lower dynamic range, compression is applied to the final mix to ensure that the dynamic range of the print master is consistent with the release format. A limiter is also used to reduce clipping (levels exceeding acceptable levels), which often occurs as tracks are summed to the master fader. If the mix has been done properly, only modest limiting will be needed at the mastering stage. If excessive limiting is required, then it may be necessary to revisit the mix to adjust levels individually. At the last stage of the final mix, *dither* (randomized noise) is applied to the output of the master fader. The randomized noise used in the dithering process is less apparent to our ears than the noise that it reduces (quantization artifacts). The gains in audio quality that result from dithering are most noticeable during quiet moments in the mix.

M. Suggestions for the Final Mix

- Variations in dynamic range (soft to loud) contribute to the expressive quality of the work and prevent the audience from becoming fatigued. Audiences respond more to relative changes in volume than to specific decibel levels.

- Dialog levels for sound tracks are mixed slightly louder (65 to 70 dB) than would be heard conversationally. Audiences gauge volume levels primarily by the mix level of dialog; consequently, dialog levels are often the reference point for the entire mix.

- When ambience has been established, it can then be lowered in the mix to make room for other sounds. The mix engineer may increase the mix level of the ambience from time to time to reestablish the ambience or in response to narrative requirements.

- An animation should not be mixed using the same aesthetic approach used to mix music-only projects. This means that the output meters should be peaking on average at a level that leaves roughly 20 dB of *headroom* (distance to maximum peak level). The additional headroom should be used sparingly. Full-scale audio will quickly fatigue the audience and often result in clipping when the mix is summed to stereo or mono.

- Make sure all panning that occurs at the auxiliary track preserves the imaging created at the source track.

- Listen to the mix for masking (louder sounds covering up softer ones), especially if the sounds share the same frequencies. This is especially important when loud sounds are panned dynamically.

- Always mix to the specifications of the release format. When possible, place monitoring software on the master fader to simulate the limitations (frequency, dynamic range, and channel count) of the final release format.

- For greater objectivity in the mix process, use an outside mix or mastering engineer to complete the mix.

N. Sound Characteristics of Various Release Formats

Understanding the technical characteristics of the release format is an important step toward creating an effective mix. Variables for release formats include the number of available channels, frequency response, and dynamic range.

1. MONO FORMATS

Mono mixes are still prepared for television programming and 16-mm film. Mixing down from multichannel to mono can result in *mono-compatibility* issues such as phase cancellation and frequency masking. If the mix was prepared in stereo or multichannel, consider the following when mixing down to mono for 16-mm film:

- Remove nonessential elements of the mix when overcrowding (frequency masking) occurs.

- Watch for clipping, which can occur when tracks are summed; 16-mm film lacks the dynamic range available for release formats that support digital audio.

- Replace left-to-right panning (stereo) with front-to-back movement (depth) using volume and reverb to create depth (foreground/background), achieve contrast, and provide motion.

- 16-mm film has a severely limited frequency bandwidth. When possible, monitor the mix at lower levels and insert EQ on the master fader, set the EQ to narrow the frequency bandwidth to a range from 100 Hz to 6.7 kHz.

- Place a countdown leader at the beginning of the film with a sync-pop placed on the "2" frame of the countdown. The two-pop (sync pop) consists of a 1-kHz tone at –20 or –18 dB, lasting

one frame in length. An additional pop is sometimes included at the tail end of the animation to provide book-end sync references. Both sync pops are used to check for sync drift.

2. STEREO FORMATS

BetaCam (analog video) is a two-channel analog audio tape format. The frequency response for BetaCam is approximately 50 Hz to 15 kHz; therefore, expect to lose some of the lows and highs as compared to the full-frequency mix. If the original session was mixed in multichannel, watch for peak overloads that can occur due to down-mixing.

DigiBeta (digital video) is a four-channel digital audio tape format widely used for festivals and demo reels. Not all DigiBeta decks have four discrete digital outs, and many festivals require a stereo rather than four-channel mix. DigiBeta supports both 16- and 24-bit files at 48 kHz. The output of a stereo mix from a digital workstation should translate fairly accurately when transferred back to DigiBeta (a process known as *layback*). If the original session was mixed in multichannel, watch for peak overloads that can occur due to down-mixing.

3. MULTICHANNEL FORMATS

The 35-mm (film) Dolby SR (spectral recording) analog audio format is compatible with most existing 35 mm projectors. SR refers to the noise reduction applied to the optical tracks (sound negative) to increase dynamic range (Figure 11.10). Dolby SR can support either a stereo mix or a multichannel mix (SR LtRt or LCRS). The Dolby SR-D designation indicates that a digital file (AC-3) has been placed between the sprocket holes of the film. The AC-3 file is a multichannel digital file that requires a special reader installed on the projector for playback. Dolby SR is a popular film format for animation festivals.

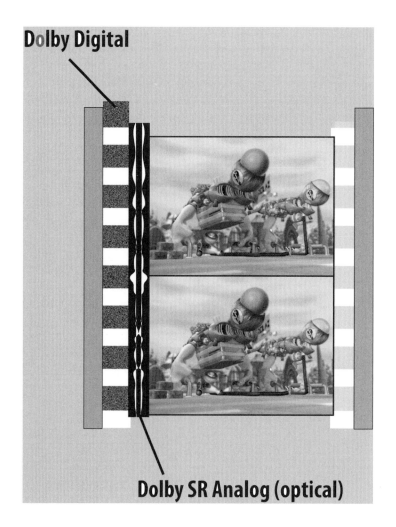

Dolby Digital

Dolby SR Analog (optical)

FIGURE11.10. Optical tracks.

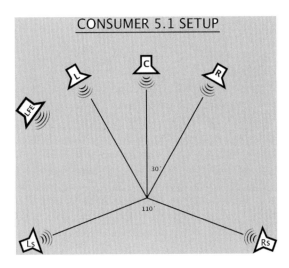

FIGURE11.11. Consumer 5.1 surround setup.

sion. If disc space allows, the discrete stereo mix can be left uncompressed, improving the quality of the mix even further. When preparing a multichannel mix that includes a LFE channel, it is good practice to place monitoring plug-ins on the master fader to emulate the bandwidth limiting (120 Hz) and level gains (+10 dB) that are applied to the LFE in the encoding process. Because many home theaters lack the subwoofer loudspeaker needed to handle the LFE, important story points are never placed exclusively in the LFE.

O. Sound Design and the DVD-V Menu

DVD-V is an interactive medium that uses menus to navigate through a variety of content. These menus often provide additional opportunities for sound design using techniques (such as looping) associated with video game production. The DVD-V spec supports multiple audio streams containing compressed (AC-3/DTS) and noncompressed (linear pulse code modulation, or LPCM) audio. These audio streams are used to provide extra features such as isolated SFX and foreign language versions.

DVD-V (digital video) is the most widely used format for home theater use. It has also gained wide acceptance as a format for demo reels; however, this format has yet to gain wide acceptance on the festival circuit largely due to the loss of video quality associated with video compression and projection losses. Unlike theatrical 5.1 setups, home theaters are set up with the surrounds placed behind the viewer rather than to the sides (Figure 11.11). In addition, they are also closer in proximity to the audience and their output levels are identical to those of the screen. This placement of the surrounds has potential implications for panning, leveling, and equalization when creating a mix for consumer playback systems.

The consumer market is still transitioning from stereo systems to multichannel. In response to this situation, Dolby created a *down-mix* option that reduces the sound track to stereo if a multichannel decoder is not detected. A discrete stereo mix is often prepared, providing a superior alternative to the down-mixed ver-

P. Creating the Release Print

The print master is delivered to the picture editor who resyncs the audio to image (*layback*) in a video-editing suite. The combined audio and video elements, known as the *answer print*, are then checked for audio playback issues such as sync drift. When the

answer print has been approved, the audio and associated picture are then transferred to videotape, creating a *video release print*. For the DVD-V format, the audio is first encoded and then multiplexed (combined with video assets) to create the master DVD-V. Print masters that are intended for film are sent to a digital-to-film transfer facility. The print master can be delivered in a variety of formats, including DA-88, Timecode DAT, AIFF/WAV files, and Pro Tools® sessions. The film lab will use the print master to prepare a release print containing the optical track and optional digital AC-3 file. The following labs are recommended for this process: www.ntaudio.com (310-828-1098; student rates available) and www.soundone.com (212-603-4300).

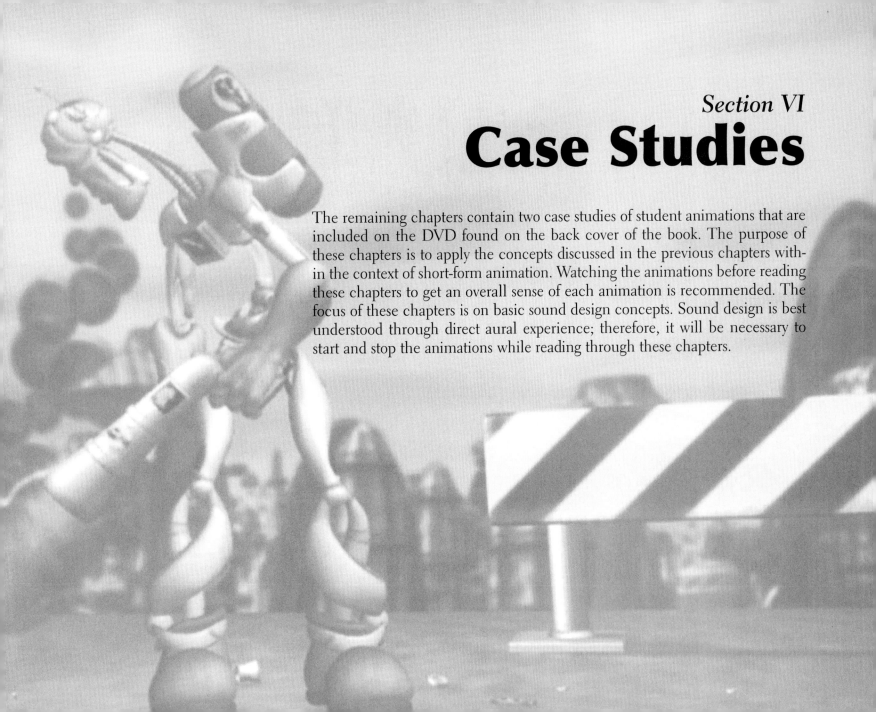

Section VI
Case Studies

The remaining chapters contain two case studies of student animations that are included on the DVD found on the back cover of the book. The purpose of these chapters is to apply the concepts discussed in the previous chapters within the context of short-form animation. Watching the animations before reading these chapters to get an overall sense of each animation is recommended. The focus of these chapters is on basic sound design concepts. Sound design is best understood through direct aural experience; therefore, it will be necessary to start and stop the animations while reading through these chapters.

Case Study:
A Trip to Granny's

A. Synopsis

A Trip to Granny's is a student three-dimensional animation created by Aaron Conover and Chris Evans. The story tells of a boy's experience visiting his elderly grandparent. The story moves between the implied reality and the child's inner fantasies. In the end, we are left to wonder what is real and what is the product of the child's imagination.

FIGURE 12.1. Granny's house.

B. Production Overview

The directors delivered a "locked" two-dimensional animatic at the end of the preproduction phase. From that point, the directors had only 10 weeks to complete the remainder of the project and no budget to do so. The DigiBeta (stereo mix) and DVD (consumer 5.1 mix) formats were selected as final release formats. All workprints were delivered as 320 ¥ 240 QuickTime™ video at a frame rate of 29.97 nondrop. A time code burn-in window was provided to help with spotting and to check for sync drift. The original audio for the sound track was developed using Digidesign's Pro Tools® software. The majority of the score was built using production music from the DeWolfe library; however, additional arrangements were prepared and recorded. An attempt was made to record as many original SFX as possible, but SFX from the libraries of The Hollywood Edge and Sound Ideas were also used. All recording, editing, and mixing sessions were done using the WAV audio file format at 24 bit, 48 kHz. The WAV audio file format was selected for cross-platform compatibility.

C. The Dialog Stem

No sync dialog or narration was required for this animation. Voice-overs were used extensively in the television mock-ups that ran throughout the animation. Each voice-over was recorded and processed (futzed) to emulate the sound quality coming from an old television set. At times, the commercials functioned only as ambient elements, while at other times they provided key story points and a back story. Mix levels and panning were used to reinforce this distinction. The concept of time lapse was reinforced by cross-fading the television from program to program. The following is a brief description of the commercials developed for this animation.

1. Verti-Broil Commercial

00:01:31:00 (off-screen moving to on-screen)

The Verti-Broil commercial, a parody on Ronco®-style marketing, promotes a vertical toaster for steaks. This commercial called for over-the-top voice-over and dramatic sound effects. The Verti-Broil spot begins off-screen to provide interior ambience and to establish Granny's character. Delay was added to the voice to give it a cheesy over-the-top production value.

2. Ninja Slug Commercial

00:02:43:28 (nonsync)

The Ninja Slug commercial provided the back story for the slug decoder watch and t-shirt worn by the boy. It also represents the kind of programming a typical boy would be drawn to and therefore helps to establish his character. The commercial was scored with pop-style music to establish a time period and to promote the gender gap between the boy and his grandmother. The cue quickly transitions to a militaristic piece to support the Patton-like voiceover. The commercial is an important means of establishing the concept that robots are disguising themselves as ordinary people. The Digidesign SciFi plug-in was used to transform the voice from human to robot, playing off the words "Remember, these robots can look like *ordinary people,* so be on the lookout."

FIGURE 12.2. Verti-Broil.

3. The Jesus Hour

00:03:45:26 (off-screen)

The *Jesus Hour* is a parody of television evangelists. The voice-over called for a stereotype tv evangelist reading. When the commercial was established it was lowered in the mix to make room for the other elements. The voice-over is brought up (spiked) from time to time to deliver humorous lines.

4. The Shopping Network

00:04:18:20 (off-screen)

The Shopping Network segment is a knock-off of paid programming. This programming is used for character development, reinforcing the stereotype that elderly people sit around watching television all day. During this sequence, we see Granny asleep in her chair, drooling all over herself. In the background, we hear the

saleswoman saying "It's gorgeous, just gorgeous," providing ironic contrast between the on-screen image and the voice-over.

5. Time-Lapse Sequence

00:04:41:14 (off-screen)

The purpose of this sequence is to compress time through visual wipes and audio cross-fades. Within the space of a few seconds, we transition from the Shopping Network to sports programming, daytime drama, and a program spot. The original programming for this sequence was recorded directly from television. For legal reasons, each program had to be reconstructed.

6. Fiber Nutz Cereal

00:05:03:08 (off-screen)

Fiber Nutz is a product designed to help anemic people get energy and remedy their constipation. Two voiceovers were needed, one to epitomize the anemic consumer and the other to deliver the upbeat sales pitch. Foley was used to create the sounds for the cereal bowl.

FIGURE 12.3. DeWolfe music used for A Trip To Granny's.

D. The Music Stem

A *Trip to Granny's* contains no sync dialog, and music is the driving element for much of the sound track. Because the production schedule was short and there was no budget for music, a decision was made to use precleared library music for the underscore (Figure 12.3).

The academic institutions blanket license with DeWolfe Music allowed the students to use an unlimited amount of their extensive library at no additional cost. Tim Souster (DeWolfe Music) composed most of the music from which the cues were derived. By using the same composer, a sense of continuity was created throughout the score. All of the source cues (except "Toxic Ninja") were reduced from stereo to mono and bandlimited to represent the low audio quality of an old television set. The following are brief descriptions of the individual cues created for this animation.

Cue 1M1

Arriving at Grandma's

Start 00:00:15:29

End 00:00:51:15

Total 00:01:35:00

"Streets of Palermo" by Tim Souster. The music for the title sequence established the quirky and unsettling feel required for the animation. An intercut edit was made to allow the cadence (ending) of the cue to sync at the point when the camera panning ends. Additional frames of black were added to the animation, allowing the cue to back time to its original start point.

Cue 1M2

Entering the House

Start 00:01:03:28

End 00:02:35:16

Total 00:01:35:00

"Angel of Death" by Tim Souster. This cue begins just as the boy looks up at the knocker (insert shot). The pensive nature of the music underscores the apprehension that he is experiencing as he contemplates entering the house. Several edits were made to sync the cadence of the cue at the point when the boy falls to the ground. The cue is driving the scene, building in volume and intensity as Granny approaches. The cue ends with a musical homage to *Psycho,* paired with an on-screen hug by Granny.

Cue 1M3

Hug from Granny

Start 00:02:16:23

End 00:02:42:20

Total 00:00:25:00

"Angel of Death" by Tim Souster. To extend the cue further, the high string note (inverted pedal point) was looped and an arrangement of the previous theme was prepared in the same key to match the previous cue thematically. The arrangement was recorded with a woodwind quintet and treated with reverb to match the earlier cue.

Cue 1M4

Ninja Slug Commercial

Start 00:02:39:18

End 00:02:51:07

Total 00:00:11:00

"Toxic Ninja" (original source music). The original source music for this cue was temped with a Joe Satriani composition. Synchronization rights could not be obtained as there was no budget for the project. A knock-off (sound-alike) was developed and recorded by local musicians, replacing the original temp music.

Cue 1M5

Ninja Slug, Part 2

Start 00:02:50:18

End 00:03:07:07

Total 00:00:16:00

"Battle Action" by Frederic Talgorn. The source music transitions from a rock style to a military style to underscore the drill sergeant voice-over. The music fades out at one point to allow the hard effects to drive the scene. The cue finishes with the same military music, which is edited so it cadences (ends) at the same point at which the commercial ends.

Cue 1M6

Cartoon Knock-Off

Start 00:02:50:18

End 00:03:07:07

Total 00:00:16:00

"Squirrels on the Spree" by Theo Langlois. The purpose of this cue was to provide source music for an off-screen cartoon created to suggest the style of a 1940s Warner Brothers short. The music selected was reminiscent of the composition style of Carl Stalling. The high and low frequencies of the music were cut (bandlimited) and the imaging was reduced to mono to suggest that the music was source music coming from the television. The cue ends with a deceleration treatment (WaveMechanic's Speed™) that allows the music to sync with the slow motion images occurring on-screen.

Cue 1M7

The Jesus Hour

Start 00:03:42:19

End 00:03:53:15

Total 00:00:10:00

"It's Gospel" by Barbara Moore. A hymn played by on church organ (off-screen) advertises the visual cut that occurs at the point when Granny presses the television remote. The cue establishes the concept of television evangelism and continues to play under the sermon to enhance the voice-over. The music is introduced in progress to promote the concept of parallel action. It is also treated with narrow bandlimiting to promote the sense of source music rather than underscore.

Cue 1M8

Dream Sequence

Start 00:03:52:00

End 00:04:23:23

Total 00:00:31:00

"Fragile Truce" by Frederic Talgorn. This cue was used to provide continuity for the sequence and to underscore the trance-like state of the on-screen characters.

Cue 1M9

Granny Is Revealed

Start 00:04:51:18

End 00:05:03:03

Total 00:00:11:00

"Frenzy" by Tim Souster. This cue begins with an ascending musical figure that hits at the moment when Granny's head swings open, exposing the mechanical brain within. This is a violent cue in the style of Bernard Herman and is used as a substitution for the boy screaming.

Cue 1M10

Peekaboo

Start 00:02:50:18

End 00:03:07:07

Total 00:00:16:00

"Frenzy" by Tim Souster. This cue begins with a series of musical pitches rolling in an upward motion (arpeggio). The arpeggio isomorphs the door opening, eliminating the need for a literal door squeak. Surround panning was used to enhance the motion implied by the arpeggio, opening from the center (mono) to all five main channels (5.0) in sync with the door opening. By limiting the instrumentation to piano, a greater sense of stealth is established for the scene.

Cue 1M11

Escaping

Start 00:05:21:03

End 00:05:36:25

Total 00:00:15:00

"Frenzy" by Tim Souster. This cue underscores the final sequence in which the boy tries frantically to escape the house. The cue replaces the need for Foley footsteps and hard effects and provides the driving linear element for the sequence. The audio track was edited in several places so it would hit at important visual sync points. A harmonica is introduced into the cue to direct our attention to the mother's eyes glowing, a nod to the audience that she, too, might be a robot.

Cue 1M12

Conflict Resolution

Start 00:05:37:00

End 00:05:56:21

Total 00:00:19:00

"Frenzy" by Tim Souster. This cue provides some resolution to the primary conflict but it also keeps us wondering what the next day might bring.

FIGURE 12.4. Opening door.

Cue 1M13

End Credits

Start 00:06:14:18

End 00:07:21:11

Total 00:00:06:00

"Battle Action" by Frederic Talgorn. The end credits were developed without prescore, so significant music editing was needed to customize the score to the many visual transitions that occur. A variety of intercuts and cross-fades were created to customize the music to the on-screen visuals. A conscious effort was made to provide hits for titles and transitions. Music from the Ninja commercial was reprised to promote continuity and suggest closure.

E. The SFX Stem

The sound effects stem contains both subjective and literal effects. Hard effects and Foley were recorded in both a studio and in the field. The robotic sequences provided excellent opportunities to develop built-up effects. Ambience was used to establish the interior and exterior perspectives while also suggesting the mood. As with the music stem, the predominance of source audio called for signal processing that contrasted source, on-screen, and off-screen sounds. The following is a selective list of SFX and their production characteristics.

1. Mom's Vehicle

00:00:00:00 (off-screen; mono; dynamic panning)

The sound of a car idling can be heard during the opening seconds of black, allowing the audience to construct a visual for a vehicle that is not yet on-screen. Multiple sound elements (rough idling and squeaky breaks) were built up to suggest that the car is old and rickety. The car is panned to center and gradually moves off to the left as suggested by the on-screen visuals.

2. Car Door Closing

00:00:34:09 (off-screen; mono; panned to center)

A hard effect of a wobbly door was used to complete the narrative that the boy has exited the car.

3. Ambience

00:00:40:19 (nonsync; stereo)

This ambience contains light wind with occasional gusts. Dry leaf sounds were added to suggest leaf piles and emphasize that the on-screen tree has lost its leaves. Animal and bug sounds were deliberately limited to suggest a cold fall day.

4. Footsteps

00:00:48:10 (sync; mono; dynamic panning)

The initial footsteps for this scene were taken from an effects library and cut to image. The remaining footsteps were recorded to image (Foley) on a hollow surface to suggest a raised porch.

5. Bird Caws

00:00:48:26 (off-screen; mono; dynamic panning)

Bird caws were added to suggest that a bird was disturbed from its nest, located in the nearby tree. The bird caws are dynamically panned to create motion and interest for a relatively static scene.

6. Screen Door

00:00:55:22 (sync; mono; dynamic panning)

The sound of a screen door was edited and time scaled to match the on-screen movements. Door squeaks and a light door slam were layered in to customize the effect. Aerosol spray was recorded and synced to the on-screen tearing of the screen.

FIGURE 12.5. Foley Footsteps.

7. Body Impact

00:01:10:15 (sync; mono; panned to center)

The impact sound of the boy's fall was created by dropping a heavy book bag.

8. Main Door Opening

00:01:17:26 (sync; mono; panned to center)

The sound of the door opening was cut from the SFX library and time scaled to match the image. Reverb was added to the interior shot of the door to provide contrast.

9. Light Switch

00:01:21:11 (nonsync; mono; panned to center)

The sound for the light switch was created by finger snapping.

10. Main Door Closing

00:01:25:28 (sync; stereo moving to mono)

The sound for the main door closing was built up and exaggerated using a bank vault door, a rolling jail cell door, reversed wind ambience, and low-frequency rumble. The sync point for the door closing can be seen in the reflection cast against the wall. The effect ends with a series of bolt locks reflecting the many types of locks shown on-screen later in the animation. Heavy reverb was applied to the sound to further exaggerate the intensity of the event.

FIGURE 12.6. Door knocker.

11. Grandfather Clock

00:01:33:13 (off-screen; mono; panned to center)

The sound of the grandfather clock creates an old-fashioned ambient drone. The clock covers the boy's cautious movements toward the interior of the house.

12. Verti-Broiler

00:01:37:23 (off-screen; mono; panned to center)

The sound of the Verti-Broiler was built-up using toaster sounds and frying bacon. The Verti-Broiler was processed with the same bandlimiting used for the accompanying voice-over to create the source effect (television).

13. Granny's Walker

00:01:44:16 (sync; mono; panned dynamically)

Granny's walker was constructed using the sounds of wicker being twisted, anvil hits, and a low-frequency rumble. The effect is hard synced and unfortunately advertises a bad visual edit at 00:02:02:12, where the footsteps are interrupted. The walker is pitched up as Granny approaches.

14. Broken Effects

00:02:03:08 (nonsync; mono; panned to center)

The sound of the picture frame crashing to the floor was created with a small glass pane. The point of impact was estimated based on the on-screen rate of fall. A clay pot was used to represent the sound of a radio falling from the night stand.

FIGURE 12.7.
The Walker

15. Sofa Squeaks

00:02:34:23 (sync; mono; panned to center)

The sound of the sofa squeak was built up using the sound of ships at dock and various spring sounds. This effect exaggerates the weight and size differences between Granny and the little boy.

16. Slugs in Flight

00:02:37:15 (sync; mono; panned to center)

The sound for the flying slugs was taken from a synthesizer and introduced prior to the scene change (prelap) as a transitional element to the Ninja Slug promotional spot. This sound also covers sound for the Ninja slugs in flight. The sound of a rocket launching was added near the end of this sound effect to cover the last projectile launched from the slug's mouth.

17. Riding the Sofa

00:02:51:28 (off-screen to on-screen; mono; panned dynamically)

The sound of horses galloping was substituted for the literal sound of sofa springs to make the on-screen visuals more playful. The gallops were introduced off-screen as an establishing sound for the shot of the boy in front of the television. Each gallop was edited to match the timings shown on-screen.

18. Air-Raid Siren

00:02:52:12 (off-screen; mono; panned to center)

The air-raid siren was added to the television commercial to heighten the sense of urgency and promote the military theme.

19. *Terminator* Homage

00:02:54:13 (sync; mono; panned to center)

Sounds for the on-screen battle images include various laser weapons firing, egg shells breaking (skulls being crushed), and synthesized ambient sounds. Warning blasts were also included to provide variation from the air-raid siren.

20. Robot Assembly Line

00:03:03:04 (sync; mono; panned to center)

A variety of servos, air compressors, and engine start-ups were layered to emulate a robot assembly line.

FIGURE 12.8. Terminator.

21. Slug Decoder Watch

00:03:15:15 (sync; mono; Doppler)

The sound for the slug decoder watch was built up using telemetry sounds (to imply that it is a communication device) and a sonar ping to reinforce its military application. The entire effect was treated with Doppler to enhance the rotation of the object.

22. Cartoon Mock-Up

00:03:23:15 (off-screen; mono; panned to center)

A cartoon mock-up was developed to simulate the sound design of a 1940s Warner Brothers animation. The sounds for the mock-up include various classic cartoon and vocal effects layered over a Carl Stalling type of underscore. Extreme bandwidth limiting was applied to the effect to make it sound as if it was coming from an old television set. The sonic narrative was decelerated and pitched down to sync with the on-screen slow-motion sequence.

23. On-Screen Vocalizations

00:03:53:25 (sync; mono; panned to center)

Snoring and gagging sounds were recorded to image (Foley). Additional baby coughs were also added (sweetened) for effect.

FIGURE 12.9. Robot Assembly.

FIGURE 12.10. Slug decoder watch.

24. Granny's Head Opening

00:04:54:10 (sync; mono; panned to center)

A built up effect was developed for the shot in which Granny's head opens, exposing her robotic construction. This effect consists of a blending of organic and mechanical elements including crushed pop cans, celery snaps, liquid being poured, and the sound of melons being squished.

25. Dream Sequence

00:04:55:15 (off-screen; surround to mono)

An off-screen sound narrative was developed to imply that the house was under attack. A low-frequency rumble was used to simulate a large ship approaching. Other elements include a windowpane breaking, wind gusts, and various laser blasts. Pressurized air was recorded and digitally reversed, creating a transitional device to suggest that the boy was no longer dreaming. This effect was enhanced in the 5.1 mix by collapsing the mix from 5.0 to the center (mono) channel just at the point at which he wakes up.

FIGURE 12.11. Head Opening.

26. Bathroom Sequence

00:05:08:05 (off-screen; mono; panned to center)

An off-screen sound narrative was built to provide motivation for the boy moving from the sofa to the bathroom. The narrative includes a toilet flushing, sink handle squeaks, and the dripping of a faucet into standing water.

27. False Teeth

00:05:18:17 (sync; mono; panned to center)

An oozing sound is layered with hydraulic servos, hinting that Granny is more than she appears to be.

28. Robot Assembly

00:05:21:12 (sync; mono; panned to center)

This cue is a reprise of the earlier built-up effect of the robot assembly plant.

FIGURE 12.12. Dentures Out.

29. Car Driving Away

00:05:38:21 (off-screen; mono; dynamically panned)

This cue is a reprise of the original auto sounds. The effect is panned from the center to left channels following the camera movement.

30. Ambience

00:05:34:17 (nonsync; stereo)

Wind ambience returns along with some basic screen door movements.

31. Granny Grows Mechanical Legs

00:05:55:23 (sync; stereo)

This sound is a built-up effect featuring engine start-ups, servos, shovel digs, and wood hits, all synced tightly to image. Aspects were pitch shifted to provide variation throughout the effect.

32. End Credits

(sync; mono; panned dynamically)

The sound design for the decoder is reprised for continuity. Telemetry sounds were synced to each letter as the decoder spells out the end credits. Various jet fly-bys are used to cover the titles breaking up and dissipating.

FIGURE 12.13. Granny Revealed.

Case Study: Sam **13**

A. Synopsis

Sam is a 3D animation created and directed by student Kyle Winkleman. This animation explores the career choices that we make throughout our lives and the challenges that come with these choices. Sam, the principle character, has become discontent with his role in life and seeks new challenges. An opportunity for change arises when Sam discovers a career-programming disc that has been discarded by a disgruntled pilot. Sam inserts the discarded disc into his computer and receives pilot training. Soon after, he embarks on a solo flight that will test his newly gained skills. During the flight, Sam's programming disc fails and he is forced to rely on his own skills rather than technology. At the conclusion of the flight, Sam must choose between the roles of janitor and pilot.

B. Production Overview

The directors delivered a "locked" two-dimensional animatic at the end of the preproduction phase. From that point, the directors had 20 weeks to complete the remainder of the project and no budget to do so. The DigiBeta (stereo mix) and DVD (consumer 5.1 mix)

FIGURE 13.1. Sam Poster.

formats were selected as final release formats. All workprints were delivered as 320 ¥ 240 QuickTime™ video at a frame rate of 29.97 nondrop. A time code burn-in window was provided to help with spotting and to check for sync drift. The original audio for the sound track was developed using Digidesign's Pro Tools® software. The entire score was built using production music from the DeWolfe library. An attempt was made to record as many original SFX as possible, but SFX from the libraries of The Hollywood Edge and Sound Ideas were also used All recording, editing, and mixing sessions were done using the WAV audio file format at 24 bit, 48 kHz. The WAV audio file format was selected for cross-platform compatibility.

C. The Dialog Stem

This animation has no sync dialog; however, radio communication from an off-screen flight controller was added to provide realism.

1. Radio Communication

00:02:40:07 (off-screen; mono; panned to center)

Flight instructions are transmitted from a control tower. The contents of the transmission do not contain story points.

2. Radio Communication

00:03:55:29 (off-screen; mono; panned to center)

Flight instructions are transmitted from a control tower. The contents of the transmission contain limited story points. The radio sounds are spiked to emphasize the phrase "clearing for landing."

D. The Music Stem

Sam contains no sync dialog, and music is the driving element for much of the sound track. Because there was no budget for music, a decision was made to use library music for the underscore (Figure 13.2).

The academic institutions blanket license with DeWolfe Music allowed the students to use an unlimited amount of their extensive library at no additional cost. Frederic Talgorn (DeWolfe Music) composed much of the music from which the cues were derived. By using the same composer, a sense of continuity was created throughout the score. Full orchestral music cues were selected to match the visual scale of the animation. The following are brief descriptions of the individual cues created for this animation.

FIGURE 13.2. DeWolfe music used for *Sam*.

Cue 1M2

Sam's Discontent

Start: 00:00:52:15

End: 00:01:09:10

Total: 00:00:16:00

"Final Encounter" by Frederic Talgorn. This cue underscores Sam's disappointment with his current role as a janitor (subtext scoring).

Cue 1M1

Title Sequence

Start: 00:00:11:29

End: 00:00:50:25

Total: 00:00:38:00

"Final Encounter" by Frederic Talgorn. This cue was designed to underscore the title sequence, establish scale, and transition the audience into the story. The cue builds to a climax, which is synced to the first on-screen ship launch . Rather than edit the beginning of the cue, an additional 26 seconds of video (black) was provided to match the music length (backtiming).

Cue 1M3

The Disgruntled Pilot

Start: 00:01:14:28

End: 00:01:09:10

Total: 00:00:24:00

"Final Encounter" by Frederic Talgorn. This cue underscores the idea that the pilot's frustration level has reached a critical point, causing him to abandon his life as a pilot. The music was intercut in several places to allow the string pizzicatos to sync with the footsteps.

FIGURE 13.3. Taking off.

FIGURE 13.4. Angry Pilot.

Cue 1M4

Becoming a Pilot

Start: 00:02:02:27

End: 00:03:00:09

Total: 00:57:12:00

"Fantastic Voyage" by Frederic Talgorn. This cue underscores Sam's transformation from janitor to pilot. The program disc (sound effect) is pitch shifted to the major seventh of the underscore as the disc drive is starting up. It soon resolves to the root of the chord, signifying that Sam is in programming mode. The cue was edited to climax at 00:02:30:16 as Sam looks up at the ship. A timpani syncs at 00:02:43:08 just at the moment when Sam activates the power thrusters. The cue ends on a pedal point, overlapping into the next cue to smooth the transition.

Cue 1M5

Becoming a Pilot

Start: 00:02:57:27

End: 00:03:42:24

Total: 00:00:44:00

"Final Encounter" by Frederic Talgorn. This cue reprises thematic material from cue 1M3 to underscore Sam's panic as the programming disc fails. The cue becomes increasingly frantic as flight conditions worsen. At 00:03:27:04, a reprise of an earlier cue is mixed with the underscore to support the on-screen flashback. A percussion track is layered at 00:03:31:01 to create a random rhythmic feeling and provide a terminating cadence (ending) for the cue.

Cue 1M6

Disaster Diverted

Start: 00:03:40:13

End: 00:04:02:18

Total: 00:00:22:00

"Final Encounter" by Frederic Talgorn. This cue underscores the exhilaration that comes when Sam defeats the odds and regains control of the ship. Additional trumpets were recorded and mixed into the cue to provide additional high-end punch. The cue begins in progress, utilizing a fade-in and SFX (masking) to smooth the in point. Extensive editing was made to the cue to ensure that the music resolves at the point in which the engine powers down.

Cue 1M7

At a Crossroad

Start: 00:04:00:25

End: 00:05:13:08

Total: 00:01:12:00

"Final Encounter" by Frederic Talgorn. This cue underscores the reflective nature of the scene.

Cue 1M8

End Credits

Start: 00:05:12:15

End: 00:06:31:05

Total: 00:01:18:00

"Final Encounter" by Frederic Talgorn. This cue underscores the resolution of the conflict and continues over the end credits.

E. The SFX Stem

Sound effects for this animation provide critical story points and support the scale at which the story takes place. Two distinctive ambience tracks are used during the flight sequence to establish the rapid transitions from interior and exterior shots. Many effects were pitch shifted to work harmonically with the underscore.

1. Flight Deck (Tarmac) Ambience

00:00:11:27 (off-screen; stereo)

The ambience is introduced prior to the first shot, creating the effect that a ship is warming up.

2. Tarmac Garbage Sounds

00:00:16:20 (on-screen; mono; dynamically panned)

A jet fly-by provides motivation for the on-screen garbage blowing across the tarmac. The garbage was recorded on a concrete floor using aluminum soft drink cans, Styrofoam coffee cups, candy wrappers, and a couple of old 3.5-inch floppy discs. The items were fanned with a large board to avoid adding blower sounds to the effect.

3. Rotating Screen Titles

00:00:20:23 (on-screen; mono; panned to center)

A rusty door hinge was used to sonify the mechanical-like rotation of the screen title, implying that the title is a physical element in the scene rather than a graphic overlay. A whoosh was added to enhance the motion of the title being blown off the screen.

4. Crane

00:00:24:15 (off-screen; mono; dynamically panned)

A mechanical lift was added to represent an off-screen crane hoisting the cargo container seen on-screen. The effect begins before the container is seen on-screen and continues after it moves off-screen.

5. The Globe

00:00:29:23 (on-screen; mono)

This effect was created by dragging concrete blocks against each other. Close microphone placement (condensers) was used to accentuate the high-frequency components. The concrete provided a sense of magnitude while also suggesting the physical make-up of the globe.

6. Cargo Lift of the Ship

00:00:36:00 (on-screen; mono; panned to center)

This stereo effect was created using a servo that was pitch shifted over time.

7. Tarmac Vehicle

00:00:37:13 (on-screen; mono; dynamically panned)

The sound of the vehicle was synthesized to give it a futuristic quality. This effect was pitched over time to suggest the engine start-up and was time scaled to create the impression that it continues to accelerate off-screen.

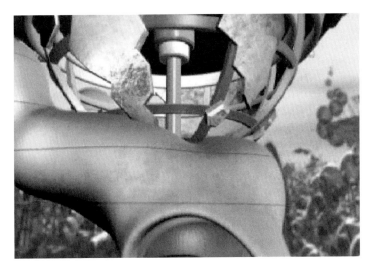

FIGURE 13.5. The Globe.

FIGURE 13.6. Angry Pilot.

FIGURE 13.7. City Ambience.

8. Launch Sequence No. 1

00:00:38:28 (on-screen; mono; dynamically panned)

This built-up effect consists of a turbo engine start-up, an air compressor, and a jet fly-by followed by a sonic boom to create the impression that the ship is taking off.

9. Flight Deck Ambience

00:00:48:28 to 00:02:46:13 (nonsync; stereo)

The ambience for this scene was created with layers of wind from urban environments. Wind gusts, cranes, and traffic sounds was added periodically to provide contrast. Two separate stereo tracks of distant air traffic were developed to enhance the ambience during quieter moments.

10. Flight Deck Blower

00:00:53:12 (on-screen; mono; panned to center)

The starter sound for the flight deck blower was created through synthesis. The primary sound of the blower consists of a wall-mounted fire extinguisher reversed. A small jet engine was pitched down to provide the sustaining element of the blower. The effect was volume automated to follow Sam's body movements. In addition, it was processed with Digidesign's VariFi™ to produce the power-down effect.

11. Landing Sequence

00:00:59:16 (on-screen and off-screen; stereo)

This built-up effect consists of several fly-bys panned and volume automated to create perspective and movement. Off-screen

FIGURE 13.8. Tarmac Blower.

garbage sounds were added to place the ship and Sam in the same environment. Pulsing whooshes were used to represent the erratic landing of the ship. Twisting leather sounds were used to represent the on-screen hand grips that secure the ship to the flight deck.

12. Flight Deck Cargo Vehicle

00:01:06:19 (on-screen; mono; dynamically panned)

The synthetic motorized sound is consistent with the first on-screen tarmac vehicle. The effect is pitched over time to suggest motor speeds.

13. Cargo Lift of the Ship

00:01:11:02 (on-screen; mono; dynamically panned)

This is the same lift used in the opening sequence, pitched down to reinforce the container descending.

14. Extending the Cockpit

00:01:11:21 (on-screen; mono; panned to center)
This effect was created using a synthesized bubble sound with a soft servo added.

15. Ventilation Sounds of the Ship

00:01:15:03 (on-screen; mono; dynamically panned)

Each vent was sonified with compressed air, pitch shifted for variation, and time scaled to match the images.

FIGURE 13.9. Cargo Lift.

16. Angry Pilot Foley

00:01:18:13 (on-screen; mono; dynamically panned)

These footsteps are covered with sounds made from twisting balloons and leather. An electrical sound was added to suggest disc failure.

17. Career Programming Disc

00:01:22:21 (on-screen; mono; panned to center)

This effect was created by rubbing the rim of a crystal glass. When the light illuminates, we hear the sound.

18. Disc Eject

00:01:24:25 (on-screen; mono; panned to center)

The eject portion of this effect is a recording of disc being ejected from an old drive. Some of the disc-handling sounds are actually

FIGURE 13.10. Programming Discs.

35-mm camera shutters. The sound of the disc hitting the tarmac was created by breaking a thin plate glass and was edited to match the image.

19. On-Screen Crane

00:01:31:05 (on-screen continuing off-screen; mono; dynamically panned)

This effect was created by layering pistons with a diesel engine. The sound is panned back and forth to image.

20. The Keypad

00:01:35:05 (on-screen; mono; panned to center)

The extension of the keypad arm was represented using an adjustable desk lamp arm. Light telemetry sounds include squeaky springs added to cover individual key punches.

21. Flight Hanger

00:01:39:24 (on-screen; mono; panned to center)

The flight hanger is a built-up effect beginning with two Foley fist hits on a thick notepad. Squeaks were added to cover the spring on the extending lamp arm. The interior of the flight hanger was built up using sounds derived from an auto mechanic shop. These sounds include air compressor tools, welding torches, and a warning buzzer. The effect ends with the sound of a hanger door closing, composed of reversed air and a large metal door closing with heavy reverb added. The door closing is an off-screen event that is timed to occur just before Sam looks back.

22. Tarmac Ambience

00:01:46:03 (off-screen; stereo)

This built-up effect was created with multiple spaceship fly-bys generated by synthesizers. Additional wind was added to complete the ambience.

23. Foley Footsteps

00:01:51:14 (on-screen; mono; panned to center)

Footsteps were introduced after the edit so as not to advertise the interruption in the walk cycle.

24. Disc Handling

00:01:56:15 (on-screen; mono; panned to center)

This Foley effect was created using the same disc drive used earlier. The effect is terminated with the sound of a camera shutter to cover the on-screen visual of the disc being removed. A small plate glass was broken to cover the sound of the disc hitting the tarmac.

25. Learning Sequencer

00:02:15:01 (on-screen; mono; panned to center)

This effect begins with the sound of crystal glass being rubbed. Each rim sound was pitched to work harmonically within the score. A whoosh with Doppler effect was added to signify that Sam has transitioned into the learning sequence. An EKG beep and a 35-mm camera sound were used to contrast the black-and-white images. The EKG represents Sam's physiological response and the 35-mm sound represents his intellectual acquisition. A flatline sound and a reversed whoosh were used to transition Sam out of the learning sequence.

FIGURE 13.11. Learning Sequence.

26. Engine Power-Up

00:02:26:20 (off-screen moving to on-screen; mono; panned to center)

The sound of a jet engine powering motivates Sam to look toward the flight vehicle. A thrust sound (pitching up) was added and cross-faded to sync with the rise of the jet.

27. Interior and Exterior Ambience

00:02:40:01 (nonsync; stereo; narrow image)

Separate ambiences were created to support the flight sequence, which cuts back and forth from interior cockpit shots and exterior vehicle shots. Hard cuts were made for the purpose of advertising the changes in perspective. The low frequencies of both ambience tracks were rolled off with EQ so as not to interfere with the low timpani notes, essentially cutting a hole in the ambience for the music.

FIGURE 13.12. Engine Power-Up.

FIGURE 13.13. Fly-Through.

28. Jet Rollover

00:02:41:02 (on-screen; mono; dynamically panned)

The jet fly-by was created using a library effect treated with Doppler and panned to imply a rollover.

29. Jet Fly-Through

00:02:42:10 (on-screen; mono; dynamically panned)

The jet fly-through was created using a library effect panned from the front channels to the Ls and Rs in 5.1.

30. Jet Exterior

00:02:46:24 (on-screen; surround)

For this exterior ambience, no volume changes were made because the camera follows the ship.

31. Fly-by

00:02:48:21 (on-screen; mono; dynamically panned)

This jet fly-by was pitch shifted and time scaled to match the on-screen image.

FIGURE 13.14. Fly-By.

32. Warning Beeps

00:02:55:15 (nonsync; mono; panned to center)

Warning beeps were added to the interior cockpit ambience and pitch shifted to match the underscore. Additional beeps were gradually added and pitched down a minor second to make the beep more dissonant and threatening.

33. Learning Disc Ejected

00:02:58:21 (on-screen; mono; panned to center)

This effect was created using the previously mentioned disc drive.

34. Button Pushing

00:03:06:15 (on-screen; mono; panned to center)

Telemetry sounds were edited to sync with the keypad actions.

35. Ship Spiraling Downward

00:03:06:24 (on-screen; mono; dynamically panned)

A low animal growl was added to a jet fly-by to increase the perception that the vehicle is falling.

36. Cockpit Ambience

00:03:09:09 (nonsync; stereo; narrow image)

Keyboard typing and fists hitting the dashboard were edited into the ambience in sync with Sam's on-screen actions.

FIGURE 13.15. Ship Falling

37. Jet Power Failure

00:03:10:19 (on-screen)

This is a fly-by with low-frequency effects (pitched-down lion growl) added. The effect was pitched down over time with WaveMechanic's Speed™ to suggest a power failure.

38. Wings Extending

00:03:15:07 (on-screen; mono to; stereo)

Various servos were edited and time scaled to fit on-screen action.

39. Engine Throttle

00:03:16:24 (on-screen; stereo)

The sound of a jet engine powering up was added in sync with the on-screen throttle motion.

FIGURE 13.16. Wings Extending.

40. Fly-Through and Roll-Over

00:03:18:12 (on-screen; surround; dynamic panning)

Panning was used to create the sonic effect that the ship is flying through you in both directions.

41. Flight Panel Warning Beeps

00:03:26:00 (on-screen; mono)

Various telemetry sounds were used to sonify the blinking lights of the flight panel.

42. Engine Powering-Up

00:03:38:24 (on-screen; mono)

This built-up effect has multiple jet-engine power-ups. The tail end of this effect was pitched down over time to reinforce the deceleration concept.

43. Landing Sequence

00:03:56:06 (on-screen; mono)

Compressed air and whooshes emphasize the visual bouncing of the vehicle as it lands on the tarmac. Leather and balloon sounds were used to represent the handgrips securing the vehicle.

44. Foghorn

00:04:15:10 (off-screen; mono; center)

The foghorn is pitched so it fits harmonically with the underscore. This sound occurs off-screen and explains why Sam looks off in the distance. It is also symbolizes the beginning of a new journey.

FIGURE 13.17. Landing.

48. Final Disc Handling

00:05:06:00 (on-screen; mono)

This effect was created using an old disc drive and a small plate glass, both pitched and time scaled to match the on-screen visuals.

49. Ambience

00:05:20:03 off-screen; stereo)

This ambience track was constructed with over 20 distinct ship sounds to create a traffic loop. The last fly-by suggests Sam is embarking on his new adventure.

45. Preparing for Takeoff

00:04:27:29 off-screen; mono

This effect was created using the sound of a turbo engine powering up, servos for retracting wings, and compressed air covering the release valves.

46. Tarmac Cargo Vehicle

00:04:40:29 (on-screen; mono; panned to image)

This vehicle was created by editing the same cargo vehicle used earlier.

47. Cargo Driver Foley Footsteps

00:04:54:07 (on-screen; mono; panned to image)

These Foley footsteps were created by clicking ballpoint pens.

FIGURE 13.18. Career Choice.

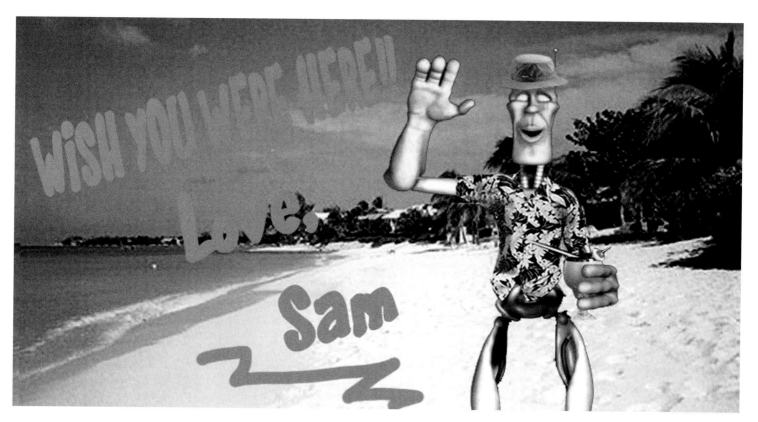

FIGURE 13.19. Angry Pilot

Bibliography

Sound Theory

Alten, S., *Audio in Media*. New York: Wadsworth, 1998.

Altman, R., *Sound Theory Sound Practice*. New York: Routledge, 1992.

Cantine, J., *Shot by Shot*. Pittsburgh, PA: Pittsburgh Filmmakers, 2000.

Chion, M., *Audio-Vision: Sound on Screen*. New York: Columbia University Press, 1994.

Holman, T., *Sound for Film and Television*. Boston, MA: Focal Press, 1997.

Kenny, T., *Sound for Picture*. Vallego, CA: MixBooks, 1997.

Lack, R., *Twenty Four Frames Under*. London: Interlink Books, 1999.

LoBrutto, V., *Sound on Film: Interviews with Creators of Film Sound*. Westport, CT: Praeger, 1994.

Sider, L., *Soundscape: The School of Sound Lectures*. New York: Wallflower Press, 2003.

Sonnenschein, D., *Sound Design: The Expressive Power of Music, Voice, and Sound Effects in Cinema*. Studio City, CA: Michael Wiese Productions, 2001.

Thom, R., *Designing A Movie for Sound*. Sweden: FilmSound.org, 1999.

Sound Techniques

Adam, T., *The Best Effect Settings for Sound Design and Mixing*. Bremen, Germany: Wizoo GmbH, 2000.

Bell, D., *Getting the Best Score for Your Film*. Beverly Hills, CA: Silman-James Press, 1994.

Berg, R., *The Physics of Sound*, 2nd ed. New York: Simon & Schuster, 1994.

Churchill, S., *The Indie Guide to Music Supervision*. Los Angeles, CA: Filmic Press, 2000.

Collins, M., *Audio Plug-Ins and Virtual Instruments*. Boston, MA: Focal Press, 2003.

Collins, M., *Choosing and Using Audio and Music Software*. Boston, MA: Focal Press, 2004.

Eargle, J., *The Microphone Book*. Boston, MA: Focal Press, 2001.

Gibson, D., *The Art of Mixing*. Vallego, CA: Mix Books, 1997.

Huber, D., *Modern Recording Techniques*. Boston, MA: Focal Press, 2001.

Jackson, B., Shark Tale: A different kind of fish story. *Mix Magazine*, Sept. 2004.

Katz, B., *Mastering Audio: The Art and the Science*. Boston, MA: Focal Press, 2002.

Kerner, M., *The Art of the Sound Effects Editor*. Boston, MA: Focal Press, 1989.

Lehrman, P. and Tully, T., *MIDI for the Professional*. New York: Amsco, 1993.

Lott, R., *Sound Effects: Radio, TV, and Film*. Boston, MA: Focal Press, 1990.

Lustig, M., *Music Editing for Motion Pictures*. New York: Hasting House, 1980.

Moravcsik, M., *Musical Sound: An Introduction to the Physics of Music*. St. Paul, MN: Paragon House, 2002.

Moulton, D., *Audio Lecture Series*, Vols. 1–4. Boulder, CO: Music Maker, 2000.

Moulton, D., *Total Recording*. Sherman Oaks, CA: KIQ Productions, 2000.

Northam, M. and Miller, L., *Film and Television Composers Resource Guide*. Milwaukee, WI: Hal Leonard, 1998.

Rose, J., *Producing Great Sound for Digital Video*. San Francisco, CA: CMP Books, 1999.

Rose, J., *Audio Postproduction for Digital Video*. San Francisco, CA: CMP Books, 2002.

Rossing, T., *The Science of Sound*, 3rd ed. Boston, MA: Addison-Wesley, 2001.

Shepherd, A., *Pro Tools for Video, Film, and Multimedia*. Boston, MA: Muska and Lipman, 2003.

Smith, M., *Broadcast Sound Technology*. Boston, MA: Butterworth, 1990.

White, G., *Audio Dictionary*. Seattle, WA: University of Washington Press, 1991.

Legal Reference Material

Donaldson, M., *Clearance and Copyright*. Los Angeles, CA: Silman-James Press, 1996.

Miller, P., *Media Law for Producers*. Boston, MA: Focal Press, 2003.

Stim, R., *Getting Permission: How To License and Clear Copyrighted Material Online and Off*. Berkeley, CA: Nolo Press, 2001.

Animation Sound History

Goldmark, D. and Taylor, Y., *The Cartoon Music Book*. Chicago, IL: A Cappella Books, 2002.

Maltin, L., *Of Mice and Magic: A History of American Animated Cartoons*. New York: New American Library, 1987.

Animation Technique

Arijon, D., *Grammar of the Film Language*, Los Angeles, CA: Silman-James Press, 1976.

Blair, P., *Cartoon Animation*. Laguna Hills, CA: Walter Foster, 1995.

Culhane, S., *Animation: From Script to Screen*. New York: St. Martin's Press, 1988.

Kozloff, S., *Invisible Storytellers: Voice-Over Narration in American Fiction Film*. Berkeley: University of California Press, 1989.

Osipa, J., *Stop Staring: Facial Animation Done Right*. Alameda, CA: Sybex, 2003.

Simon, M., *Producing Independent 2D Animation*. Boston, MA: Focal Press, 2003.

Whitaker, H., *Timing for Animation*. Boston, MA: Focal Press, 1981.

Williams, R., *Animators Survival Kit*. New York: Faber & Faber, 2002.

Winder, C. and Dowlatabadi, Z., *Producing Animation*. Boston, MA: Focal Press, 2001.

Reference Books

Breeze, C., *Digital Audio Dictionary*. Indianapolis, IN: Howard W. Sams, 1999.

Konigsberg, I., *The Complete Film Dictionary*. New York: Penguin Group, 1987.

Articles

Benzuly, S., Production music libraries in 2004. *Mix Magazine*, April 1, 2004.

Droney, M., Avast and away! *Mix Magazine*, Jan. 1, 2003.

Hawkins, E., Cartoon cutups: music editing for TV animation. *Electronic Musician*, June 1, 2000.

O, S., Build a personal studio on any budget, Part I. *Electronic Musician*, July 1, 2002.

Peck, N., Sound by design. *Electronic Musician*, March 1, 2001.

Peck, N., Making the cut. *Electronic Musician*, June 1, 2004.

Robair, G., Build a personal studio an any budget, Part II. *Electronic Musician*, July 1, 2002.

Production Featurettes

A Guy Like You: Multi-Language Reel, *Hunchback of Notre Dame*, Walt Disney Pictures, 1996.

Anastasia: A Magical Journey, *Anastasia*, 20th Century Fox, 1997.

Creating the Voice of "Casey Jr.," *Dumbo*, Walt Disney Pictures, 1941.

Films Are Not Released; They Escape, *Star Wars II: Attack of the Clones*, 20th Century Fox, 2002.

Jimmy Neutron: Boy Genius, Paramount, 2001.

Looney Tunes: Golden Collection, Warner Brothers Pictures, 2000.

Music and Sound Design, *Dinosaur*, Walt Disney Pictures, 2000.

You're Not Elected, Charlie Brown, *It's a Great Pumpkin, Charlie Brown*, Paramount Pictures, 1966.

70/30 Law, *Treasure Planet*, Walt Disney Pictures, 2002.

Supplemental Features, *Toy Story*, Pixar, 1999.

The Making of Jurassic Park, *Jurassic Park Collector's Edition*, Universal Pictures, 2000.

Walt Disney Treasures: Silly Symphonies, Vol. 4, Walt Disney Pictures, 1991.

Index

Robin Beauchamp/Focal Press
DVD navigation structure
author: Mike Goubeaux
m@mikegoubeaux.com
www.mikegoubeaux.com

DVD Navigation Outline

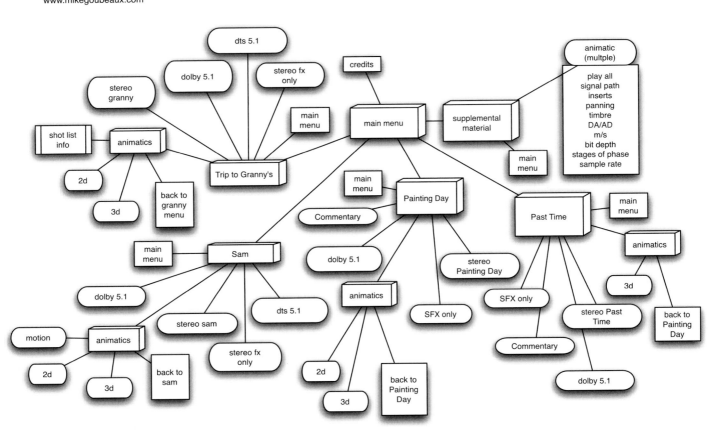

dts 5.1

dolby 5.1

stereo fx only

credits

animatic (multple)

play all
signal path
inserts
panning
timbre
DA/AD
m/s
bit depth
stages of phase
sample rate

stereo granny

main menu

main menu

supplemental material

shot list info

animatics

2d

3d

back to granny menu

Trip to Granny's

main menu

Painting Day

main menu

Past Time

main menu

Commentary

animatics

main menu

Sam

dolby 5.1

stereo Painting Day

3d

dolby 5.1

stereo sam

dts 5.1

animatics

SFX only

SFX only

stereo Past Time

back to Painting Day

motion

animatics

2d

3d

back to sam

stereo fx only

2d

3d

back to Painting Day

Commentary

dolby 5.1

motion media

dvd menu